TURNER'S LATER PAPERS

TURNER'S LATER PAPERS

A Study of the Manufacture, Selection and Use of
his Drawing Papers 1820–1851

PETER BOWER

TATE GALLERY PUBLISHING

OAK KNOLL PRESS

cover:
see cat.no.68B

Published by order of the Trustees 1999
on the occasion of the exhibition at the Tate Gallery
16 March – 13 June 1999
Research of the Turner papers was supported by The Leverhulme Trust

Published by Tate Gallery Publishing Limited
Millbank, London SW1P 4RG
and Oak Knoll Press, 310 Delaware Street, New Castle, DE 19720
© Tate Gallery and the author 1999 All rights reserved

A catalogue record for this publication is available from the British Library
Library of Congress Cataloguing-in-Publication Data is available
ISBN 1 85437 295 5 (Tate Gallery Publishing)
ISBN 1 884718 97 3 (Oak Knoll Press)

Designed and typeset by Caroline Johnston
Photography by Tate Gallery Photographic Department;
technical photography by Rod Tidnam;
reassembled sheet photography by David Clarke

Printed on Parilux matt cream 135gsm
Printed in Great Britain by Balding + Mansell, Norwich

CONTENTS

FOREWORD

In 1994, Peter Bower was awarded a grant by the Leverhulme Trust which made possible his continued research into the subject he had first explored in 1989, culminating in the 1990 catalogue and exhibition at the Tate Gallery, *Turner's Papers*.

Following on from that exhibition, *Turner's Later Papers* looks at the ways in which advances in papermaking technology affected Turner's use of paper during the latter part of his career. The exhibition provides a fascinating opportunity to look at original works from the Turner Bequest alongside transmitted light images and micrographs of the paper surface. Peter Bower has been able to identify where a number of works from the Bequest have been cut from the same sheet, and some of these are mounted together for the first time. The presentation of such material is labour-intensive and special thanks must go to Philip Miles and Geoffrey Winstone for the graphic design of the exhibition, and to those staff at the Tate Gallery – particularly in the departments of paper conservation and photography – who have made it possible.

In addition, the exhibition examines the advances made in the design and production of paper during the period. We are most grateful to the Royal Society of Arts, to Nicholas Wiseman and to Peter Bower himself, all of whom have generously lent items which illustrate the technology involved in making the papers that Turner selected in his later career.

We would like to thank the Leverhulme Trust for making it possible for Peter Bower to complete his research into this subject. Above all, we would like to thank Peter Bower for his tireless enthusiasm and energy in bringing the project to completion.

Nicholas Serota
Director

ACKNOWLEDGMENTS

This research into Turner's use of paper began in 1989 and the sheet by sheet analysis of all the works on paper in the Turner Bequest has been an absorbing and rewarding project. I have been greatly privileged to have had the opportunity to examine Turner's work throughout his working life, and gain some understanding of the part played by the changing nature of his materials in the development of his work and on his working habits. The project was first undertaken with a Turner Scholarship funded by Volkswagen and for the past four years has been supported by the Leverhulme Trust. I owe a great debt of thanks to both these organisations and to the Tate Gallery for their generous support for an area of research that had previously received little recognition. I am particularly grateful to both the Royal Society of Arts and Nicholas Wiseman for making rare items available for the exhibition.

I would also like to express my appreciation of all the people who have answered queries, provided material or helped with access to works and archives all over Britain and Europe, often elucidating obscure areas and providing crucial information at important points in the research: Peter Addison, John Balston, Susan Bennett, Martin Butlin, Mungo Campbell, Paul Clark, Robin Clarke, Tom Collings, Alan Crocker, Harry Dagnall, Harriet Drummond, Trevor Fawcett, John Hazell, Richard Hills, Colin Johnston, the late Michael Kitson, John Krill, Jane McAusland, Christine MacKay, the late George Mandl, Tim Morton, Bruno Navarre, Susan North, Charles Nugent, Emma Pearce, Guy Peppiatt, Gerard Pink, Derek Priest, Mark Sandiford and Phillipa Mapes, Frieder Schmidt, Tanya Schmoller, John Simmons, Kim Sloan, John Smith, Peter Staples, Jean Stirk, Peter Tschudin, Rosalind Turner, John Van Oosterom, Nicola Walker, David Wallace-Hadrill, Barry Watson, Stuart Welch, Henry Wemyss, Alan Witt, Tony Woolrich, Andrew and Christy Wyld and Marnix Zetteler. I would also like to express my appreciation of all the kindness and patience shown by the staff of many institutions, in particular Bath City Library, the British Library, the British Museum, Kent County Archives, the National Gallery of Scotland, the National Monuments Record, the National Paper Museum, Manchester, the National Portrait Gallery Archives, the Patent Office, the Science Museum Library, and Somerset County Records. Any errors of fact or interpretations are of course my own.

I would like to thank Nicholas Serota and all my many colleagues at the Tate Gallery, past and present, for their enthusiasm, support,

practical help, information, advice and helpful criticism throughout both the research and this particular exhibition: Iain Bain, Camilla Baskcomb, David Brown, Ann Chumbley, Andy Dunkley, Richard Hamilton, Dave Lambert, Marcus Leith, Andy Loukes, Anne Lyles, Tessa Meijer, Brian Mckenzie, Philip Miles, Heather Norville-Day, Leslie Parris, Ruth Rattenbury, Helen Sainsbury, Kazia Szeleynski, Sarah Taft, Joyce Townsend, Ben Tufnell, Ian Warrell, Andrew Wilton and Calvin Winner. Very special thanks are due to Rod Tidnam for all his efforts on the micrography, transmitted light images and other photography, to Dave Clarke for his reassembled sheet photography and to Piers Townshend for the reassembly of several sheets. I would particularly like to thank both publishers for making possible the publication of this second volume of my researches: Celia Clear, Tim Holton, and my editor Judith Severne from Tate Gallery Publishing and Robert Fleck and John von Hoelle of Oak Knoll Books, Delaware, USA, for their imaginative collaboration on this publication.

Over the past ten years the collaboration with other Turner Scholars on their various researches in the Turner Bequest has proved indispensable to furthering my understanding of the complexities and minutiae of different aspects of Turner's life and work: I would particularly like to thank Cecilia Powell, Maurice Davies, Jan Piggott, Gillian Forrester, James Hamilton and Eric Shanes for their generous and stimulating cooperation.

My greatest thanks must go to my wife Sally for her invaluable, good humoured and patient help during the completion of this long project.

INTRODUCTION

This catalogue continues the exploration of the part played by paper in Turner's working life. The study of Turner's paper usage in the first half of his career, up to 1820, was published in 1990.[1] That volume contained an introductory section on basic handmade papermaking processes and watermarks. The introductory section in this publication takes in those developments in papermaking during the years 1820–1851, concentrating on this occasion on raw materials, finishing techniques and those changes in the papermaking process that are relevant to Turner's working practices in the years under discussion, rather than merely describing the basic process.

Each artist has their own preferences when it comes to the papers they work on, and it has proved fascinating to see how the types of papers that Turner used early in his life seem to have coloured his choice throughout his career. The white watercolour papers, made by Balston, the Hollingworths, Ruse & Turner, Ansell, and Bally, Ellen & Steart, that he chose to work on were generally those whose surfaces and tones were reminiscent of the Post writing papers which he had used for many of his earliest watercolours. Even the blue, grey, buff and brown coloured watercolour papers, whether English or continental, that he loved to work on, owed their tones and textures to the 'Academy' papers, the blue and brown wrapping papers that he had drawn on as a student in the Royal Academy Schools.

Many of the papers he used, including those for his lecture notes and correspondence, were, even when made by some of the most renowned makers of his day, 'retree' sheets, papers that had some visible fault, but not one sufficient to make the whole sheet useless. Such sheets sold at cheaper prices than those of the first quality. As with all artists there were of course occasions when he worked on whatever was to hand, whether backs of letters or scraps of wrapping paper, but generally his choices were careful and considered. It would be fascinating if we could know what papers remained in his studio, unused, on his death. One can only speculate as to what they might have been and why they had not been used: had time just run out or were there sheets discarded as unsuitable? The auctioneer Elgood's inventory of Turner's property at Queen Anne Street after his death shows Turner keeping his paper in all sorts of places on every floor of the house.[2] Do the various storage places for different papers relate to different types of paper?

Second Floor, East Room: 6 mill Boards, 2 sketching books etc.

First Floor, Front Room (Studio): Deal Cupboard with Quantity of Drawing Paper, Japanned box with sundry paper.

Ground Floor, Entrance Hall & Staircase: Chest of 3 drawers with paper.

Further Rooms: Sundry Rolls of Paper, Sundry Millboards.[3]

Turner's work itself is the best evidence of what lay behind his choice of a very complex range of papers. There are swift sketches on scraps of paper, large sheets of watercolour paper used for colour beginnings and finished watercolours, English and continental coloured papers (whose makers have until now received little recognition for their great achievements), roll sketchbooks, and various experiments with other papers such as glazed cards, laminated boards, machine-made papers, as well as individual sheets tried out by Turner, but not returned to. This catalogue also contains some 'curiosities': Austrian forgeries of Whatman paper used by Turner, cheap machine-made 'Colossal Continuous Drawing paper', small pocket books used as sketchbooks but actually designed for other uses, and some examples of 'homemade' sketchbooks.

The final section of the catalogue consists of works by other artists in the Tate's collection, illustrating these artists responses either to a paper also used by Turner, or to some of the other papers easily available to Turner, but which he never appears to have used. Examining the work of some of Turner's contemporaries such as Samuel Laurence, Clarkson Stanfield, James Duffield Harding, John Sell Cotman, Peter De Wint, David Cox, John Constable, and Samuel Palmer, throws considerable light on their understanding of their chosen materials and the nature of their individual skills and vision.

Turner's return from Italy in February 1820, when he was forty-four years old, and invigorated and energised by the drama of light he had experienced in his long sojourn in the South, ushered in a period of great change, experiment and growth in every aspect of his work. The part played by paper, the very ground he worked on, in both transforming his techniques and contributing to the growth of his vision, is crucial to an understanding of his working practices. All works of art on paper, in whatever medium, depend for their success on a deep and vivid understanding, by the artist, of particular surfaces and the ways those surfaces can be worked. The actual technology of papermaking was undergoing more and faster changes, and each of those changes had an effect on the ways artists were able to work. In the case of Turner, innovative and demanding, such changes were often exploited to their limit.

Although this study is primarily an exploration of his use of draw-

fig.1 Mahogany board used for stretching watercolour papers when painting. The other side of this board was later used for the oil painting *George IV's Departure from the 'Royal George' 1822*, *c*.1823–5.

ing papers one cannot ignore what Turner learnt and understood about the possibilities of papers from his etching and mezzotint work. His direct involvement in the production of both the *Liber Studiorum* and the *Little Liber* works and his collaborations, to varying degrees, with the artists and craftsmen who engraved his plates in so many other projects, taught him much. These men of skill and experience had great understanding of the characteristics and potentials of a very different range of papers which would surely have contributed much to Turner's intricate grasp of surface and the way light works on, and is reflected from, a surface.

The luminosity and vibrancy of so many of the colours visible in Turner's watercolour and bodycolour works from this period on, owe much to a complex use of oil techniques transferred to watercolour. The ability of particular papers to withstand the various ways of working that his vision demanded was much enhanced by the increasingly sophisticated technology of papermaking. The rapid introduction and exploitation of the paper machine by an increasing number of makers had made the diehard handmade papermakers change both their working practices and their very concepts of what papermaking was about. The advance of the paper machine forced those makers who retained handmaking to strive for increasing quality and increasing range in the types of papers they made: they moved further and further towards the 'quality' end of the market.[4]

There are many descriptions of Turner working with his paper stretched in some manner on boards, but almost no evidence survives of what actual methods he used. There is one surviving board used for sketching in the Turner Bequest. This particular large mahogany board, measuring $29^5/8 \times 36^3/16$ (750 × 920), has only survived because the other side of the board was used for an unfinished oil painting, *George IV's Departure from the 'Royal George', 1822*, of *c*.1823–5.[5] As Townsend describes it:

> Paper was glued to it, not taped or pinned and torn off hurriedly after watercolour paint had been applied. In his middle years Turner had a series of small drawing boards with handles on the reverse so that each sheet could be plunged into water in turn, and kept wet as he painted it.[6]

Although this particular board still bears the remains of pieces of paper, the technique described cannot have been used for very many of Turner's watercolours, as the examination of the watercolours in the Bequest shows almost no evidence on most of the sheets that they had been through this process: there is no sign on the versos of most of the watercolours that they were ever glued to anything. Many of the sheets retain one, two or more of their deckles; the torn edges seem to

show none of the damage which, judging by the remnants on the board, they would have had if this technique was used. Equally I have seen no such evidence on the works outside the Bequest that I have examined. The one sheet that may well have been used in this manner is a colour study of an unknown subject, but its dimensions preclude it being one of the sheets sketched on this particular board.[7]

Most of the descriptions of Turner using boards date from the earlier part of his career and are very vague, but physical evidence exists in many sheets to support them. There are examples from early in Turner's career of papers having been folded over boards and pinned, but almost nothing from later in his career.[8] There are a few examples of sheets with folds around each edge that may well have been used in a 'sketching frame', a simple device for locking a sheet onto a board sold by many colourmen.[9] A different and slightly more detailed account, from another occasion, gives a more instructive description:

> he stretched the paper on boards and, after plunging them into water, he dropped the colours onto the paper while it was wet, making *marblings* and gradations throughout the work. His completing process was marvellously rapid, for he indicated his masses and incidents, took out half lights, scraped out high-lights and dragged, hatched and stippled until the design was finished.[10]

Turner continued to go his own way, obviously not swayed by the increasingly sophisticated and fashionable changes dictated by many of the colourmen, stationers and merchants. Although many of the papers, particularly the whites and off-whites may appear visually very similar, Turner was actually using an increasing range of papers during the second half of his life, buying groups of sheets, sometimes in relatively large amounts, of those that he liked and then continuing to use them as long as the mills stayed in business and those papers remained available.

Amongst the archives of the artists' colourmen Winsor & Newton is a brief typescript written in 1925 by W.E. Killick, who had worked for the company for very many years, which gives a flavour of the man and the certainty of his opinions when concerned with materials. It tells a tale:

> which I think is authentic, and that is, that Mr Winsor during his life was pretty intimate with the great artist Turner, who used to get his colours from us, and noticing from time to time the very fugitive colours that Turner bought from us, plucked up courage one day to remonstrate with him for so doing. Turner's answer, in spite of the friendship between the two men was somewhat

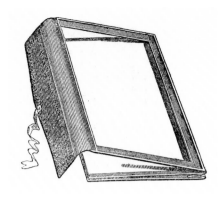

fig.2 Sketching frame of the type sold by colourmen such as Winsor and Newton and Reeves from the 1840s onwards. Such frames had japanned tin frames for holding down the drawing securely, half-bound leather tuck and a pocket for holding loose sheets and finished works. They were available in Octavo Imperial, Quarto Imperial, Half Imperial and Quarto Royal.

uncompromising; he is alleged to have said 'Your Business Winsor is to make colours for Artists, mine is to use them.' I am afraid poor Mr Winsor had nothing to say in reply.[11]

Choosing the works for a catalogue such as this presents certain problems. Almost any work could have been chosen, but I have selected those works which allow discussion of Turner's paper usage, but which also illustrate some of the extraordinary changes that were taking place within the European paper industry during the first half of the nineteenth century.

Weight and texture differences are not always indicative of a 'different' paper when describing papers from some sources: quality control varied considerably from mill to mill. The major criteria for ascribing individual sheets to particular batches of paper come from the fibres used, the degree of beating and the evidence, within the sheets, of the moulds that they were made on. Some of the identifications of particular papers could be clarified by further examination and analysis.

It is also important to note that some of the apparent differences between these papers may well be merely batch differences rather than the papers having actually come from different sources. Merchants and artists' colourmen continued to use the same mills for their supplies over long periods of time, but the moulds deteriorated and were replaced, methods of pulping changed and it was never possible for mills to get consistent supplies of rags and other raw materials. All this contributed to variations, sometimes subtle, sometimes quite dramatic, in the appearance and character of different batches of what were, nominally at least, the same paper.[12]

It is no accident that the advent of a generation of great painters in watercolour, Turner, Girtin, Cotman, Cox and others, coincided with a time of great change and experimentation in the industries providing them with their raw materials. But one important consideration must be taken into account in any discussion of Turner's use of his materials, and that is his sheer skill. My ten-year examination of the twenty thousand or so works on paper in the Bequest has shown that he was perfectly capable of turning any paper to advantage. Even the lightest, flimsiest machine-made writing paper could be vigorously worked on in watercolour, pencil and crayon to dramatic and extraordinary effect (see cat.no.41). Although he would have been able to work practically any paper as and how he wanted, most of the time he made very specific choices.

By the end of Turner's life some of the artists' papers being produced had become so specialised that they had lost much of their versatility and potential. A slightly later generation, notably Cox and

Palmer, were to move away from these use-specific watercolour papers, both in their different ways becoming increasingly particular about their papers. Turner died before this process had really taken hold. By the end of the century the various pressures of the amateur and technical drawing markets had changed the nature of drawing and watercolour surfaces out of all recognition and produced a uniformity of texture and grain that gave a bland, almost lifeless surface to many papers.

1 Bower 1990.

2 J.G. Elgood, Appraiser and Auctioneer, *Inventory of 47 or 46A Queen Anne Street, the Late Residence of J.M.W. Turner*. Listed in Wilton 1987, p.248.

3 Although two distinct supplies of this material are described in the Inventory there is little evidence that Turner ever really used millboard, except for a very few oil sketches. Indeed many of them, catalogued over the years as being on millboard are actually on laminated or prepared papers rather than true millboards.

4 This is true of Fine papermakers, those primarily involved in the production of white papers designated by the Excise as Class I papers for taxation purposes. Many of the small rural mills making rope-browns, brown-whites, sugar blues, hemp browns etc. for wrapping papers and press boards continued to operate much as they had always done until the latter years of the nineteenth century. Several mills which converted to machine making continued to retain a vat or two for making their own wrappings. The long fibres of hemp ropes, traditionally used for such papers, were almost impossible to use on the earliest Fourdrinier paper machines.

5 NO2880, B&J 248B.

6 Townsend 1993, pp.17–18.

7 TB CCLXIII 381, 396 × 738 (15⅝ × 29), with very torn and ragged edges.

8 E.g. TB LXX O, *Dolbadern Castle* of 1798–9. see Bower 1990, p.71.

9 Many such pieces of equipment are illustrated in various colourmen's trade catalogues from the 1830s onwards. Some artists, Cotman for instance, made their own.

10 James Orrock, quoted by Gage 1969, p.32.

11 W.E. Killick, 'A Short History of the House of Winsor and Newton Ltd', 1925, Mss in Winsor and Newton Archives, Harrow.

12 This is still true today: many well-known paper brands change quite significantly from time to time as mills constantly source new raw materials supplies, upgrade their equipment and modify their techniques.

MAP SHOWING SOURCES OF PAPERS INCLUDED IN CATALOGUE

Many European borders have changed since Turner's time and two of the mills listed as Austrian are now in other countries.

British makers and mills

1	Richard Barnard	Eyehorne Mill, Hollingbourne, Kent
2	T. & J. Hollingworth	Turkey Mill, Maidstone, Kent
3	William Balston	Springfield Mill, Maidstone, Kent
4	Richard Turner & Letts	Upper Tovil Mill, Maidstone, Kent
5	Smith and Allnutt	Great Ivy Mill, Maidstone, Kent
6	William Weatherly	Chartham Mill, Chartham, Kent
7	William Turner	Chafford Mill, Fordcombe, Kent
8	Charles Wilmott	Shoreham Mill, Shoreham, Kent
9	John Muggeridge	Carshalton Mill, Surrey
10	John Dickinson	Apsley Mill, Hertfordshire
11	Thomas Creswick	Mill Green Mill, Hatfield, Hertfordshire
12	Thomas Edmonds	Rye Mill, Wycombe, Buckinghamshire
13	John Edward Spicer	Alton Mill, Hampshire
14	William Brookman	Test Mill, Romsey, Hampshire
15	William & Thomas Slade	Hurstbourne Priors Mill, Hampshire
16	Bally, Ellen & Steart	De Montalt Mill, Bath, Somerset
17	Joseph Jellyman	Downton Mill, Downton, Wiltshire
18	Alexander Cowan	Valleyfield Mill, Midlothian, Scotland
19	Unknown maker	Uxbridge, Middlesex

French makers and mills

| 20 | Chapuis | Moulin de St Claude et Lessard, St Claude, Franche Comte |
| 21 | Jardel | Couze, Bergerac, Dordogne |

Italian makers and mills

22	Pietro Galvani	Pordenone, Fruili-Venezia-Giulia
23	Pietro Miliani	Fabriano,
24	CS	Brescia, Lombardy

German makers and mills

25	Jordan	Hasserode Mill, Magdeburg
26	Ludwig Piette	Dillingen Mill, Saarland
27	Richard Bocking	Kautenbach, Trarbach, Rheinland-Pfalz
28	Ludwig Roeder	Neustadt a d Weinstrasse, Rheinland-Pfalz

Austrian makers and mills

29	Gabriel Ettel	Pelsdorf Mill, Bohemia (now in Czech Republic)
30	Peter Weiss	Val Sugana Mill, Torrento Maso, Southern Tyrol (now in Italy)
31	I. von Pachner	Klein Neusiedl Mill, Lower Austria

Swiss makers and mills

| 32 | J. Bristlen | Nyon |
| 33 | Zürcher Papierfabrik | An der Sihl |

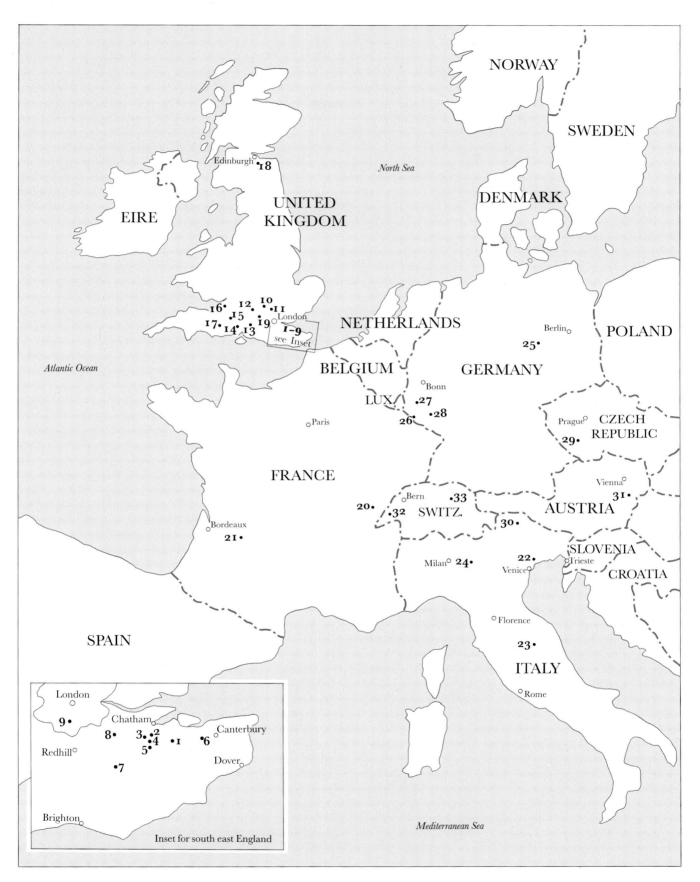

NORWAY

SWEDEN

DENMARK

North Sea

Edinburgh •18

UNITED
KINGDOM

EIRE

POLAND

Berlin○

•25

NETHERLANDS

GERMANY

16• 12• 10• 11
 •15 •
17• •19 London
 14• 13• 1–9
 see Inset

BELGIUM

LUX. Bonn○
 •27
26• •28

Prague○ CZECH
 REPUBLIC
 •29

Atlantic Ocean

Paris○

FRANCE

Bordeaux○
•21

20• Bern○ •33
 •32 SWITZ.

Vienna○
 31•

AUSTRIA

30•

SLOVENIA

SPAIN

Milan○ •24

22•
Venice○ Trieste○

CROATIA

Florence○

23•

ITALY

Rome○

Mediterranean Sea

Inset for south east England

London○
9•

Chatham○
8• 3• •2
 5• •4 •1 •6 Canterbury○
Redhill○

•7

Dover○

Brighton○

CATALOGUE

Unless otherwise stated all works are by
J.M.W. Turner.

All papers are handmade except where
stated.

All measurements are given in millimetres, followed by inches, height before
width. It must be stressed, however, that
a better understanding of the scale and
proportions of particular papers can be
achieved using traditional measures. All
the English handmade and machine-
made papers used by Turner were made
in inches and, for the most part, the con-
tinental papers used by Turner were also
made in the traditional measurements of
their countries of origin.

Where it has been possible the original
designed use of the paper has been indi-
cated.

Where possible, the original sheet size
and folding arrangements of sketchbooks
has been indicated. Where different
sketchbooks with different measurements
have been given the same paper size
descriptions, the differences in measure-
ments are the result of different folding
and trimming patterns. Similarly sketch-
books with the same measurements but
described as having come from different
paper sizes, are also the result of trim-
ming and folding patterns.

In some cases, due to the density of the
paper itself, the watermarks listed for
particular papers are not visible under
ordinary lighting conditions. These
papers have been examined using a fibre
optic light source which has allowed the
watermarks to be read.

Quotations from contemporary accounts
are given in their original spelling and
punctuation.

The use of square brackets [], with or
without letters or numbers within water-
mark descriptions indicates missing parts
of the watermark.

Abbreviations

B&J Martin Butlin and Evelyn Joll, *The
Paintings of J.M.W. Turner, RA*, 2 vols.,
rev. ed., London & New Haven
1984.

TB A.J. Finberg, *A Complete Inventory of the
Drawings of the Turner Bequest*, 2 vols.,
London 1909.

W Andrew Wilton, *The Life and Work of
J.M.W. Turner*, London and Fribourg
1979. Includes catalogue of water-
colours.

Paper and its Changes during Turner's Lifetime (cat.nos.1–11)

Turner's paper usage is a measure of his other talents: discriminating and informed by a deep understanding of the nature of the surface textures and strengths of different papers. Quite early in his career he developed an almost intuitive understanding of what media would work best on what surface. This deep and vivid understanding of the tones, textures, surface strengths, and the depth and intensity of the sizing used are all integral to his work: the paper is rarely just a neutral ground carrying an image.

Two recent studies have reappraised Turner's interest and involvement with science and technology.[1] But neither has remarked on the intimate effect that the new developments in science and technology were to have on the production of the materials that Turner worked with and how this affected the works themselves. The pigments and paper he worked with were the product of just such changes. Townsend has discussed the introduction of new pigments[2] and Gage has also recorded such changes,[3] but the papers have never before been subjected to the in-depth historical and scientific analysis they deserve.

Turner's working life from 1787 to 1851 spans one of the most significant periods in both British and European papermaking history, when a generally small-scale and craft-based industry evolved into a heavily industrialised factory system. This period saw the invention of the paper-machine, the development of new equipment and techniques, the introduction of new raw materials. An increasingly discerning public, including artists, were demanding increasingly use-specific papers designed to meet their particular needs, rather than relying on the older group of basic types which had served for many centuries: namely writings, printings and wrappings.

Much of this growing specialisation was due to the activities of merchants, stationers and colourmen who were differentiating more and more subtle developments in paper qualities and characteristics as selling points when marketing individual papers, both to amateur and professional customers.[4] Artists themselves contributed to this process, telling the colourmen what they wanted. The evolution of medium-specific papers depended on a rapidly growing understanding amongst makers of the possibilities inherent in their process and an equal growth of understanding, amongst users, of what they wanted in a paper.

Many of these 'drawing' papers were actually designed and produced for various kinds of more technical drawing, rather than for the fine artist. The market for fine artists' papers has always been relatively small, but by the early years of the nineteenth century the market for engineering, architectural, surveying, and map-making papers, all of which needed surfaces which could take colour washes and ink, was enormous. It was this market that made the development of such papers economically viable for the mills.[5]

The handmade paper industry had always been somewhat different from many other craft-based industries: most mills had been operating a factory system, where individual workers carried out highly specific tasks rather than working at all stages of the process, long before the introduction of such practices determined the shape of British industrial change. The introduction of the paper machine changed the paper industry in other ways: it streamlined production, from the wet pulp to the reeled-up dry paper, into a continuous process monitored only by the machine man.

The pace of technological change and the consequent changes in organisation and economics of so many industries in the early to mid nineteenth century concerned many people: for some the benefits were manifest, for others the growth of exploitative 'factory' processes was an anathema. Andrew Ure thought that 'The Blessings of the Factory System' lay in the following:

> The principle of the factory system then is, to substitute mechanical science for hand skill … On the handicraft plan, labour more or less skilled, was usually the most expensive element of production – *materiam superabat opus* [the work exceeded the material]; but on the automatic plan, skilled labour gets progressively superseded, and will, eventually, be replaced by mere overlookers of machines …[6]
>
> Improvements in machinery make it possible to fabricate some articles which, but for them, could not be fabricated at all. They enable an operative to turn out a greater quantity of work than he could before, – time, labour, and quality of work remaining constant. they effect a substitution of labour comparitively unskilled, for that which is more skilled[7]

Some of this may well be true of the paper industry. Indeed, John Dickinson is reputed to have been able 'to make a papermaker out of a hedge' following his dismissal of all the papermakers at his Apsley mill:

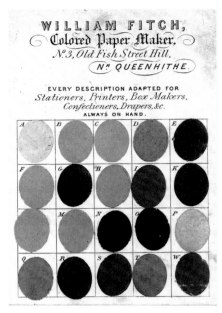

fig.3 Trade card from William Fitch of Rotherhithe, typical of early nineteenth-century publicity material, containing twenty samples of the coloured papers he sold.

Mr D was very much occupied all the Morning arranging new setts of workmen in place of those who have left ... Mr D set on 4 labourers as engineers and was up all night to look after them ... Had a number of men from A[bbots] L[angley] parish to select workmen from ... Mr D hir'd some more men.[8]

None of these new men were skilled papermakers, but some may well have had experience in, or family connections with, the various paper mills in the area, mills that included Nash, Batchworth, Home Park, Two Waters and Frogmore. Apsley was soon working again at full stretch.

John Fielden, MP for Oldham and also a manufacturer at Todmorden in Lancashire, and who had himself been 'set to work in my father's mill when I was little more than ten years old', considered the 'curse' of the new industrialisation to be that 'as improvements in machinery have gone on, the avarice of "masters" has prompted many to exact more labour from their hands than they were fitted by nature to perform'.[9]

However bad conditions were in some places, and wherever Dickinson got his workers from in the 1820s, it is interesting that of the sixty-three surnames in the list of workers at Apsley Mill in 1823, thirty-five are still to be found amongst the list of employees quoted by Evans for the year 1955.[10]

In 1813 the papermaker Robert Bacon, of West Mills, Wareham, Dorset, writing to William Balston, considered that the effects of the introduction of the machine, the troubles with combinations of workers, problems of supply etc. would all combine 'to place the manufacture in larger hands'.[11]

The earliest machine-made papers seem to have been designed primarily as printings or for wrappings. Of the twenty-three Scottish mills operating thirty paper machines in 1832 five are described as producing writings and one, Edward Collins of Dalmuir, Dunbartonshire, as producing 'Superfine and second writings, printings and music, plate. drawing, blotting and coloured'. Of the others most are producing printings, greys and browns, cartridge, millboards, binder's boards and pressings, and several are noted as producing coloured papers.[12]

The quality of a lot of paper certainly declined in the 1820s, in both hand and machine-made papermaking, as the pressures on both types of manufacturing grew more powerful and they reached parity of output: increased raw material costs and irregularity in raw material supply, workers' rights, and falling prices all contributed to this situation. The combination of increasingly low-grade cotton, and linen, rags with an over-reliance on chlorine bleaching at high strength and the

over-enthusiastic use of china clay as a loading had an extraordinary effect on the quality of output from many mills. By the 1820s the problems were so bad that many people were losing confidence in some papers and their makers. Enterprising handmade makers, such as Thomas Edmonds of Rye Mill, Wycombe, who did not use such methods, started to market their papers differently, making a feature of their purity: Edmonds produced a very fine white wove drawing paper, in both Imperial and Double Elephant, watermarked T EDMONDS 1825 in one corner of the sheet and NOT BLEACHE^D in the other.[13]

Coleman gives some figures for the general reduction in prices of papers over the period 1797–1860, based on the price of one of the commonest printing papers, Printing Demy, bought by Longmans the publishers. From a high point in 1811–12 of some 32 shillings a ream the price continues to drop steadily, despite slight rises at various times, to 15 shillings a ream in 1860.[14] It should be noted that this steady decrease in price was not just the result of the mechanisation of the industry but was also affected by the serious depression in the economy as a whole that occurred at the end of the Napoleonic Wars and which lasted right through the 1820s.

Over the period 1804–60 Coleman calculated that the output of paper and pasteboard in the UK had grown from about 15,000 tons to almost 100,000 tons.[15] Of this the relative amounts of handmade and machine-made paper changed dramatically, with the crossover point in 1825 when equal amounts of paper were being produced by each manufacturing method:

1804	Handmade: 14,500 tons	Machine made: below 200 tons
1825	Handmade: 11,000 tons	Machine made: 11,000 tons
1860	Handmade: 3,900 tons	Machine made: 95,000 tons [16]

Such a vast change in the balance between hand and machine manufacture is to be expected as the new machines became increasingly better engineered, larger in scale, swifter in operation and capable of producing much better quality papers. But what was it that kept the handmade mills in business?

Those handmade mills which specialised, which went 'up market' to satisfy the increasingly sophisticated niche markets being created by some merchants, artists' colourmen and stationers, mostly thrived. Two famous 'handmade' names from the early part of the machine-made period in the 1820s and 1830s flourished by producing highly individual papers designed for use by artists. Both Thomas Creswick, renowned for his drawing papers, beloved by De Wint and many others, and George Steart, producer of the fine coloured watercolour and drawing papers so favoured by Turner, Cotman and others made

considerable fortunes. Both the businesses ceased operation only on the retirement of their main protagonists, rather than from any of the economic disasters that beset so many mills in the 1820s and 1830s.

Technical innovations and the new skills necessary to implement them drove papermakers into increasing specialisation and encouraged the production of a wider range of better quality use-specific papers. This process also produced some profound changes in the different ways sheets behaved in use, but many of these changes were not always visible. The development of new hydraulic presses, primarily to speed up production and to give greater strength for writing papers (which had had to change with the introduction of the steel nib, which demanded a much greater surface strength than the quill) also gave greater pressure and compacted the surface of the sheet differently. Improvements in felt manufacture were also occurring at the same time and some makers began to develop new and more complex wet pressing sequences: not just one quick press to remove the water, but another pressing with dry felts, another without felts and with less pressure, another with all the sheets in a different order, and so on.

Any gelatine-sized handmade sheet goes through two drying processes, once just after it is formed and then again after it has been sized. The first drying is crucial to both the stability and strength of the sheet. All paper, but particularly watercolour paper, is best dried over a long period using airflow and gravity. Speeding up the drying process, particularly by the use of heat, has the effect of not allowing all the tensions within the sheet to resolve themselves right out to the edges of the sheet. Each sheet is subject to enormous internal tensions as it dries, shrinking as it gives up its water to the air around it. Each fibre gives up water and as it does so it tugs on the fibres with which it is mechanically entangled, creating waves and ripples visible in the surface of the sheet. This process is known as cockling and is more or less visible in most handmade papers.

Drying a watercolour sheet in the winter gives a much longer length of time for these tensions to resolve completely. It is no accident that the papers that allowed British watercolour artists to develop their art in new and perhaps surprising ways were made in a climate such as Britain's. French papermaking, particularly by makers such as Columbier, Dupuy and Richard from the Auvergne, was renowned in the eighteenth century for the extraordinary bite and definition that could be achieved with engraved and etched plates. Papers dried much faster in the Auvergne, giving less time for shrinkage and thus producing a slightly 'softer', less dense, sheet that allowed the engraving plate a beautiful bite into the surface of the sheet. Because these plates were rarely run through the press more than once there was no intrinsic reason why the papers needed great internal stability. The

fig.4 The drying loft at Afonwen Mill, North Wales, showing the wooden louvres used to direct the airflow over the wet paper. Paper from Afonwen can be found in the *Naples, Rome C. Studies* sketchbook Turner used in Italy in 1819–20 (TB CLXXXVII).

difficulty many English makers had in matching the quality of French plate papers in the eighteenth century is partly due to the difference in these drying times.[17] Some makers had begun to use heat in the late eighteenth century to speed the process up, and by the 1820s most handmade mills, particularly those making fine white papers, had installed steam pipes in their drying lofts.

Another major change was the introduction of a new method of drying the sheets flat. The traditional method of drying over cow or horse hair-covered ropes (ropes that unlike hemp would not mark or discolour the wet sheet) had always had one disadvantage: when first dried every sheet had what was called a 'back', a bend in it where it had hung over the rope. This area of the sheet was often distorted by differential shrinkage leaving creases and cracks in the surface as well as distorting the actual shape of the sheet. A second result is the distortion of the long edges of many handmade sheets dried by this method, which are slightly curved, where the middle of the sheet has not shrunk as much as the outer edges. For many uses this did not matter too much; paper was generally sold folded in quires of twenty-four sheets and the 'back' was hidden in the fold. Much paper was sold for printing, where again it would not matter.[18] Many artists did not mind the presence of the 'back'; there are many examples including several famous paintings by Turner, Cotman, Cozens, Joseph Wright of Derby, and Paul Sandby, where the 'back' is clearly visible in the work and sadly 'read' as damage by some conservators who desperately try to do something about it, much to the detriment of the work.

But some artists did not like it, particularly as they desired to make larger and larger works. Colourmen such as Ackermann were also convinced that the paper would be better without it and when a method of drying that did away with the 'back' was developed they marketed it extensively. The merchants were always looking for new papers to present to their customers, whether amateur or professional, and many artists used such highly developed papers for some of their works, whilst continuing to find other papers to use as well. 'Seamless drawing papers', i.e. papers without this disfiguring line were being marketed by Winsor & Newton and others quite early in the nineteenth century.

Seamless drying, where the wet sheets are laid flat in spurs, on muslin or coarse canvas 'sails', was not a new process. Any information as to when this practice actually began would be warmly welcomed. There are many large watercolour papers from the earliest years of the nineteenth century which show no trace of a rope mark or 'seam' anywhere on them, but the earliest reference I have yet found to this method of drying, particularly being used as a selling

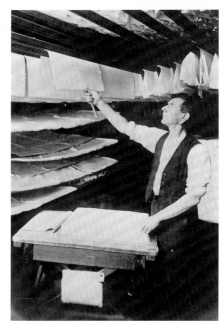

fig.5 Drying paper by both methods: hanging paper over ropes, or bars, and also laying the sheets flat on 'sails'. Hayle Mill, Kent, c.1920.

point in relation to watercolour papers, comes in an 1861 trade catalogue issued by Winsor and Newton where, after the entries for 'Whatman's Drawing Papers' and 'Whatman's Drawing Paper of Extra Weights' can be found 'Whatman's Seamless Drawing Papers'. The note above the sizes and prices reads:

> These Papers are similar to the foregoing stout Drawing Papers, but are perfectly flat, and without any seam mark across the centre of the sheet.[19]

Many factors contributed to the change in surface textures and strengths in the drawing papers available to English watercolour artists from the 1820s onwards. Changes in raw materials and their processing, the new drying techniques, and improvements in pressing and finishing, all had their effect but another important contribution was made by developments in the weaving of the papermakers' felts, used in couching and pressing the sheets.

The functions of a papermaker's felt, which is not a felt at all but a woven woollen blanket, are primarily twofold:

1. The felt is the first surface the newly formed sheet comes across when the sheet is couched. A felt must cushion the newly couched wet sheet during pressing, holding it firm, without any distortion, under the great pressures necessary for reducing the water content of the sheet during the first wet press after formation.
2. The weave of the felt must allow the water to drain out of the sheets during pressing, without distorting them. It must also allow water to be taken up by the felt as the pressure in the press is released.

Both sides of the felts used in handmade papermaking come into contact with the wet sheet.[20] Great care is taken in the weaving of these felts to produce the same texture on both sides of the felt. The weave and the workmanship must be of the highest quality to withstand the rigours of repeated high-pressure pressing as well as the regular washing and cleaning necessary.

Two main factors contribute to the differences between the surfaces of the two sides of the handmade sheet of paper:

1. The 'suction' effect on the fibres in the wire side surface as the mould is lifted from the pulp in the vat. These fibres have already taken up some of the texture of the wire forming surface: i.e: the impression formed by the wire, of whatever gauge, whether laid or wove.

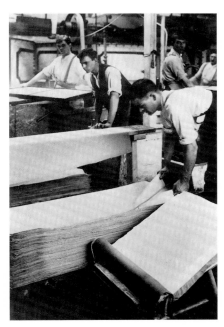

fig.6 Laying newly pressed sheets at Hayle Mill. The layer is separating the still wet sheets into a pile, bottom left of the picture, and returning the felts to the coucher, ready for use again.

2. The 'pressure' effect exerted downwards on the feltside fibres as the sheet is couched.

Along with the introduction of hydraulic presses (see cat.no.7) new developments in felt technology contributed to the more even pressing of newly formed wet sheets, giving greater surface consistency and coherence.

The advent of the paper machine gave many opportunities to the young and enterprising: James Kenyon, whose family had long been involved in the woollen trade, started his business in Bury in 1827. He soon began to concentrate on industrial weavings including felts for both hand and machine-made papermaking. His *Blanket Book* of 1843 gives

> prices for weaving wet felts from 2s 3d to 3s 6d per stone – and 9d extra for putting up if under 10 wows and 1s extra if under 5 wows (1 wow = 3 yards in length)[21]

These changes in handmade paper production had the overall effect of creating stronger, denser surfaces, whilst retaining a measure of flexibility in the sheet. Paper could be given very different surfaces, designed precisely to cater to an individual artist's preferences. Turner and Cotman generally painted in watercolour and bodycolour on the smoother finishes, whereas Cox and De Wint, for example, often worked on much more rugged textures.

1 Hamilton 1998 and Rodmer 1997.
2 Townsend 1993, and other publications.
3 Gage 1989. See also the various papers in Townsend 1997.
4 See Krill 1987 for a fuller discussion of this development.
5 Some idea of the scale of the demand for technical drawing papers can be seen in the National Maritime Museum's collections of ship drawings. The massive increase in shipbuilding occasioned by the Revolutionary and Napoleonic wars with France led to the Admiralty placing massive orders for the finest drawing papers with the Kent papermaker Joseph Ruse. Every new ship of the line, frigate, schooner, etc., needed paper for its designs, but each of these ships also carried small boats, barques or pinnaces, which each had to have their own drawings. The National Maritime Museum has some 1,500,000 such ship drawings in their collection.
6 Andrew Ure, *The Philosophy of Manufactures*, London 1835, p.25.
7 Ibid., p.29.
8 Entries from 7, 8, 9 Jan. 1821, from Ann Dickinson's *Diary*, quoted in Evans 1955.
9 John Fielden, *The Curse of the Factory System*, London 1836, pp.31, 34.
10 Evans 1955, Appendix A, pp.231–3.
11 Robert Bacon to William Balston, 3 Aug. 1813. Balston MSS, Kent County Archives.
12 Clapperton 1967, p.128.
13 These problems are discussed in Murray 1824.
14 Coleman 1958, pp.202–3. Coleman based his figures on some thirty to fifty purchases a year.
15 Ibid., p.200.
16 Ibid., p.206.
17 See Brenda Weller, 'Intaglio Printmaking Papers and the RSA', unpublished thesis.
18 The 'back' would disappear into the spine (folio) or be trimmed off in the binding (top edge – quarto, long edge – octavo, top edge – 16mo, long edge – 32mo etc).
19 Winsor & Newton Drawing Paper Stationers, *Catalogue for the Trade Only*. Issued 1 Nov. 1861, p.4. Winsor & Newton Archives.
20 In contrast only one surface of the felts used in a size bath (see cat.no.9) or on a Fourdrinier paper machine (see cat.no.11) come into contact with the paper, so different weaves were developed for these uses.
21 Muir 1964, p.39.

ANONYMOUS

1 The Rag Room at Tuckenhay Mill, Devon *c.*1900

Photograph
152 × 205 (6 × 8)
Peter Bower

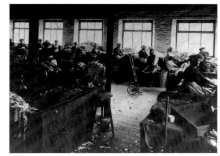

1

The group of four photographs shown here (cat.nos.1, 4, 5, 9) were all taken at the renowned Tuckenhay Paper Mill, near Totnes, Devon. Tuckenhay Mill is sited where Bow Creek meets the River Harbourne, south of Totnes. The South Hams of Devon had little industry and the imposing mill buildings nestling in among the trees must have appeared to have come from another world when they were built in 1829:[1]

> Although distant from large towns and main roads, the mill had the assets of a situation in a dust and smoke-free valley where there was no other factory, and of an abundant water supply of very pure spring water for the manufacture of high quality vat paper.[2]

These photographs give a very accurate picture of the interior of a nineteenth-century handmade paper mill that specialised in the production of the finest 'Best Extra Superfine and Superfine Patent Vat mould and Handmade Papers'[3] including artists' drawing and watercolour papers.

'Care in sorting the rags produces a great beauty in the paper'; so says the anonymous author of a text on paper making in 1848.[4] Throughout the late eighteenth and early nineteenth centuries many authors stressed that careful choice and careful cleaning and preparation were essential to the making of fine strong papers:

> The people who go about the streets to buy up rags and old garments, sell them to the great dealers, who for the London market employ women to sort them into five sorts, which are denominated nos 1, 2, 3, 4, and 5, according to their respective qualities. No 1 being superfine, and wholly linen … the other sorts have different degrees of fineness down to no 5, which is completely canvas, but it is proper for making inferior printing papers, when it has been bleached a good colour.[5]

Working in the rag house was a hard, dirty business and the rewards were small. Much of the material the rag cutters had to work with was filthy, there was constant dust from the rags, and even the threat of illness from contaminated or infected clothing.

> When the rags are brought to the mill, the first thing is to form them into heaps according to their qualities: this is done by women. They are then conveyed in baskets to the rag house, where another set of women, and sometimes children, called ragcutters, receive them. Each of the women stands at a table, the upper surface of which consists of iron wire cloth, beneath which is a drawer. A knife or scythe is fixed in the centre of the table, in nearly a vertical position; the woman is placed so as to have the back of the blade opposite to her, while on her right hand, on the floor, is a large wooden box with many divisions. She examines the rags, opens seams, removes dirt, pins, needles, buttons, or other substances which might injure the machinery, or damage the quality of the paper, and then cuts the rags into pieces not exceeding four inches square, by drawing them across the edge of the knife or scythe. Each woman can cut about three quarters of a hundredweight of home rags, or a hundred and half of foreign rags, in the day of ten working hours. The wages of the women average from tenpence to a shilling a day.[6]

Rags were sourced from all over Europe, there were never enough of them to supply the demand and some countries such as France and Portugal forbade the export of rags.

The linen rags employed in the paper manufacture of this country are collected in large quantities at home; but a large supply is also obtained from abroad. This article is imported from Germany, Italy, Sicily, and Hungary, to the amount of about 5,000 tons a year; the value of which is reckoned at from about £21–£22 per ton, freight included.[7]

It is a real measure of the skill of all the people working in the mills that they could produce such consistency in their papers from such unpromising beginnings.

1 Simmons Collection, *Watermills of Devon*, Science Museum Library Archives.
2 Shorter 1971, p.135.
3 *Kents Paper Mills Directory*, 1890. The Patent vat mould papers mentioned were produced on a chain mould machine supplied by the Zurich engineers Escher Wysse.
4 Anon., *The Manufacture of Paper*, *c.*1848.
5 'Paper' from Abraham Rees, *Cyclopaedia*, 1819.
6 Anon., *The Manufacture of Paper*, *c.*1848.
7 Ibid.

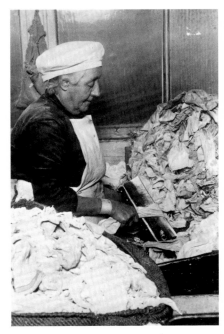

fig.7 Cutting rags at Hayle Mill, Kent

2 Rags: the basic raw material of Turner's papers

For most of papermaking history and most of Turner's working life the basic raw materials for papers were linen, cotton and hemp sourced from old rags, new cuttings, old rope, sailcloth, etc. The rags seen here date from the early nineteenth century and are in the kind of condition that papermakers would have received them: some of them clean and white but others dirty, even mouldy, covered in the grime of use. It is a minor miracle that from such unprepossessing materials, the beautiful range of white and coloured papers that Turner worked on were made.

There was a constant shortage of rags, especially 'fines', the best and whitest linens and cottons; this led to more and more mills using lower grade rags.

The increase in the use of cotton rag, a very different fibre to either linen or hemp, but often mixed with linen rags rather than the pure linen, or linen-hemp mixes found in earlier papers led to some of the changes noticeable in the papers available to Turner. Cotton's relatively short fibre length, when compared with linen and hemp, its lesser capacity to hydrate than linen, and the lower degree of fibrillation achievable all combine to produce a softer sheet with less integral surface strength. Some mills attempted to counteract this by an over-reliance on hard sizing with gelatine.

The change both to more cotton usage and to an increasing reliance on lower grades was accelerated by the rapid advances in bleaching using chlorine gas. For the first time chemical bleaching allowed lower grades to be used for the finer papers. But bleaching and an over reliance on china clay as a loading were not always to the advantage of the user of the paper.[1]

> Of late years, however, great alteration has taken place with respect to the materials from which various kinds of paper are prepared: the application of chemistry has enabled the manufacturer to extend considerably the list of those materials which was originally in great measure confined to white linen rags.[2]

2

Papers that might suffer from poor choice of materials and bad manufacture were not always distinguishable from good sheets when they were first made, but they often revealed their drawbacks quite quickly. The Commissioners of Excise[3] remarked that

> The improvements in the machinery and processes employed in the preparation of all kinds of paper, and especially the improved maceration of the pulp in the vats or engines renders it extremely difficult to distinguish the nature of the original materials. The manufacturer is thus enabled to prepare from the materials prescribed for the second class paper an article in all respects equal to any of the kinds of paper belonging to the first class.[4]

The Excise were after all primarily concerned with papermakers who were evading some or all of the duty payable, rather than any concern with the strength and durability of the paper. If the Excise could be so easily deceived then the customer faced with brand new white paper was more likely to accept it at face value and only realise his mistake in the years to come. Much deception against both the buying public and the Excise was practised by the substitution of often very inferior rags for best fines. This lowering of quality was a by-product of the drive for profit during the recession that followed the Napoleonic Wars[5] and then later a response to the increasing pressures placed upon the surviving handmade mills by the accelerating demand for raw materials from the rapidly increasing machine-made industry.

McCullough describes the situation that any careful examination of surviving papers can show us, namely that

> The modern discoveries in chemical science have not only materially facilitated the manufacture, but have greatly enlarged the supply of materials from which paper can be made. Until these few years, the sweepings of cotton mills, owing to the grease and dirt with which they are mixed up, were of no value whatever, except as manure: but means having been discovered of rendering them white they are now made into very good paper.[6]

Such papers may well have left the mill looking very good, but many of them deteriorated very fast indeed. Even the better papers, made with a careful understanding of the new paper chemistry, were to be affected. All such processing has an effect on the strengths and consequent behaviour of both the fibre during formation and the sheet during use, all too often for the worse.

1 Murray 1824.
2 HMSO, *14th Report of the Commissioners of Inquiry into the Excise Establishment and into the Management and Collection of the Excise Revenue throughout the United Kingdom*, London 1835, p.11.
3 The Commissioners of Excise oversaw every aspect of paper production. The regulations governing paper were laid out in a complex of Acts of Parliament that had by the early years of the nineteenth century become increasingly burdensome to the papermakers and harder for the excise to enforce. See Dagnall 1998 for a definitive examination of this complex subject.
4 As n.2 above.
5 Prices of paper were actually declining during the years after the defeat of Napoleon. The pressures on the makers were very considerable. During the 1830s the amount of money demanded by the Excise as Duty Payable was twice the amount the papermakers had to pay out in wages to their 27,000 employees. HMSO 1835, (see n.2 above), p.15 and Appendix 41.
6 McCullough, *Commercial Directory* quoted by the papermaker John Dickinson in a letter, dated 10 Sept. 1834, to the Commissioner of Excise.

3 Polarised light micrograph of papermaking fibres

Illustrated on page 65

This image shows a blend of two fibres, linen rag, originally derived from flax, *Linum usitatissimum*, and hemp, *Cannabis sativa*, derived from old ropes or canvas sailcloth.[1] Papermakers preferred to work from old rags and rope rather than the raw plant because much of the basic preparation they would have had to do on the fibre had already taken place during the manufacture of the cloth or rope.

These two fibres, either singly or in combination, provided the basic raw material for most European papermaking throughout Turner's working life. From the 1790s onwards increasing amounts of cotton rag also came into use and the use of hemp gradually became confined to lower grade wrappings and boards.

Linen (flax) fibres are thick walled and relatively long (3–13 mm) with a fairly uniform central canal, but the width of any individual fibre may vary considerably along its length. For identification purposes the striations and cross markings are particularly useful. Hemp fibres are very long indeed with well-defined longitudinal striations, cross markings, swellings and constrictions along the fibre length. Examining papermaking fibres through a microscope necessitates either the staining of the fibre to show the surface and internal detail more clearly or, as here, the use of polarised light to bring out the detail. Many of the features noticeable in the raw plant fibre become blurred or disappear during the fibrillation and hydration that takes place during beating.

The main reason for the use of these two fibres for most papermaking for such a long period of time was their versatility. Papermakers learnt to develop very specific properties during the preparation and beating of the fibre, properties that allowed them, if necessary, to use the same basic raw materials to create papers with very different characteristics.

1 The word canvas is derived from the word cannabis. *Concise Oxford Dictionary*, 4th ed., 1958, pp.173–4.

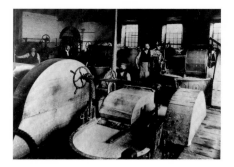

ANONYMOUS

4 The Beater Floor at Tuckenhay Mill, Devon *c.*1900

Photograph
152 × 205 (6 × 8)
Peter Bower

An old saying in the paper industry is that 'Paper is made in the beater'. It does not matter how good you are at all the other stages of the papermaking process, unless you get the choice and preparation of the fibre right the paper will simply not do what is wanted of it during use. Traditional stampers, used for pulping, although capable of producing very fine pulps, did not allow great subtlety in the beating process. The advent of the hollander beater allowed papermakers a different understanding of the sophisticated possibilities inherent in particular fibres, and to explore the development of their potentials in this new machine. They began to appreciate that the degree of beating, the wetness or freeness of the fibre, the length and speed of the beat, the weight of the roll, the angle and configuration of the bedplate and the roll bars could all contribute to the creation of very different behaviour in the finished sheet of paper, even when the base raw material was the same.

This growing understanding of the basic pulping process led to an increased awareness of the smaller and smaller distinctions between types and grades of raw materials. In the 1780s there were perhaps eight kinds of easily distinguishable rags; by the 1850s over a hundred distinct categories were on offer from the rag merchants. The blending of fibres, or different qualities of the same fibre has occurred throughout papermaking history but the hollander beater gave the papermaker a much greater degree of control over his material.

Consistent supplies of rag fibre have always been a problem. In earlier centuries fibres had usually been blended for reasons of cost, sometimes aesthetics, and often had been forced on the papermaker by shortfalls in particular supplies. Now it became more scientific, as the characteristics of different fibres could be developed in the beater to achieve desired ends in the behaviour of the finished sheet in use. Many papermakers took up such challenges, with more or less success. They began to produce much more flexible sheets, more versatile papers, that were more capable of taking the increasingly demanding work of the watercolourists.

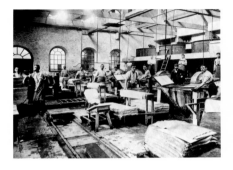

ANONYMOUS

5 The Vat Room at Tuckenhay Mill, Devon *c.*1900

Photograph
152 × 205 (6 × 8)
Peter Bower

This image captures the increasingly industrialised nature of this essentially craft-based business during the nineteenth century. Each of the five vats in the photograph are fed with pulp from their own stuff chests (upper right). Each vat has a crew of three: the vatman, who forms the sheets, the coucher who transfers the newly formed sheets onto a woven woollen felt, and the layer who sees to the pressing of the sheets. Newly formed sheets of paper are heavy and the 'packs' are moved from the vat to the press on the tracks in the floor.

6 Laid papermaking mould and deckle 1820s

Oak, pine, copper and brass
Two sheet Foolscap mould and deckle
Outside dimensions: $374 \times 940 \times 38$ ($14^{11}/_{16} \times 37 \times 1^{1}/_{2}$)
Deckle: outside dimensions: 401×961 ($15^{3}/_{4} \times 37^{7}/_{8}$)

Chain lines: 25 mm (1 inch) apart
Laid lines: 8 per cm (25 per inch)
No watermark
Maker's stamp: WE once on mould and twice on deckle.

Peter Bower

6A Detail of forming surface and support struts.

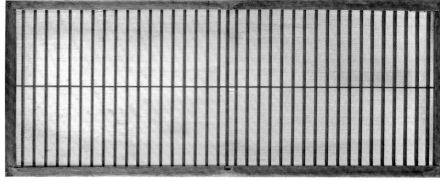

6

Most of the papers used by Turner were made by hand, sheet by sheet, in small mills. Two distinct types of mould were used: laid, the type shown here, and wove, where the forming surface is made from woven wire cloth rather than the wires seen in this example.

The mould and deckle are dipped into the vat of pulp and the vatman takes up an amount of pulp. As the water drains through the forming surface the mould is shaken to produce a wave in the water that holds the pulp. Excess pulp is thrown off the far edge of the mould and as the wave returns across the forming surface the mould is shaken sideways to send cross waves across the width of the mould, 'closing' the sheet.

The thickness of the sheet is determined by the density of the pulp in the vat, the speed of dipping the sheet, the depth of the deckle and the skill of the vatman.

This mould produced two sheets each $13^{5}/_{8} \times 17^{5}/_{8}$ inches (346×447) when wet. This is slightly larger than the nominal Foolscap paper size, $13^{1}/_{2} \times 17$ inches, and takes account of the shrinkage of the sheet during drying.[1]

The identity of the WE stamp on the mould and deckle is as yet unknown but a possibility is the Watford Engineering Works established by George Tidcombe in 1827. This mould came originally from Nash Mills, Hertfordshire, only a few miles from Tidcombe's works. Tidcombe had been apprenticed to the London based engineers, Hague and Topham, in 1814 and later worked with John Hall at Dartford and Bryan Donkin (see

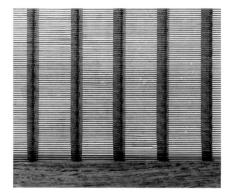

6A

cat.no.11). George Tidcombe and his friend Strudwick went to Watford to erect a paper machine at Hamper Mill and decided to set up in business there in partnership with a member of the Brewer family, one of the best-known wire weavers and mould makers in the country.[2]

The design of this particular mould is a little old fashioned for the supposed date: it is a single-faced mould, where the forming wires sit directly upon the support struts. Earlier in the century, double-faced moulds had been invented, where the forming surface sits on a series of support wires, lifting the surface away from the struts and allowing better drainage and a more even density of sheet. The double-faced mould soon superseded the single, but single-faced laid papers were still being made in some mills throughout the century. Indeed by the end of the century the use of a slightly different form of single-faced mould, often called Antique Laid had become quite fashionable, particularly for fine printing and some stationery papers.

A description of forming sheets, contemporary with this mould, stresses some of the problems encountered in this process, particularly the importance of forming an even sheet:

> The dipper should be attentive, in distributing the matter on the mould, to reinforce the corner the coucher is to take hold of, in raising and extending the sheets; for without this precaution he would break a great many. Also, if he takes up too much matter on his mould, if he does not equally extend it, or if he strikes his mould against the drainer. In all these cases the matter is accumulated in certain parts of the mould … When the vat is too hot, the stretching out of the sheet will be ill performed … Add to this, that in letting the matter run towards one of the edges, by not giving his arm a regular motion, he may form a feather-edged paper, which may likewise happen if he does not extend his stuff sufficiently, … if his arms are too stiff, and he gives a bad shake, or if the mould be ill made.[3]

1 Labarre 1952, p.259, lists twenty-six variants for Foolscap papers, designed for writing, printing, drawing, wrapping and other uses, ranging from 13×16 up to $14^{1}/_{2} \times 18^{1}/_{2}$ inches.
2 Clapperton 1967, p.341.
3 From the entry on 'Paper' in Rees, *Cyclopaedia*, 1819.

WILSON LOWRY AFTER JOHN FAREY

7 Mr Bramah's Hydrostatic Press
1812

Steel engraving
Trimmed within the plate mark
263 × 202 (10 × 8¼)

White wove
Watermarked: 1811[1]

From Abraham Rees' *Cyclopaedia or Universal Dictionary of Arts, Sciences, and Literature*, London 1820

Peter Bower

The increasing sophistication of much of the equipment used in making paper by hand throughout the first half of the nineteenth century is well illustrated when the machinery in this plate is compared to the capstan press illustrated in the background of cat.no.10. Joseph Bramah invented the hydraulic press in 1795 and it was rapidly exploited by many papermakers in the increasing industrialisation of the handmade industry as part of the handmade papermakers' response to the invention and introduction of the first papermaking machines in 1804. This industrialisation, which had begun earlier in the eighteenth century was given fresh impetus by the need for handmade papermakers to produce more paper, of better quality and faster. It was to continue throughout the nineteenth century, leading to an extraordinarily sophisticated and complex blend of men, women and machines working in close harmony. Despite the mechanisation, papermaking by hand remained a craft process, where most learning was one to one in the apprentice system, and most knowledge and understanding of the processes and techniques continued to be empirical.

Bramah's new press was less labour intensive, and less time consuming than the earlier Samson capstan presses. It allowed more sheets to be pressed at a time and under greater pressure. Although many papermakers would still consider that the capstan press imparts a better finish to the sheet, the new powered press gave a consistency of performance that was generally to be welcomed. Its relative speed of operation also allowed for more complex pressing sequences to be developed in the search for better finishes, designed to meet the specific needs of such uses as watercolour

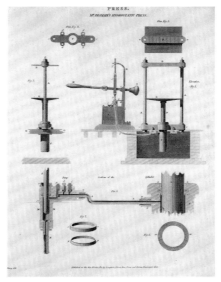

7

and drawing, without overly increasing the time involved.

Bramah's first patent, which recommended the use of his presses in papermills, claimed

> New methods of Producing and Applying a More Considerable Degree of Power in all Kinds of Mechanical Apparatus and other Machinery requiring Motion and Force, than by any Means at Present practised for that Purpose.[2]

There is evidence that Matthias Koops had installed, or at least wanted to install a hydraulic press at Neckinger Mill, Bermondsey, in 1800, some years before Bramah had actually taken out his patent. Bramah's press became an important part of any new mill. One was installed by William Balston, who made so much of the paper used by Turner, at his newly built Springfield Mill, Maidstone, in 1806. A measure of the renown of Bramah's press can be seen in the sale particulars for Aston Furnace Paper Mills, Birmingham, where the makers' names of only three pieces of equipment are given in the list of all the mills' equipment: '10½ inch Cylinder Bramah's Patent Hydrostatic press'.[3]

Bramah's second patent, dealing with the hydraulic press was even more specifically designed for papermaking. Bramah stated that using his new 'hydrostatic' press obviated the need for

employing such a considerable number of presses for the dry work, which is unavoidable in works of even but a tolerable extent, owing to the length of time the paper is obliged to continue in them in a compressed state, and on which account a larger capital is necessary as well as capacious buildings.[4]

The increase in both speed of operation and in amount of pressure did not only benefit the economics of handmade papermaking. They had some important effects on the actual behaviour of the paper when in use, particularly for highly 'designed' papers such as fine writings, printings and drawings.

The combination of this new advance with the now general use of double-faced moulds, which gave the vatman a slightly different 'shake' when forming the sheet, allowing him to consolidate and 'close-up' the sheet more efficiently, as well as new methods of gelatine sizing (see cat.no.9) led to a further increase in the surface strengths of the sheet. The use of two-sheet moulds, at least for sizes up to Demy and Medium, also dramatically speeded up production. The increasingly widespread use of cotton rags of various qualities, as opposed to the traditional linen, also changed the nature of the papers being made, and, at least during the earlier years of the century led to the development of some very successful papers.[5]

The changes in pressing techniques had a considerable effect on the actual surface strength of the sheet. After wet pressing, linen has a much higher relative surface strength when it is a thin sheet than when it is thicker. Some of the lightweight writings that Turner used for many watercolours show just this kind of characteristic. A cotton rag or cotton linter based sheet of the same weight and bulk would quite literally not be able to take the kind of vigorous and often many layered working that he subjected them to. This increase in surface strength, and the differences in the way the sheets were pressed also had an effect on the way size worked on the surface of the sheet, changing the absorption of the surface, allowing coloured pigment to sit on the surface differently and more brightly.

This plate was drawn by John Farey junior (1791–1851), a technical author and draughtsman, who contributed many of

the articles and their illustrations to Rees' *Cyclopaedia* between 1806 and 1818, including the article on 'Paper' which was published in volume 26, part 1 on 27 November 1813. Other subjects where Farey contributed both text and illustrations included 'Foundry', 'Manufacture of Cotton', 'Printing', 'Tilt Hammer' and 'Windmill'.[6]

1 Abraham Rees' *Cyclopaedia or Universal Dictionary of Arts, Sciences and Literature*, was published over a long period of time. Although this plate comes from the 1820 edition, most of the watermarks found in the plates date from 1811 and 1812 and the plate itself carries an 1812 date. The design of the watermark numbers suggests that the paper for this print was probably made by John Dickinson at Nash or Apsley Mills, Hertfordshire.

2 Patent No.2045, 1795.

3 The other two pieces of named equipment being a '24 Horse Power Steam Engine (Boulton & Watt principle)' and 'an improved Patent Paper Machine (by B. Donkin & Co of London), 42½ inches between the Deckles; cast Iron Frame; all in a most complete and perfect state' (see cat.no.11). Auction details, text from an unnamed newspaper, Sept. 1819, found on the back of an obituary notice of the engineer James Watt. Information from Richard Hills.

4 Patent No.2840, 1805.

5 The dangers of the over-enthusiastic use of chlorine-based bleaching, china clay fillers and low-grade cotton rags, so prevalent in the years 1815–30 among many of the lesser papermills, and for the most part confined to the lower end of the writings and printings market, are discussed in the introduction and under cat.no.43.

6 Farey also provided illustrations for articles written by other authors, includng 'Agriculture', 'Astronomy', 'Horology' and 'Surgery'. A full list of his works can be found in A.P. Woolrich 'John Farey, jr, technical author and draughtsman: his contribution to Rees' *Cyclopaedia*', *Industrial Archaeology Review*, vol.20, 1998, pp.46–67, and further information in A.P. Woolrich, 'John Farey jr (1791–1851): Engineer and Polymath', *History of Technology*, vol.19, 1997, pp.111–42.

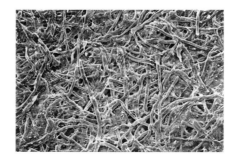

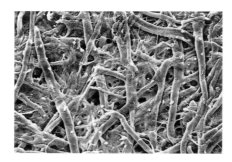

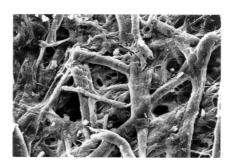

8A

8 Scanning electron micrographs of the surfaces of different papers

8A White wove watercolour paper produced by Bally, Ellen & Steart in 1820.

At × 40, 100, 200 and 400 magnification

See cat.no.16 for an example of a white wove watercolour paper from this maker.

8B White wove watercolour paper produced by William Balston and Co. at Springfield Mill in 1824, watermarked J WHATMAN / 1824.

At × 40, 100, 200 and 400 magnification

See cat.no.21 for an example of a white wove watercolour paper from this maker.

8C Flecked blue wove watercolour paper produced by Bally, Ellen & Steart in 1832.

At × 40, 100, 200 and 400 magnification

See cat.nos.50–3 for different examples of the flecked blue wove watercolour papers produced by Bally, Ellen & Steart at De Montalt Mill, Bath.

Turner's preoccupation, almost obsession with the intricacies of light was well served by the surface textures and strengths, and the internal strengths, of the papers becoming available to him from the 1820s onwards. Quite simply, he could not have painted his later works on most of the papers available to him at the beginning of his career.

By the 1820s many mills were producing papers designed specifically for watercolour, but their products showed considerable differences: sources and choice of raw materials, methods of preparation, variations in mill practice, and it must be said differing levels of ability in the papermakers themselves all had an effect on the finished product. Some mills were better at gelatine sizing than others. Some were more discriminating in their choice of rags, preferring to use the best clean white 'fines' rather than get involved in the complex chemistry of bleaching. Although chlorine bleaching allowed the maker to utilise lower grades of rags for making white papers, it also

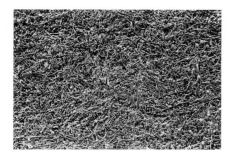

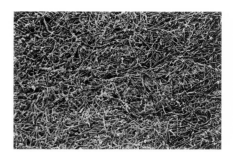

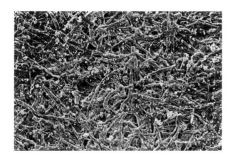

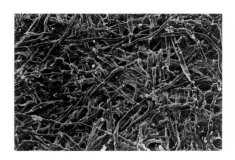

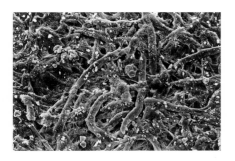

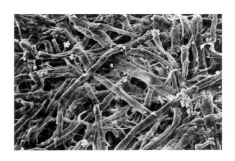

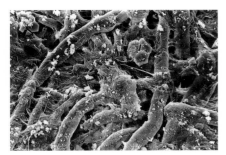

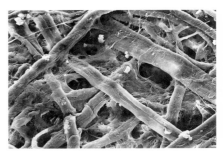

meant a loss of length and strength in the fibre, often compounded by the over-enthusiastic use of china clay in the furnish.

The makers of the papers these scanning electron micrographs (SEMs) were made from, William Balston and George Steart, who between them were responsible for a very high proportion of all the papers used by Turner, were careful and innovative papermakers. Despite the differences in date and types of rags used by Steart there are considerable similarities in the beating of the fibres and the even nature of the texture in the two examples of his papers, which are quite distinctive when compared to the Whatman example. Even so these papers have more in common with each other than with many of the other papers on the market then, or indeed with the watercolour papers available to artists now.

The images shown here are scanning electron micrographs of the surfaces of papers used by Turner. SEM images can be most useful in identifyng the fibres used and also in allowing comparisons between surface characteristics or details of different papers. The images seen here were produced from papers from the author's collection by John Smith at the Department of Materials Science, School of Engineering and Advanced Technology at the University of Sunderland, as part of a project by Paul Clark to develop a new linen-based gelatine-sized watercolour paper.

ANONYMOUS

9 The Size House at Tuckenhay Mill, Devon *c.*1900

Photograph
152 × 205 (6 × 8)
Peter Bower

The sizing of watercolour paper is crucial to its successful use. The surface must have sufficient strength to take repeated working and to allow colour to be lifted off. Many papermakers have stressed the importance of great care in sizing: Jack Barcham Green, of Hayle Mill, Kent, thought that

> Apart from the work of the vatman this is the most difficult operation, as no two sorts of paper require the same

8B

8C

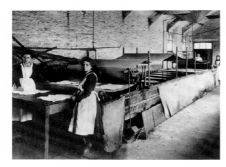

9

treatment, and the seasons of the year and the weather may affect the result of sizing.[1]

This photograph shows the gelatine size bath seen from the dry end where the unsized 'waterleaf' paper is fed into the bath of hot gelatine, held between two felts, travelling the whole length of the bath and given a light press between a pair of squeeze rolls at the other end. Throughout the nineteenth century these machines were traditionally operated by women who had the responsibility of ensuring that the percentage of gelatine in solution was correct for each different type of paper, that it was applied at the correct temperature with exactly the right amount of alum and the appropriate acidity. If the size solution is too weak, or the proportion of alum too little, then the finished sheets will be too soft. Different weights and types of paper require different strengths of size: a light-weight hard writing paper will need a weaker solution than a heavier weight, such as a 140 lb Imperial watercolour paper.

After the sheets have passed through the size bath they are piled up on top of each other and the pile is then covered with felt to prevent the edges drying too fast and to stop the newly sized sheets becoming chilled by draughts. The sheets are still hot at this point and must be allowed to cool down slowly to avoid the size staining the paper.[2] Some hours later the pile, or pack, is parted, to allow air to get at each sheet. Another pile is made, covered again with felt, and allowed to stand overnight. The next day the sheets are hung up, or laid out on canvas sheets, in spurs, groups of sheets, to dry. The number of sheets in a spur varies depending on the size and weight of the sheet: 140 lb Imperial will be grouped in

four or five sheets, while lighter-weight Imperials may be in spurs of up to ten sheets.

Jack Barcham Green also reckoned that

> The time of year has a lot do with good sizing. My father always told me it was a mistake to make or size Drawing Papers during August, but papers made during October and November will mature quickly and size easily. This is due to the foggy mornings in the late autumn which soften the waterleaf paper in the loft after it is dried, if the louver boards are fully open.[3]

After about forty-eight hours the sized sheets are dry and the louvres are opened for a day or so to mature the size in the airflow. When the sheets are taken down from the drying loft they have generally cockled and have wavy edges, problems which have to be corrected. They are carefully placed in a pile and a few days later a 1 inch thick board is placed on top of the pile. A week later a 56 lb (25 Kilo) weight is placed on the board, a week later another weight is added, a week after another weight and so on, until the gradually increasing pressure has smoothed out the cockles and waves.

During Turner's lifetime the process of sizing went through several changes. The older heated tub where a few sheets at a time were sized eventually evolved, via various intermediate forms and techniques, such as Whatman's box techniques described by Joshua Gilpin,[4] into the type of size bath seen here. Within the industry as a whole the materials used in sizing changed from gelatine to rosin, but most handmade paper mills continued to use gelatine for the finest papers until well into the middle years of this century. Perhaps a more significant change, however, was what the gelatine size was made of.

The use of 'scrolls', the parings from the vellum and parchment makers, or the use of kid leather for plate papers[5] and other highly specific methods gave way in many mills to a general use of rabbit skin, fish, bone and by the mid-nine-teenth century in England at any rate, the import and use of buffalo hide from the United States. All these sources have distinct effects on both the appearance and the behaviour of the sheet. Scrolls

gave a very clear gelatine, hardly changing the actual colour of the fibre at all, whilst rabbit and more particularly buffalo were very 'yellow' changing the tone of a white sheet quite considerably.

The cleanliness of the size house and the utensils used as well as the length of time a batch of size was used also had a great bearing on the quality of the finished sheet. Some mills were punctilious about their size, others used the same batch over and over again, filtering and reheating it until it really ceased to have any life. By this stage it was also usually rather dirty, giving a dull cast to the sheet.

J.S. Lee, manager between 1870 and 1896 of Hodgkinson's Wookey Hole Mill, Somerset, left strict instructions to his son Frank, who succeeded him as manager until 1916, regarding every aspect of the running of the mill, including the following notes in respect of sizing:

> You should be using dry hides or dry skins; the same must be put in cold water until they are properly soaked and be cut in small pieces before they are put in the washer. Always see they are thoroughly washed and all of the lime out of them. If any portion of lime is left in the skin, the lime will destroy the size, therfore the paper will not bear ink [or watercolour] … Above all other branches in papermaking make yourself well acquainted in the Sizing Department, which is the main stuff in the Paper Trade … Always see that you keep all size tackle in good working order and perfectly clean in this respect.[6]

1 Barcham Green 1967, p.18.
2 Later in the nineteenth century some mills introduced cooling machines where the sized sheets were run on a long endless felt travelling over rollers. By the time they reached the end of the machine they had cooled right down.
3 Barcham Green 1967, p.20.
4 The unpublished 'Journals of Joshua Gilpin'.
5 As specified by James Basire for 'Antiquarian' paper to be made by James Whatman at Turkey Mill, Maidstone.
6 J.S. Lee, MS notes, 1896, published as 'Advice from a Father to his Son', *The Quarterly*, no.18, April 1996, p.3.

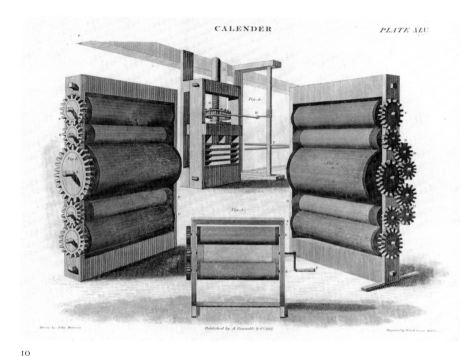

CALENDER

PLATE XLV

10

W & D LIZARS AFTER JOHN DUNCAN

10 Calender Stack 1817

Engraving
209 × 270 (8³⁄₈ × 10⁵⁄₈)
Peter Bower

This plate, published by A. Constable &
Co. in Edinburgh in 1817, shows two dif-
ferent calender stacks as well as the older
form of wet press operated by a capstan.
Calenders were operated in stacks of
rolls, usually five in number. The rolls
were made of iron, steel, or in many
cases hundreds of sheets of paper lami-
nated together and turned on a lathe to
produce a perfect cylinder, using the
'endgrain' of the paper as a polishing
surface. Their purpose was to impart
various degrees of smoothness to the dry
sheet. Initially invented for handmade
papermaking they came into their own
on the paper machine.

The earlier method of glazing or
smoothing sheets can be seen in fig.8
where sheets of paper were interleaved
between metal plates and moved around
under a waterpowered glazing hammer
to polish them.

fig.8 *View in the Paper Manufactory of the Work of
Polishing or Sleeking with the Hand and Sledge* 1762,
engraving. From *The Method of Making Paper*
published in the *Universal Magazine*, 1762, re-
engraved from J.J. François de Lalande's *L'Art
de faire le papier*, originally published in Paris in
1761. The women in the top half of the picture
are glazing sheets by polishing them by hand,
while below a glazing hammer is being used
to smooth several sheets at a time.

ANONYMOUS

11 Two Papermaking Machines

Steel engraving
165 × 256 (5¹⁄₂ × 10)
Peter Bower

The two Fourdrinier paper machines
illustrated here date from the 1830s.
They were built by Bryan Donkin
(1768–1855), the man who turned
Nicholas-Louis Robert's (1761–1828) orig-
inal invention of 1798 into practical reali-
ty. Robert's idea had been 'simplifying
the methods of manufacture of paper
and making it less expensive … without
the help of a single workman and by
purely mechanical means'.[1] The concept
behind the paper machine was to
combine all the complex stages of paper-
making into one continuous process.
Although Robert's machine met some of
these criteria it was Donkin and his back-
ers, the Fourdrinier Brothers (after whom
such machines are generally called), who
produced the first production machines,
which operated at Frogmore and Two
Waters Mills in Hertfordshire in 1804.

Over a period of some twenty-five
years all the various elements of the
machine were put together: T.B. Cromp-
ton patented the addition of drying cylin-
ders in 1820.[2] The Dandy Roll, which
allowed both laid and wove papers to be
made on the machine, and allowed
papermakers to watermark machine-
made papers successfully for the first
time, was patented in 1825 by John and
Christopher Phipps.[3]

The working of the machine (from left
to right in the bottom of the two
machines illustrated) consists of a stuff
chest (V) containing pulp. The pulp is
transferred to a vat (t) before passing
through a slice (S) onto the forming wire
(wc) at (a). The width of the sheet is con-
trolled by the deckle straps (d). The wet
sheet is transferred to an endless felt (f)
passing under a first press (r') and a sec-
ond press roll (r"). The continuous wet
sheet then passes round three heated dry-
ing cylinders (S 1–3) before being reeled
up dry on the reel (R).

For the papermakers the biggest single
argument for introducing the Fourdrinier
machine seems to have been purely eco-
nomic, with very little thought given to
the quality or durability of the paper they
would produce on such machines.

PAPER. PAPER MAKING MACHINE.

11

With a velocity of ninety seconds the machine would produce 84¾ reams (40,680 sheets) of 14 × 18 inch paper in a twelve-hour day, the equivalent of the daily output of eight vats, by Kent custom where 10¾ reams was accepted as a vat's daily output at this date. One machine man (although whether only one machine man was standard manning for early machines has yet to be determined) at £2 9s 0d per week was therefore taking the place of thirty-two men: the vatman, coucher, layer, and parter of each vat. The other advantage was the increased size of sheets that could be made on the increasingly wide machines. A normal vat crew could make paper sizes up to Double Medium (22 × 35 inches) but for papers above that size a second coucher, the 'upper end boy', was needed. The contrivance developed by Whatman to produce Antiquarian paper (31 × 53 inches) needed a crew of eleven to operate.[4]

By 1806 when William Balston was building his new Springfield Mill at Maidstone, the first of Donkin's production Fourdrinier machines were already in operation at Frogmore and Two Waters in Hertfordshire.

Ten months before Springfield opened William had inspected a machine, and sent Catherine a large piece of its paper. 'If you should adopt it', she answered, 'I hope it will not be at the expense of your popularity, for I would rather see you generally beloved than very rich'.[5]

Papermakers considered long and hard about the advisability of installing one of the new machines: two years later in March 1808 when Balston was about to travel to Two Waters, Catherine Balston wrote to her husband William regarding this possible purchase of a Fourdrinier machine:

It appears to me, that going to Two Waters [to see the machine there] must lengthen your journey … should you afterwards adopt this machine, it may be advantageous to yourself to have seen them all – I should like much to go with you to Dover and I think you will there have an opportunity of seeing how far Mr Phipps finds it possible to realise the advantages that Fourdrinier states, and consequently, of determining better whether it will be desirable for your purpose.[6]

Phipps had purchased Donkin's Machine No.3, with a 5 foot wide wire, 33 ft 6 inches long, the first to be sold to a mill not operated by the Fourdriniers, in 1807.[7] Balston did go to Two Waters and saw the machine in operation, making 'litress' – a kind of cartridge paper – but was not impressed by either the speed of operation or by the long financial calculations as to the machine's profitability provided by Leger Didot, who at that date was still involved with the Fourdrinier brothers.[8]

Balston continued to develop his mill as a handmade mill, producing a range of printing, writing and drawing papers, but competition from the increasing number of Fourdrinier mills who were primarily making printings, led to the mill concentrating on fine writings and artists' papers.

After the split between the Hollingworth Brothers and Balston in 1805, the first 'Whatman' mill to start making by machine was the Hollingworth's Turkey Mill, where by 1857 they were relying entirely on a Fourdrinier machine, having ceased handmade production completely. Springfield was eventually to acquire a Fourdrinier machine, but that was not until 1932 when a 60 inch machine was installed for the production of filter papers.

1 Letter from Nicholas-Louis Robert to the Minister of the Interior, Paris, 9 Sept. 1798. See Clapperton 1967, p.17. Clapperton's book is the best single introduction to the extraordinary engineering skills that made the paper machine possible.
2 T.B. Crompton, Patent No.4509, 1820.
3 J. & C. Phipps, Patent No.5075, 1825.
4 According to Leger Didot's calculations, from a letter to Balston in 1808, quoted in Balston 1954, p.52.
5 Quoted in Balston 1954, p.51.
6 Letter from Catherine Balston to William Balston, 16 March 1808. Kent County Archives U2161/z1/2.
7 Clapperton 1967, pp.44, 294.
8 Balston 1954, p.52.

WHITE PAPERS (cat.nos.12–47)

Painting in watercolours, as performed by the British artists of the Present School ... may be almost considered as a New Art.[1]

It is no surprise that, in 1812, commentators on the Arts should declare that watercolour could almost be described as a New Art. Changing sensibilities and aspirations in many artists, coupled with the development of new pigments, paints and papers had combined to produce a situation where the potential of watercolour as a medium was being realised in ways that would have been unimaginable two decades before. Drawing papers designed for watercolour were only recognised as a different category of paper in 1794, when after some years of evolving, they became subject to tax in their own right, appearing in the excise duty lists as First Class Paper for the first time:

> All Paper that may be used for or applied to the Use or Purpose of Writing, Drawing and Printing, and also all Elephant Papers and all Cartridge Papers, which shall be made in Great Britain shall be deemed and taken to be Papers of the First Class.[2]

This appearance, by name, in the First Class Excise category was a reflection of the increasing amounts of such paper that were beginning to be made. John Balston records two orders placed by the London stationer Keys with his ancestor William Balston for sixty reams of drawing Elephant in 1807 and 160 reams of drawing paper in 1812.[3] These large amounts of paper, some 100,000 sheets, show the increasing scale of operation in some of the handmade paper mills. Mills increased production by both increasing the number of vats in operation and by introducing two-sheet moulds for larger sizes of paper. Mills all over Europe had used two-sheet moulds for smaller paper sizes for well over a hundred years, but the introduction of such moulds for larger sheet sizes was resisted by many of the workers in the mills because of the sheer physical labour involved.[4]

The thirty-six different white papers illustrated here have been chosen to show some of the variety of papers available to Turner, and also something of what determined his choices of watercolour and drawing papers. Watermark evidence and microscopic analysis show that Turner bought several relatively large batches of white watercolour papers during the 1820s, many of which he continued to use for many years. He also acquired smaller groups of sheets, and many sketchbooks containing watercolour papers, as well as notebooks and pocket books containing writing papers. He bought much of his paper in

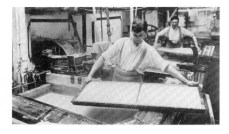

fig.9 Making two sheets of paper at a time at Hayle Mill, c.1920. The use of such two-sheet moulds greatly increased the production of those mills which introduced them in the early nineteenth century.

London but also acquired other papers, as loose sheets and sketch-books, on most of his tours in Britain and on the Continent.

The groups of white papers bought in the 1820s which Turner was still working on many years later include several different 'Whatman' papers, from both William Balston at Springfield Mill and the Hollingworths at Turkey Mill, and batches from Ansell, from Bally, Ellen & Steart, from Edmonds, and from Ruse & Turner. Sometimes these are from particular batches of paper but in some instances what appear to be similar watermarks hide considerable differences. Close examination of the sheet sizes, weights, furnish, degree of sizing and the surface texture of two sheets included here show that the Bally, Ellen & Steart paper used for the large Grenoble study (cat.no.16) and that used for *Sunrise* (cat.no.46) are, despite their B.E. & S. / 1823 watermarks, distinctly different papers. In some instances he continued to use a particular paper almost throughout his life: both the 1825 sketch of Cockermouth (cat.no.17) and the 1841 study of Heidelberg (cat.no.18) are on paper from a batch that Turner first used in the mid 1790s.

Some of the papers he used were made specifically for watercolour, but many others were made as writing papers. As William Enfield remarked in 1809, 'Any Paper that will do for writing will do for Drawing'.[5] Despite Turner's increasing reliance on papers made for watercolour, particularly in those works destined for sale, it becomes increasingly obvious, the more you examine his work, that he could make almost any paper work for him. Turner used the products of famous makers as well as those from small provincial mills in Britain, France, Italy, Germany and Switzerland. Most of the white papers shown here are handmade, but there are examples of papers made on Fourdrinier machines, from a relatively low-grade cartridge (cat.no.30) to a very superior Swiss-made writing paper (cat.nos.41, 42).

The general consensus amongst his contemporaries was that wove paper was the paper to work on: 'be provided with wove paper, in other words drawing paper, without wire marks [laid and chain lines], of different thicknesses and sizes.'[6]

Turner can be found using laid papers on some occasions when circumstances demanded (cat.no.55). Most of the continental sketchbooks he bought contained laid paper, but he rarely used anything but pencil on them. Many of the papers used were quite lightweight compared to those of his contemporaries. John Varley recommended

For colouring from nature, thick paper, of rather a rough texture, such as cartridge, is preferrable ... if thin Wove Paper be used, it

will be best to mount them two or three thicknesses first, as they are more likely to wrinkle than the thick paper.[7]

Some of the papers reflect the great changes taking place within the industry. Edmonds's insistence on making 'unbleached' watercolour papers (cat.nos.43–5) reflected the problems many mills were having with both quality and supply of raw materials. The increasingly important search for alternatives to rags as a raw material is also reflected in the cereal straws used to make some of the papers (cat.nos.32, 33).

One of the great talents evident in Turner's work is his ability to work areas of the sheet over and over again with no loss of clarity. Some of this is due to the actual nature of the papers he was working on, so very different from the relatively soft watercolour papers, based on cotton linters rather than linen rag, available to us today, but more significant was his understanding of the relationship between the surface of a sheet and the marks made on it. His understanding of surfaces had grown over years of working in pencil and in watercolour on a wide range of different papers. He made thousands of swift pencil sketches, on papers of varying surface strengths and hardness, using graphites of very different strengths. He used the tone, texture and grain of the sheet in hundreds of watercolours, washed and layered and stippled, lifting colour cleanly off from the surface. By no means all papers were capable of such sure handling, or retaining a sharp and clear individual definition with rarely any muddying or blurring of individual marks.

Not all the white papers shown here have been identified, although wherever possible suggested origins and possible dates of making have been given. Even when a watermark is present, it has not always been possible to suggest more than a probable source, because records documenting that particular maker have not yet come to light. The prices Turner paid for his papers could be quite expensive. In 1840 Winsor and Newton were selling ranges of watercolour papers at the prices listed below. In 1840 they were not specifying which of the two Whatman mills were supplying their papers, but by 1849 they were selling 'Whatman's Turkey Mill Drawing Papers' made by the Hollingsworths.

Whatman's Drawing Papers[8]

	Size (in inches)	£	s	d	(per quire)
Demy	20 × 15	0	2	3	
Medium	22 × 17	0	3	4	
Royal	24 × 19	0	4	3	
Super Royal	27 × 19	0	5	4	

Imperial	30 × 22	0	7	3
Colombier	34 × 23	0	11	3
Atlas	33 × 26	0	11	3
Dble Elephant	40 × 26	0	14	6
Antiquarian	52 × 31	3	10	0

Drawing Papers of Extra Qualities

		s	d (per quire)
Royal	extra thick, rough	8	6
Imperial	stout	9	0
Ditto	extra stout, rough	12	6
Ditto	extra thick	15	0
Colombier	stout	13	0
Ditto	extra thick	15	0
Dble Elephant	extra thick	18	0
Imperial	Drawing Cartridge	5	6
Royal	Cartridge	3	0

Turner seems to have preferred to work on the lighter weights and after 1820 only rarely can he be found working on the largest sheets of paper.

Turner's constant drawing, particularly in his travelling sketch-books, and the colour beginnings exhibit an exuberant enjoyment of the sheer sensual pleasure of drawing and painting. The brush caresses, glides, batters and stabs the surface, even grinds against it. The pencil dances sometimes in tempest, fast and furious in many of the swift, small travelling sketches, marking a moment in a single line of subtle and shifting weight amongst the almost minimal surface differences of the sheet. Turner understood the scale of the surface of a paper, he knew what size marks were appropriate to his particular ends in an individual work, and with what degree of wetness or dryness the colours could be applied. Even an apparently smooth-pressed gelatine-sized wove writing or watercolour paper is a veritable landscape of valleys of light and shade that he used unerringly to his advantage, giving light back to the viewer suffused with the colours of his marks.

1 'Observations on the Rise and Progress of Painting in Watercolours', *The Repository of Arts, Literature, Commerce, Manufactures, Fashions and Politics*, vol.8, no.47, Nov. 1812, p.258.

2 Act of Parliament (34 Geo III, c.20). For further information on the complex subject of the taxation of paper see Dagnall 1998.

3 Balston 1998, p.252.

4 Two-sheet moulds for larger sheet sizes were introduced by the Whatman mills in 1826. Simon Green 'Papermaking Moulds', *The Quarterly*, no.23, July 1997, p.1.

5 William Enfield, *Elementary View of the Fine Arts*, London 1809, p7.

6 William Nicholson's *Encyclopaedia*, 11, London 1809.

7 An advertisement by John Varley, 1818, bound in with a copy of David Cox, *A Treatise on Landscape Painting and Effect in Watercolours*, London 1814.

8 Both these listings are taken from Winsor & Newton, *Catalogue and Price List for the Trade Only*, London 1840, p.33. By 1849 the catalogue had been renamed *Catalogue and Price List for the Profession Only*.

12 Rochester Castle 1821

From the *Medway* sketchbook

Buff paper-covered boards, brown leather spine, brass clasp, leather pencil holder and yellow edge painting

119 × 193 × 16 (4⁹/₁₆ × 7⁵/₈ × ⁹/₁₆)

Page size: 113 × 190 (4¹/₂ × 7¹/₄)

Post Octavo

White wove writing paper

Watermark: R BARNARD / 1820

Made by: Richard Barnard

Mill: Eyehorne Mill or Park Mill, Hollingbourne, Kent

Pencil

TB CXCIX 18 v

D17395

12A Transmitted light image of watermark from TB CXCIX 19 and 60.

12B Micrograph of paper surface and graphite at × 20 magnification.

12

12A

Turner had long apppreciated the fact that many gelatine-sized writing papers also take the pencil very well. Consequently he was happy to use as sketchbooks all sorts of small notebooks and pocket books that had not actually been designed as sketchbooks. This small book is part of the largest body of such sketchbooks in the Bequest that can be identified as having come from one source. They were bought, probably in batches, and used by Turner over a seventeen year period. They are all mass produced, rather than made to order, Post Octavo notebooks with paper-covered boards, leather spines and brass clasps, some with additional leather pencil holders. They were bound up using batches of Thin Post wove writing papers from five different makers, some of whose papers Turner also used on other occasions as full sheets.

The paper found in this particular sketchbook was made by Richard Barnard who had been the proprietor of Eyehorne Mill, Hollingbourne, since 1781–2.[1] In 1809 he took over the actual running of the mill and in 1810 mortgaged it to his nephew, also called Richard.[2] By 1819 he and his nephew were also operating Park Mill at Hollingbourne.[3] Richard Barnard the elder died in 1825.

Despite the differences in paper source, various details of the physical

12B

construction of these books, notably the spines, clasps, methods of attaching the pencil holders, and methods of folding down the cover papers onto the boards all show them to have been produced at the same bindery.

One indication that these small notebooks were mass produced comes from the way they have been cut and bound together. Rather than individual sheets, or pairs of sheets, being folded, bound as sections and then trimmed, the papers have been treated somewhat differently:

piles of sheets have been trimmed to double the intended page size, in this case approximately 114 × 360 (4 × 14¹/₄), folded into sections and then bound. In the case of the Smith and Allnutt sketchbooks the papers appear to be grouped and trimmed in sixes; other papers show a similar grouping but a little less clearly.

The complete list of these sketchbooks is given below, together with details of the paper they contain and their date of use. It will be seen that the bulk of them have watermarks dating from 1819 and 1820, despite being used in some cases many years later. There are several variant binding designs within this group which can be distinguished; these are indicated in the listing below as the following types:

Type 1. Buff paper-covered boards, brown leather spine, brass clasp, approximately 90 leaves (variable)

Type 2. Buff paper-covered boards, brown leather spine, brass clasp, leather

pencil holder, approximately 90 leaves (variable)

Type 3. Grey (originally bluer than seen here) paper-covered boards, brown leather spine, brass clasp, approximately 90 leaves (variable)

Type 4. Grey (originally bluer than seen here) paper-covered boards, brown leather spine, brass clasp, leather pencil holder, approximately 90 leaves (variable)

Type 5. Marbled paper-covered boards, brown leather spine, brass clasp, leather pencil holder, approximately 40 leaves (variable)

Type 6. Brown paper-covered boards, brown leather spine, brass clasp, leather pencil holder, approximately 90 leaves (variable)

Date of use: 1819–20
TB CLXXV, *Milan to Venice*
 Paper watermarked: ALLEE / 1813
TB CLXXVII, *Ancona to Rome*
 Paper watermarked: ALLEE / 1813
TB CLXXIX, *Tivoli and Rome*
 Paper watermarked: ALLEE / 1813
TB CLXXXVI, *Naples, Paestum and Rome*
 Paper watermarked: ALLEE / 1813
TB CLXXIV, *Turin, Como, Lugano, Maggiore*
 Paper watermarked: SMITH & ALNUTT / 1818
TB CLXXVI, *Venice to Ancona*
 Paper watermarked: SMITH & ALNUTT / 1818
TB CLXXXII, *Albano, Nemi, Rome*
 Paper watermarked: SMITH & ALNUTT / 1818
TB CLXXXV, *Pompeii, Amalfi, Sorrento, Herculaneum*
 Paper watermarked: SMITH & ALNUTT / 1818
TB CLXXXVIII, *St Peter's*
 Paper watermarked: SMITH & ALNUTT / 1818
TB CXCI, *Rome and Florence*
 Paper watermarked: SMITH & ALNUTT / 1818

Hamilton's description of the binding of these sketchbooks after Turner's 1819–20 tour of Italy is an extraordinary misreading of the actual information present in the sketchbooks:

Soon after he got home Turner sent at least a dozen sketchbooks away to be bound in plain card boards with leather spines. He had taken them to Italy as floppy, unbacked notebooks, for the sake of lightness and ease of transport. We know this from the instructions to the binder left in one book and because some pencil drawings run into the gutter where they have been tightened by binding.[4]

He bases all this on the presence of one word 'clasp' written on TB CLXXXIII f.72. This book is not even one of the 'dozen' he talks about, being Post Quarto (10 × 7^{15}/$_{16}$) and made up using a white wove, watermarked J WHATMAN / 1814, prepared with a grey wash from the same batch of grey washed sheets, prepared by Turner himself, found in other sketchbooks used on this tour.[5]

Although it may well be that this one book was bound up after the tour, and by the same bindery where Turner bought many of his sketchbooks, there is no evidence in the sheets, or the structure of the books themselves, that this group of books listed above were bound, or rebound after use; no dirt on the 'floppy covers' or usage on the edges that, if Hamilton is right, would have been unprotected in a way that a bound book is not.

The rest of this series of sketchbooks is listed below, together with their types. There are sufficient differences in the leather used for the spines and the slightly different sizes of the books to suggest that, even among books listed as being of the same type, they are the products of different batches of binding, perhaps from the hands of different binders working in the same bindery.

Date of use: 1821
TB CXCVIII, *Folkestone* Type 3
 Paper watermarked:
 T EDMONDS / 1819
TB CXCIX, *Medway* Type 2
 Paper watermarked:
 R BARNARD / 1820

Date of use: 1822
TB CC, *King's Visit to Scotland* Type 3
 Paper watermarked:
 ALLEE / 1819
TB CCI, *King at Edinburgh* Type 5
 Paper watermarked:
 R BARNARD / 1820

Date of use: 1824
TB CCIX, *Norfolk, Suffolk and Essex* Type 4
 Paper watermarked:
 ALLEE / 1819
TB CCIV, *River* Type 5
 Paper watermarked:
 R BARNARD / 1820
TB CCXI, *Paris Seine & Dieppe* Type 5
 Paper watermarked:
 R BARNARD / 1820

Date of use: 1825
TB CCXII, *Thames* Type 4
 Paper watermarked:
 ALLEE / 1819
TB CCXV, *Holland, Meuse & Cologne* Type 4
 Paper watermarked:
 ALLEE / 1819
TB CCXIII, *Mortlake & Pulborough* Type 2
 Paper watermarked:
 R BARNARD / 1820

Date of use: 1827
TB CCXXVI, *Windsor & Cowes* Type 2
 Paper watermarked:
 R BARNARD / 1820

Date of use: 1829–30
TB CCXXXVIII, *Kenilworth* Type 2
 Paper watermarked:
 R BARNARD / 1820
TB CCXXXIX, *Worcester & Shrewsbury* Type 2
 Paper watermarked:
 R BARNARD / 1820

Date of use: 1830
TB CCXLIII, *Petworth* Type 6
 Paper watermarked:
 ALLEE / 1819
TB CCXLVI, *Arundel* Type 4
 Paper watermarked:
 ALLEE / 1819

Date of use: 1831
TB CCLXVI, *Minstrelsy of the Scottish Borders* Type 2
 Paper watermarked:
 J JELLYMAN / 1828
TB CCLXVII, *Abbotsford* Type 2
 Paper watermarked:
 J JELLYMAN / 1828
TB CCLXIX, *Stirling and Edinburgh* Type 2
 Paper watermarked:
 J JELLYMAN / 1828

Date of use: 1832
TB CCLXXVIII, *Mouth of the Thames* Type 5
 Paper watermarked:
 R BARNARD / 1820

Date of use: 1833
TB CCXCVI, *Brussels up to
Mannheim* Type 2
 Paper watermarked:
J JELLYMAN / 1828

Date of use: 1836
TB CCXCIII, *Val D'Aosta* Type 2
 Paper watermarked:
J JELLYMAN / 1828

1 Balston 1992, vol.I, p.322.
2 Balston 1992, vol.II, p.15.
3 *Excise General Letter*, 26 June 1819
4 Hamilton 1997, pp.203–4.
5 Bower 1990, pp.113–16.

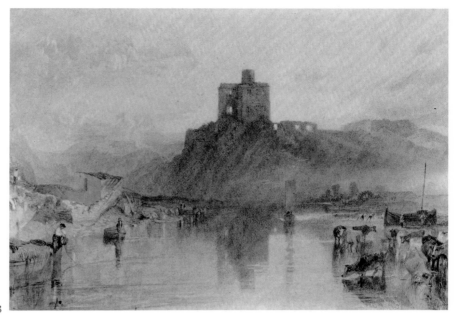

13

13 Norham Castle on the Tweed
1822–3

156 × 216 (6¹⁄₈ × 8¹⁄₂)

White wove drawing paper
No watermark
Unknown maker, probably Bally,
Ellen & Steart

Watercolour and bodycolour

TB CCVIII O
D18148

13A Micrograph of the paint layer
and the surface of the sheet at × 20
magnification.
Illustrated on page 71

Norham exerted a continuing fascination
for Turner: he returned to the subject
seven times in significantly important
watercolours and an astonishing oil,
between 1798 and the 1840s. In most of
the watercolours he chose to explore the
effects of light on atmosphere, utilising
various properties of his paper grounds
in very specific ways. For example, the
four Norham Castle works from the
1790s, all on a much larger scale than this
work, explore in different ways the
translucence of paper, using different
methods of washing colour on the back
of the sheet in three instances and in the
other case painting on a secondary sup-
port.[1]

Most of the *Rivers of England* water-
colour series were executed on Holling-
worth's Whatman paper, watermarked
J WHATMAN / TURKEY MILLS / 1822 or
1823, but this sheet is a completely differ-
ent paper. Comparisons between the sur-
face of this sheet and that seen in
cat.no.14, also from the *Rivers of England*
series, show this sheet to be creamier in
tone, to have a more pronounced surface
'grain' and a very different felt mark.
Part of the colour difference has perhaps
come from a slight yellowing of the
paper's tone over time. This kind of dis-
coloration is typical of warm white
papers from several makers during the
early years of the nineteenth century, and
is particularly common in some 1818–23
white woves made by Bally, Ellen &
Steart, the most likely makers of this
paper.

Comparisons between this paper and
that used in the *Grenoble Bridge* of 1824–5
(cat.no.16) show the often considerable
differences between surfaces and textures
even in papers from the same maker at
around the same period. In the case of
these two works Turner has had very
different purposes in mind: the Norham
work has been designed to be engraved
from, whereas the Grenoble work was a
preparatory study for another water-
colour and Turner has treated their sur-
faces very differently. It is a measure of

George Steart's skill as a papermaker
that his papers were capable of taking
very many different ways of working.

1 See Bower 1990, p.51 for a discussion of two
other Norham Castles in the Bequest, TB L B and
C, and the watercolour W 225, at Cecil Higgins
Art Gallery, Bedford, in all of which the back of
the sheet has been washed with colour. The
fourth work, W 226, now in a private collection
appears to have been laid down onto a secondary
support which has also been painted, in a similar
manner to the *Llandeilo Bridge and Dynevor Castle* at
the National Museum of Wales. In this work
another version of the painting has been painted
on a second sheet of paper, perhaps before the
main work. See Christine Mackay, 'Turner's
Llandeilo Bridge and Dynevor Castle', *Burlington
Magazine*, vol.140, no.1143, June 1998, pp.383–6.
Other views of Norham Castle on paper by
Turner include the *Liber Studiorum* print RL 57
and a monochrome drawing, TB CXVIII D, on a
J WHATMAN / 1801 white wove writing paper.

14 The Mouth of the Medway

*c.*1824

156 × 218 (6¹⁄₈ × 8¹⁄₂)
White wove watercolour paper
Watermark: J WHATMAN / TURKEY
MILLS / 1822
Made by: T. & J. Hollingworth
Mill: Turkey Mill, Maidstone, Kent

Watercolour

TB CCVIII P
D18149
Illustrated on page 65

14A Transmitted light image of the watermark.

14B Micrograph of the paper surface at × 20 magnification.

The group of finished works relating to the *Rivers of England* series that remain in the Turner Bequest were all worked, with one exception, on a white wove water-colour paper made by the Hollingworth brothers. This image has been chosen rather than any other from the series because the river pictured, the Medway, together with its tributaries such as the Len, the Loose and the East Malling Stream, was the river that had powered and, in some cases provided the water for, so many of the paper mills that pro-duced the papers that Turner used throughout his career. Besides the two Whatman mills, Turkey and Springfield, there were so many other mills on this river and its tributaries: from William Turner at Chafford some thirty miles inland, whose papers are found in some of Turner's sketchbooks, to mills in the Maidstone area, East Malling, Hayle, Upper and Lower Tovil, Poll Mill.

Of all the sheets in this group only five are watermarked. Four of the sheets have been trimmed from the whole sheet cut-ting right through the watermark verti-cally. As can be seen from the illustration the watermark in this sheet is aligned differently with the watermark running horizontally across the sheet.[1]

There seems little logic to Turner's choice of Whatman papers. Both the companies, the Hollingworths at Turkey Mill and Balston at Springfield Mill, that made 'Whatman' paper were producing very similar products. Turner seems to have worked sometimes indiscriminately on the products from the two mills.

14A

14B

Cat.nos.20 and 21 are examples of papers from the two mills produced in the same year.

Their common trade name 'What-man' linked the fortunes of the two mills in a very close relationship that was not always friendly, but they did help each other out in times of crisis, such as short-ages of raw materials and orders. In the early years, after the dissolution of the original partnership between Balston and the Hollingworths, some of their papers were also being marketed in London together. William Gaussen, Balston's partner, writing to him in 1814 about the poor sales of drawing papers, listed what papers he was holding in stock. Amongst the Balston-made Whatman papers we also find listed £1,000 worth of What-man paper from the other mill, 'Holling-worths' Printing Demy', in London and a further £300 'at Mill'.[2]

1 The other watermarked works are TB CCVIII L and W both watermarked J WHA... / TURK... / 18... and TB CCVIII M and V, watermarked with the other halves of those marks: ...TMAN / ...EY MILLS / ...22.
2 Letter from William Gaussen to William Balston, 9 June 1815, Kent County Archives.

15 Walmer Castle near Deal, Kent

*c.*1825

185 × 225 (7¹⁄₂ × 8⁷⁄₈)
Post Quarto folded to Post Octavo
White wove writing paper
Watermark: W WEATHERLEY / 1822
Maker: William Weatherley
Mill: Chartham Mill, Chartham, Canterbury, Kent

Watercolour

TB CCLXIII 354
D25477

15A Transmitted light image of the watermark.

15B Micrograph of the paper surface at × 15 magnification.

Despite the very distinct choices Turner made in the papers he worked on in his studio, he commonly worked on whatev-er was to hand when travelling in Britain or on the continent. But even then he often chose very interesting papers to work on. This small sheet of very good quality lightweight writing paper is typi-cal of the notepapers available up and down Britain in the early years of the nineteenth century. As can be seen from this work, these sheets were sold folded, in quires of twenty-four sheets at a time. The most common sizes were Post Quar-to (nominally 9 × 7¹⁄₂), Large Post Quarto (nominally 10 × 8), but often found in this smaller notepaper size, and Post Octavo (nominally 7¹⁄₂ × 4¹⁄₂).

Three other works in the Bequest are also on the same paper, possibly original-ly making up the four quarters of the whole sheet.[1] There are many examples in the Bequest of individual sheets or small groups of sheets used by Turner once or twice and never again. It may well be that this paper was originally

bought by Turner for writing letters and that he ended up using it for these works. Unfortunately none of his surviving correspondence is on this paper.[2] Cat.no.22 shows another example of Turner working on a lightweight writing paper, but from a different maker.

Chartham is an old mill, in the freehold of Canterbury Cathedral until 1860 when the Dean and Chapter sold it. It was originally built as a fulling mill, but put to papermaking in the 1730s by Peter Archer. After passing through the hands of a wide variety of other Kentish papermakers, a Buckinghamshire farmer and papermaker, a Sussex papermaker, two other gentlemen from Buckinghamshire, another gentleman from Sussex and a firm of Canterbury bankers the leasehold was bought for £4,000 by William Weatherley, originally a papermaker from Deptford in north Kent. He operated Chartham Mill from 1818 until his death in April 1852, at first in partnership with John Lane, an innkeeper from Dartford and then from 1822, the year this paper was made, on his own. Coleman describes how 'with this change the mill seems to have entered on a long period of successful development after the uncertainties of the war years'.[3] Until 1840 and the installation of a Fourdrinier machine by Bryan Donkin, Chartham had remained a two vat mill, turning out about a ton a week of good-class paper.[4] Chartham is still working today, producing tracing, detail and other lightweight draughtsmen's papers.

This sheet has been recently conserved. Until then it had, in common with many writing papers of the period, been strongly affected by light discoloration, and indeed if one looks carefully the affected area is still slightly visible. Fig.10 shows the same work before conservation.

1 TB CCLXIII 248, a sketch of Brighton; 270, a sketch of Brighton beach and pump house; and 287, a study for *Deal, Kent*.
2 As part of the complete documentation of Turner's paper usage, a record of the origins of all the papers he used in his correspondence will shortly be available in the Study Room at the Clore Gallery.
3 D.C. Coleman, 'The Early History of Chartham Mill', *The Paper Maker*, Aug. 1955, p.57.
4 Spicer [n.d.], p.184.

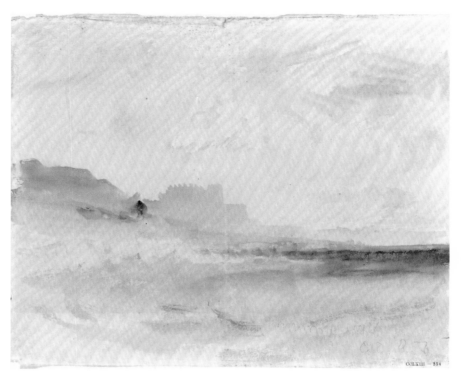

15

15A

15B

fig.10 TB CCLXIII 354, before conservation, showing the extent and depth of discoloration

**16 Preparatory study for
'Grenoble Bridge'** *c.*1824–5

555 × 750 (21¹/₂ × 29¹/₂)

White wove watercolour drawing
paper
Watermark: B. E. & S. / 1823.
Made by: Bally, Ellen & Steart
Mill: De Montalt Mill, Combe
Down, Bath, Somerset

Watercolour and pencil, with some
stopping out

TB CCLXIII 346
D25469

16A Transmitted light image of the
watermark.

16B Micrograph of the paper
surface at × 15 magnification.

16

This work is one of a group of five large
essays into this particular subject, of
which four are in the Turner Bequest
and the fifth, the finished work, is at Bal-
timore Museum of Art, Maryland, USA.[1]
The group as a whole are on three differ-
ent papers. The work shown here, anoth-
er study and the finished work are all on
the same Bally, Ellen & Steart 1823
paper. Another study is on an unidenti-
fied white wove drawing paper and the
final study on a white wove watermarked
J WHATMAN / TURKEY MILLS / 1825.
Warrell discusses the dates of execution
of this interesting group.[2]

It may or may not be accidental that
this group of intimately related works are
on different papers, but Turner's explo-
ration of the same subject on different
papers is not unique to this group: see
cat.nos.39 and 40 for views of Ehren-
breitstein from the same date but worked
on very different papers. It occurs too
often in the Bequest for this to be mere
accident and generally involves the use of
a handful of different papers from a quite
small group of papermakers. All artists
have preferences for particular papers,
papers which suit the speed and pressure
of the brush in their hand and which can
cope with the often very vigorous
demands the artist makes upon them.

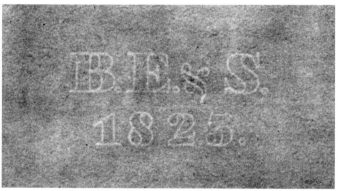

16A

1 The three other works in the Bequest are:
 TB CCLXIII 367: 474 × 692 (18¹¹/₁₆ × 27¹/₄)
 TB CCLXIII 368: 504 × 711 (19³/₄ × 28)
 TB CCLXIII 391 (add): 554 × 767 (21¹/₂ × 30¹/₄)
 J WHATMAN / TURKEY MILLS / 1825. Possibly
 TB CCLXIII 345, now recorded as missing.
 Baltimore (68.28), w 404: 530 × 717 (20⁷/₈ × 28¹/₄).
 B.E. & S. / 1823
2 Warrell 1991, p.44.

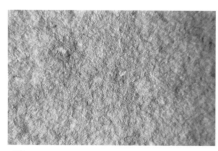

16B

17 Sketch for 'Cockermouth Castle, Cumberland' *c.*1825

343 × 482 (13½ × 19)

White wove drawing paper
Watermark: 1794 / J WHATMAN
Made by: William Balston and the
Hollingworth brothers
Mill: Turkey Mill, Maidstone, Kent

Watercolour

TB CCLXIII 92

D25214

17A Transmitted light image of the watermark.

17B Micrograph of the paper surface at × 15 magnification.

There are several examples in the Bequest of Turner working on relatively old papers.[1] An even later use of another sheet of 1794 / J WHATMAN paper can be seen in cat.no.18, a colour study of Heidelberg executed in *c.*1841, nearly fifty years after the paper was made.

Like all artists Turner kept stocks of paper for use: remnants of different batches bought years before must have been stored in his studio. What made him choose this particular paper for this work can only be guessed at, but the rich glowing light is reminiscent of some of his experiments in the 1790s when he was using large sheets of 1794 Whatman paper to explore the glow possible in back painting seen in some of his views of Norham Castle and other works.[2]

This paper has the watermark 1794 / J WHATMAN like so many other papers that Turner used, but one must be wary of assuming that all the different examples of the papers watermarked 1794 / J WHATMAN are the same. Papers were being made for many purposes and each different use had its own sheet size, even if the papers were given the same size name. As the list below shows, a Demy printing is a different sized sheet from a Demy drawing. Known 1794 / J WHATMAN papers found in the Bequest include the following, some of which are found in three different finishes and all in different weights. It should be noted that in many instances only parts of these sheets can be found in the Bequest.

The sizes given below are the nominal sizes: there was often considerable variation in size between different batches made on the same moulds. Changes in the furnish used, degree of beating,

weight of sheet and seasonal differences in relative humidity and temperature could all affect drying times and the shrinkage in the sheet as it dried, leading to variations in the size of the finished paper.

The basic 1794 / J WHATMAN watermark followed standard positions in the sheet for laid and wove, but the scale of the lettering varied, depending on the size of the sheet: bigger sheets generally had bigger watermarks. The marks were handmade and thus vary slightly from one to another. Turkey Mill used double moulds for the smaller sizes of sheet, giving two subtly different marks on each mould in the pair. Some of the Post, Large Post and Foolscap sheets were watermarked twice in each sheet, giving four marks on each mould and eight to the pair.

17

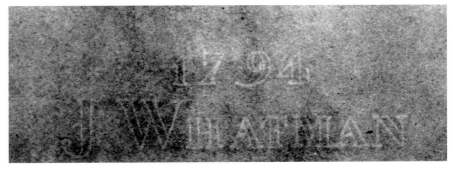

17A

17B

1 For example, see Bower 1990, pp.62–4 for a discussion of Turner's use of a nearly forty-year-old paper for one of his *Views over the Lake at Stourhead* of 1798.
2 For example, TB L B and C, and the watercolour W 225, Cecil Higgins Art Gallery, Bedford, and W 226, now in a private collection.

**Table: Papers watermarked 1794 / J WHATMAN found in the Turner
Bequest, either as whole or part sheets**

Size	Designed Use	type	dimensions (ins)
Antiquarian	drawing	wove	31 × 53
Atlas	drawing	wove	26 × 34
Colombier	drawing	wove	23½ × 34½
Demy	drawing	wove	15½ × 21
Demy	printing	wove	17½ × 22½
Double Elephant	printing	wove	27 × 40
Double Elephant	drawing	wove	26¾ × 40¼
Double Medium	writing	wove	23 × 36
Foolscap	writing	laid and wove	13½ × 17
Foolscap	drawing	wove	13¼ × 16½
Imperial	writing	wove	22 × 30
Imperial	drawing	laid and wove	22 × 30½
Imperial	printing	laid and wove	22 × 30
Large Post	writing	laid and wove	16½ × 21
Medium	writing	wove	18 × 23
Medium	drawing	wove	17½ × 22
Royal	writing	laid and wove	20 × 25
Royal	drawing	wove	19 × 24
Royal	printing	wove	19½ × 24¼
Small Imperial	drawing	wove	21½ × 28½
Super Royal	drawing	wove	19½ × 27¼
Thin Post	writing	laid and wove	15¼ × 19½
Thick Post	writing	laid and wove	15¼ × 19½

**18 Large Colour Study of
Heidelberg** *c.*1841

486 × 693 (19⅛ × 27⁵⁄₁₆)

Super Royal
White wove drawing paper
Watermark: 1794 / J WHATMAN
Made by: William Balston and the
Hollingworth brothers
Mill: Turkey Mill, Maidstone, Kent

Worked in pencil and watercolour

TB CCCLXV 34
D36325

18A Transmitted light image of the
watermark.

18B Micrograph of the paper
surface at × 15 magnification.
Illustrated on page 71

Turner's use of this paper so many years
after its manufacture raises certain ques-
tions. How long had Turner had this

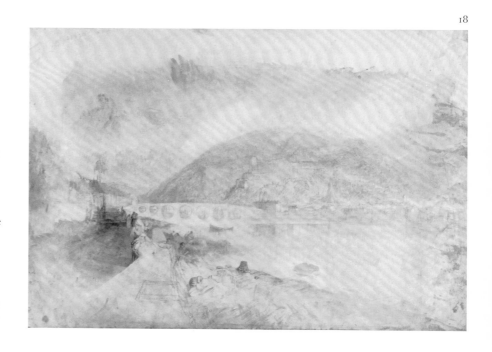

18

paper, does it relate to any of the batches of Super Royal 1794 Whatman that he was using in the 1790s and perhaps more importantly, what was it that made him return to it over forty years later?

It may well be that this sheet comes from the same batch of paper as the bulk of the sheets that he had used in 1801 on his Scottish tour, that is, the paper he had used for three watercolours connected to that tour, TB LX B, E and G, as well as the large batch of paper he had prepared with a wash of tobacco and indian ink for the *Scottish Pencils* (TB LVIII).[1] Its use does suggest that it was worked up in the studio rather than away from home at Heidelberg. By the latter part of his career Turner was generally working, when travelling, on sheets a quarter of this size.

There are other examples of Turner returning to a paper many years later: the 1998 Turner exhibition at the British Museum showed the numinous *Lucerne by Moonlight* of 1843 in which Turner returned to the same batch of thin writing paper, watermarked J WHATMAN / 1816, that he had used, prepared with a grey wash, for many of the series of fifty-one *Views of the Rhine* of 1817. That exhibition also showed several of the fifty-one views, including some on the same paper.[2]

1 Other early Super Royal 1794 / J WHATMAN sheets include TB XXXI J (although this is a two-ply laminated card) and the papers used in some sketchbooks: TB XXXVIII, TB XLV, TB LIII and TB LIV.
2 See Sloan 1998. The Lloyd Bequest *Views of the Rhine* from 1817 on the J WHATMAN / 1816 writing paper are *Abbey near Coblenz*, *Lurleiberg and St Goarhausen*, and *Bingen from the Nahe*. Two others in the Lloyd Bequest, *Hirzenach below St Goar* and *The Johannisberg* are on a very similar lightweight writing paper, watermarked J WHATMAN / 1814.

19

19A

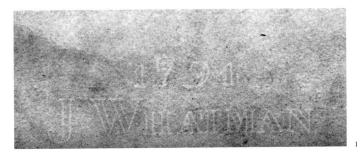

18A

19 Sketches of Avignon and Villa Nuevo 1828
From the *Lyons to Marseilles* sketchbook

Parchment bound pocket book
113 × 146 × 11 (4⁷/₁₆ × 5³/₄ × ⁷/₁₆)
Page size:98 × 146 (3⁷/₈ × 5³/₄)
Cream double-faced lined wove paper
Chain lines: 22–25 mm (⁷/₈–1 inch) apart, variable
Formation: poor, very badly beaten, much process dirt, couch faults and air bubbles. Very variable weight
No watermark present
Made by: Probably Jardel
Mill: Couze, near Bergerac, Dordogne, France

Pencil

TB CCXXX 38v, 39r
D21065, D21066

19A Transmitted light image showing the presence of chain lines, but no laid lines and the poor formation of the sheet. Taken from one of the better-formed blank sheets (TB CCXXX 67).

19B Micrograph of the surface of TB CCXXX 39 at × 30 magnification, showing the graphite and the prominent felt mark in the surface.

Lined woves, papers which appear to have chain lines similar to those seen in laid papers but no laid lines, enjoyed a brief vogue in southern Europe in the first part of the nineteenth century. The purpose of such mould design is still unclear: it offers no practical benefit in papermaking terms or in terms of the use of the sheet and must therefore be primarily decorative.[1]

The identification of some papers can be extremely difficult. But, despite the lack of a watermark in this paper there are some indications as to its origin. Firstly, the very prominent felt hair impression in the surface is typical of some of the smaller French mills in the early years of the nineteenth century, but such surfaces can also be found among some north Italian provincial papers. Secondly, the style of paper mould seen in use here was very fashionable in some French and Italian mills in the first half of the nineteenth century.

But there are differences between the French and Italian versions of this paper.

19B

Most French lined wove paper is cream or off-white in colour, whereas the Italian versions are slightly blued. Comparisons with examples of both French and Italian lined wove papers in my collection show great similarities with a French cream lined wove paper watermarked JARDEL and dating from *c.*1820.[2] Gaudriault lists twenty-nine members of the Jardel family operating a collection of mills at Couze and Sarlat in the Dordogne between 1656 and 1813, but which of the several Couze mills produced this paper cannot be identified.[3] One argument against a member of the Jardel family would be the quality of the sheets seen in this sketchbook, which are well below the standard usually seen in their work.

Another example of a lined wove paper in the Bequest is TB CCXXXIII, the *Genoa and Florence* sketchbook, which contains a well formed, good quality, blue lined wove paper watermarked with a unicorn and flag and countermarked G B / B. It has a less prominent felt hair texture than that seen in TB CCXXX and is typical of the blue Italian lined woves found in the 1820s and 1830s.

This paper may have been made by the Banolda family. Guiseppe Banolda was using G B B as a watermark in the 1760s, but whether the company continued to operate into the nineteenth century has yet to be determined. One argument against Banolda as the maker of this paper is that the area around Genoa was an old-established papermaking area and given the use of this book beginning at Genoa it is likely that the paper has a Genoese origin. Banolda was operating in the Veneto.[4]

1 Unlike 'Lined Brief', a legal paper, in English practice at least, generally wove Foolscap, watermarked with a marginal line and 36 or 42 lines at 90° to it, across the width of the sheet, used for drafting legal documents. This was based on Jonathan Phipps' patent, dated 21 August 1790,

for teaching writing by means of heavy watermarked guidelines in the paper.
2 Bower Collection 00156BM. This Jardel sheet is of a very low quality compared to their usual production. The three Italian examples, all dating from *c.*1820 were:
 (i) Blue lined wove, watermarked with a circled fouled anchor and countermarked ALMASSO, Bower Collection 00149BM – 00151BM.
 (ii) Blue lined wove, watermarked ALL / INGLESE in a circle, Bower Collection 00152BM– 001555BM.
 (iii) Blue lined wove, watermarked fouled anchor / JOS & EM RAPH / AZULAY, Bower Collection 00120BM.
3 Gaudriault 1995.
4 Ivo Mattozzi 'Le filigrane e la questione della qualità della carta nella Repubblica Veneta della fine del '700. Con un catalgo di marchi de filgrane del 1767–1797' in *Produzione e uso delle carte filigranate in Europa (secoli XIII–XX)*, Fabriano 1996, pp.309–39.

20 A Sea Piece after 1829

559 × 580 (22 × 22⁷⁄₈)
White wove watercolour paper
Watermarked: J WHATMAN / TURKEY MILL / 1829
Made by: The Hollingworth brothers
Mill: Turkey Mill, Maidstone, Kent
Watercolour
TB CCCLXV 35
D36326

20A Transmitted light image of the watermark.

20B Micrograph of the surface of the paper at × 15 magnification.

20B

20

20A

21 A Stormy Sea *c.*1829

368 × 565 (14¹/₂ × 22¹/₄)

White wove watercolour paper
Watermarked: J WHATMAN / 1829
Made by: William Balston
Mill: Springfield Mill, Maidstone,
Kent

Watercolour

TB CCCLXV 36
D36327

21A Micrograph of the surface of
the paper at × 20 magnification.

21

Both the part sheets used for cat.nos.20
and 21 are from Imperial, nominally
22 × 30 inches, white wove watercolour
papers with 'Whatman' watermarks, but
they are in fact the products of two
different companies and two different
mills. In 1794 James Whatman the
younger, who worked Turkey Mill,
Maidstone, Kent, had retired and the
mill was operated by a partnership
between Whatman's protégé, William
Balston, and the two Hollingworth
brothers. Whatman was the best-known
papermaker in Britain and the Whatman
name was almost synonymous with fine
papers.

Balston wanted to make his own way
and in 1805 the partnership was dis-
solved, with the Hollingworths continu-
ing to work Turkey Mill and William
Balston designing and building his own
mill at Springfield, on the banks of the
River Medway a few miles away on the
other side of Maidstone.

After the dissolution of the partner-
ship both the new companies had
the rights to use the already famous
Whatman name in their watermarks.
The argument over whether both mills
had the right to use the Whatman
name continued for some years
until Susannah Whatman, James
Whatman's widow, wrote to William
Balston:

before you began your mill Counsell
had pronounced that no law could
prevent their [the Hollingworth
brothers] continuing the name and
that they would have a verdict in their
favour in a Court of Justice ... the
opinion is very plain – no room for
any more doubt.[1]

It was finally resolved that papers made
by the Hollingworths were to be distin-
guished from Balston's paper by
the addition of the words TURKEY MILL
or TURKEY MILLS in the watermark.

Despite the rivalry between Turkey
and Springfield Mills, it was in their
interest to come to each other's aid some-
times. The public took little notice of the
fact that two different companies pro-
duced 'Whatman' paper: what hurt one
company could easily hurt the other.
Balston's wife, Catherine, gives an exam-
ple of their co-operation in a letter to her
husband:

Fausett says that Hollingworths will
send you two or three tons of rags in
their own wagon this week. Their
people told him that their horses had
not so much employment as usual, as
they are only working two vats at
Turkey.[2]

21A

This co-operation was to continue off
and on throughout the nineteenth and
for most of the twentieth century.

Despite the similarities between the
two papers, the micrographs show subtle
variations in tone and texture between
the two surfaces. Both papers were
designed specifically for watercolour,
made from pure linen rag and gelatine
sized. But differences in rag supplies
(even though, as we have seen, the two
'Whatman' mills helped each other out
with supplies on occasion), degrees of
beating, the felts used, drying and sizing
techniques led to obvious if subtle differ-
ences between the products of the two
mills.

1 Letter from Susannah Whatman to William
 Balston, May 1810, Kent County Archives,
 U2161/ Z1/2.
2 Letter from Catherine Balston to William
 Balston, 27 July 1813, Kent County Archives,
 U2161/ Z1/2.

22 **'Athens: The Acropolis' and 'The Plains of Troy', two sketches for illustrations to Byron** *c*.1830

388×225 ($14^{7}/_{8} \times 8^{7}/_{8}$)

Thin Post Quarto, unfolded
White wove writing paper
Watermark: W KING / 1828
Made by: John Edward Spicer
Mill: Alton Mill, Hampshire

Watercolour

TB CCLXIII 253
D25375, D25376

22A Transmitted light image of the watermark.

22B Micrograph of the surface of the sheet at × 20 magnification.

22C Raking light image of the blind-embossed stamp BATH / Prince of Wales' feathers / SUPERFINE in a vertical oval.

22

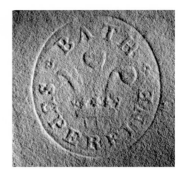

22C

22B

22A

Lightweight writing papers such as this had been one of Turner's favourite paper types earlier in his career and he continued to use them occasionally. This untrimmed sheet with its two images is a particularly fine example of this kind of paper. It was sold folded in quires of twenty-four sheets for letter writing. The stationers, or more rarely the papermakers themselves, would stamp the quires with various designs, such as the one seen here. Stamping the whole folded quire at once generally meant that the impression of the stamp was almost invisible on the inner sheets. Another image of *The Acropolis* (TB CCLXIII 290), is on a part sheet of the same batch of paper with the same watermark, but in this case the blind-embossed stamp is very faint indeed.

Despite the W KING name in the watermark this paper was produced by John Edward Spicer. William King had worked Alton Mill from *c*.1780[1] until 1796,[2] but his successors at the mill continued to use his name in their watermarks until the end of Alton's active life as a papermill early in the twentieth century, and it could still be found in use at other mills operated by the Spicers until only a few years ago.

John Edward Spicer had taken over the running of the mill from Thomas Easton in 1826[3] but was bankrupt by 1846[4] when he had 'run up debts and liabilities amounting to upwards of £12,000' with his private debts over

£10,000. By 1858 the mill was being worked by three members of the Spicer family: Henry, William Revell and John Henry.[5]

Hurst gives two lists of moulds from 1858 and 1861 respectively showing the W KING watermark still in use. The 1858 list has eleven pairs of W KING moulds in Post, Royal, Super Royal, Single Medium and Foolscap sizes. The 1861 list has ten moulds in Imperial, Super Royal, Royal, Wove Foolscap and Post.[6]

Papers from Alton Mill are not that common in Turner's work, but can also be found in use amongst his correspondence, including a letter to Clara Wheeler of 3 June 1839 on a wove Post Quarto sheet with the same BATH / Prince of Wales' feathers / SUPERFINE oval blind-embossed stamp. The paper is almost

identical to the very lightweight sheet shown here but is watermarked ALTON MILL / 1828.[7]

1 *Reading Mercury and Oxford Chronicle*, 27 March 1780 where the mill was described as being able to produce fine goods 'from the purity of the water supplying the Engine'.

2 *Reading Mercury and Oxford Chronicle*, 27 June 1796, where the mill was described as 'the very convenient and commodius paper mill'.

3 *Excise General Letter*, 13 Sept. 1826.

4 *London Gazette*, 4 Dec. 1846.

5 Jane Hurst, 'British Watermarks: Moulds and Watermarks from Alton Mill, Hampshire', *The Quarterly*, no.28, Oct. 1998, p.8. This article also illustrates the moulds for two W KING watermarks, including one dated in the watermark 1895.

6 Ibid., p.8.

7 BM add mss 50119 f12/13. Another letter, to James Holworthy, 4 Dec. 1826 is watermarked ALTON MILL / 1826. BM add mss 50118 f75/76.

23 Nude Figure 1830–1
From the *Rokeby and Appleby*
sketchbook

Memorandum book bound in red
leather with pencil pocket
76 × 96 × 11 (3 × 3³/₄ × ⁷/₁₆)
Page size: 74 × 90 (2¹⁵/₁₆ × 3⁹/₁₆)
White wove writing paper
Formation: good
Watermark: W BROOKMAN / 1829
and W BROOKMAN / 1830
Made by: William Brookman
Mill: Test Mill, Romsey, Hampshire

Pencil

TB CCLXIV 3v
D25529

23A Transmitted light image of the
watermark W BROOKMAN / 1829
from TB CCLXIV 10 and 24.

23B Raking light micrograph of the
graphite on TB CCLXIV 3v at × 30
magnification.

Turner worked in a very wide variety of
different sized sketchbooks, many of
which, like this example, were not
designed for sketching but as small note-
books. The paper, however, as a strong
surfaced writing paper designed for use
with a steel nib, was usually perfectly
suited to graphite. Other small size pock-
et books include TB CCLXV, *Berwick*
sketchbook used on the same tour and
TB CCVII, *Gosport* sketchbook, in use
1823–4.

Very little is known about the histories
of many of the smaller provincial mills,
but gradually research is uncovering
more and more details of the mills that
supplied so much of the country with
paper. The name of William Brookman
is recorded as working Test Mill, one of
three paper mills at Romsey, Hampshire,
from 1818 until 1866 but, given the long
tenure it is probable that there were two
William Brookmans, father and son.[1] At
some point during the Brookmans'
involvement with Test Mill a paper
machine was introduced. In 1860
William Brookman is recorded as making
printing papers and after his departure
William Harvey operated a 60 inch wide
paper machine making Royal Hands,
Small Hands and Browns.[2]

1 Shorter 1993, p.204.
2 *The Paper Mills Directory*, 1860, 1866, 1876.

23

23A

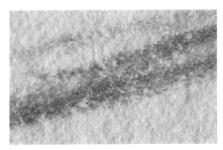

23B

24 Sketches of Loch Ness and its surrounding area 1831

From the *Fort Augustus* sketchbook

17½ sheets of trimmed writing paper folded in half and pinned together with two stout metal pins

Page size: 187 × 146 (7¾ × 5¾)

Foolscap

Blue 'corrected white' double-faced laid writing paper

Laid lines: 9 per cm (22 per inch)

Chain lines: 2.5 cm (1 inch) apart

Formation: good

Watermark: Hanoverian coat of arms

Countermark: BOOTH / 1828

Unknown maker

Pencil

TB CCLXXVI 16v and 17

D26993, D26994

24A Transmitted light images of the watermark and countermark from TB CCLXXVI 1 and 48 and TB CCLXXVI 24 and 35. Note the damaged B in the maker's name. The complete watermark is present but could not be photographed because of the tightness of the spine.

24B Close-up detail of the head of one of the pins holding the book together at × 7 magnification.

24C Micrograph of graphite on the paper surface at × 15 magnification.

Throughout Turner's working life he had recourse to 'homemade' sketchbooks such as this, where a small wad of part sheets of writing paper has simply been folded in half and used for the vigorous recording of a range of scenes.

Whether the pins were inserted into the spine of the 'book' before or after Turner worked on the pages is open to doubt. There is some evidence in the spine of both sides of folio 17 seen here, and on other sheets, that the pencil goes deeper into the fold than would be possible if the pins had been present. This suggests that the loose leaves were pinned together after they were drawn on. The pins themselves are handmade of an alloy that has not tarnished and are typical of those made in Gloucestershire, the centre of the handmade pin trade prior to 1820.[1]

The occurrence of the Hanoverian arms at an 1828 date is relatively rare. This style of watermarking Foolscap

24

24A

24B

24C

papers had enjoyed a brief vogue during the Revolutionary and Napoleonic wars with France in the earlier years of the century but most papermakers had returned to using the seated Britannia mark to indicate Foolscap sheets.

Other examples of the Hanoverian royal arms can be found in papers used by Turner, both in the Bequest and outside it, for example a quire (24 sheets) of a white laid Foolscap paper, watermarked with the Hanoverian arms and countermarked T HYDE & CO / 1806, of which Turner used twenty-three sheets for his notes for one of his lectures as Professor of Perspective at the Royal Academy and the twenty-fourth sheet for two pen and ink drawings, *A Study for 'The Garreteer's Petition'*, and *The Amateur Artist*.[2]

Examination of the details of the watermarks, particularly the damage and distortion seen in various of the letters and numbers of the countermark, shows three different forms of the watermark are present. Papermakers usually worked with a pair of moulds when forming sheets and by the 1820s most mills producing sizes of paper such as Foolscap would have worked wth double moulds, forming two sheets at a time, thus giving four slightly different marks for the pair of moulds.

It has so far proved impossible to identify the maker of this paper. There are no recorded papermakers named Booth at this period in the British Isles, although the name crops up much later in the century in both Lancashire and Yorkshire.[3] It may be that Booth was a stationer or merchant who had a mill make up paper for him with his own mark.

The only other recorded use of this watermark is in the United States where a BOOTH / 1828 watermark is found in a customs document dating from 1838.[4]

1 Information from Susan North of the Victoria and Albert Museum.
2 The lecture notes are BM add mss 46151 Q and the two drawings are TB CXXXI A and TB CXXI B. See Bower 1990, pp.104–6 for a discussion of this paper.
3 Schmoller 1992, p.40.
4 Gravell and Miller 1983. Watermark 112, Morris Library of the University of Delaware: Customs House Records, Philadelphia, 1838.

25

25 Barnard Castle 1831

From *Minstrelsy of the Scottish Borders* sketchbook

Buff paper-covered boards with red-brown leather spine and brass clasp and edge painting
119 × 192 × 16 (4⅝ × 7½ × 9/16)

Page size: 113 × 190 (4½ × 7¼)

Post Octavo
White wove writing paper
Watermark: J. JELLYMAN / 1828
Made by: Joseph Jellyman
Mill: Downton Mill, Downton, Wiltshire

Pencil

TB CCLXVI 32v and 33
D25822/D25823

25A Transmitted light image of the watermark found in TB CCLXVI 4 and 32v.

25B Micrograph of the paper surface of TB CCLXVI 32 at × 15 magnification.

One of a group of sketchbooks purchased together, probably from the same stationer who provided a lot of Turner's sketchbooks, including the bulk of the sketchbooks that he took on his 1819–20 tour of Italy (although the paper in these was not made by Jellyman, but by two different makers: Thomas Smith and Henry Allnutt at Ivy Mill, Maidstone, or William Allee at Hurstbourne Prior Mill, Hampshire).[1]

Turner used a range of thirteen sketchbooks of very different types on his tour of Scotland in July and August 1831, ranging from 'off the shelf' notebooks such as this to the 'homemade' *Fort Augustus* sketchbook (see cat.no.24). Two other sketchbooks, from the same binder and with papers made by Jellyman were used on this tour: TB CCLXVII, *Abbotsford* and TB CCLXIX, *Stirling & Edinburgh*. They differ in one respect from this

sketchbook in that the watermark J JELLYMAN / 1828 does not contain the full stop. The three 'Jellyman' sketchbooks were made in the same manner as the earlier batch of sketchbooks, from the same source, used on the Italian tour: rather than being made up of signatures of complete folded sheets, they have been produced from thin strips of paper cut to size in blocks (see cat.no.12).

The earliest reference to papermaking at Downton Mill comes from 1740 when it was operated by the Snelgar family.[2] By 1781 it was worked by Joseph Jellyman when his 'utensils and stock in his paper mill' were insured for £400.[3] Business must have prospered as nine years later his 'utensils and stock' were valued at £500.[4] Jellyman did not own the mill, but held it under a lease from the Bishop of Winchester. In 1828 he may well have been worried as the mill was put up for sale by the owners, but in fact he or his heirs continued in operation for many years to come.[5] The 1828 advertisement for the mill's sale is worth quoting in full, for the description it gives of the complex interrelationship between different rural industries and their ownership:

To be Sold by Private Contract, either together or separately. All those valuable Corn and Grist Mills situate in Downton, in the County of Wilts, with a dwelling house, stable and outbuildings, garden and two acres of meadow land, the whole forming a small island.

Also, all those most desirable and complete Paper Mills, and excellent spring of water, adjoining the aforesaid Corn Mills, together with a neat Dwelling House, stable and various other outbuildings, and garden thereto adjoining. The mill contains one water wheel, 3 engines [Hollander beaters], 2 vats and three chests, 1 pump and 10 presses.

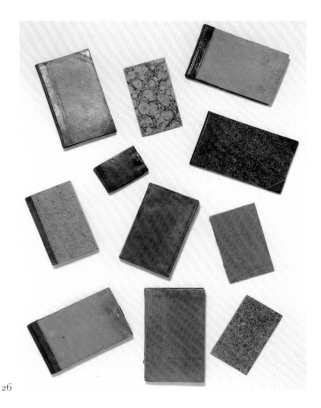

25A

25B

26

The above premises are held under lease for lives from the Bishop of Winchester renewable at a fine certain.

Also those seven tenements, with the outhouses and gardens adjoining, and one large drying loft, being copyhold of inheritance of the Manor of Downton. To view the mills and premises apply to the respective tenants.[6]

At this date Jellyman must have shared the site with others engaged in milling corn, but shortly after the sale he expanded his operation as a second mill at Downton, 'probably an adjacent building but a separate mill' is listed as being operated from 1830 onwards by the Jellyman family for the production of pasteboard.[7] The original mill had been given the Excise Number 343 and the new mill 'occupied by Joseph Gillyman [sic]' was given the Excise number 550.[8]

26A

26B

1 See Bower 1990, pp.113–16.
2 *Victoria County History*, vol.4, 1959.
3 Sun Fire Insurance Policy No.438591, 23 Jan. 1781.
4 Sun Fire Insurance Policy No.565277, 20 Jan. 1790.
5 It is unlikely (but not impossible) that the Joseph Jellyman who worked Downton in 1781 was the same Joseph Jellyman still operating the mill in 1844.
6 *The Times*, 5 June 1828.
7 *Simmons Archives*: VCH, vol.4, 1959.
8 *Excise General Letter*, 1 July 1834.

26 A collection of sketchbooks used by Turner on his 1831 tour of Scotland

Berwick (TB CCLXV)
Abbotsford (TB CCLXVII)
Edinburgh (TB CCLXVIII),
Stirling & Edinburgh (TB CCLXIX)
Stirling and the West (TB CCLXX)
Loch Long (TB CCLXXI)
Loch Ard (TB CCLXXII)
Staffa (TB CCLXXIII)
Sound of Mull, No.1 (TB CCLXXIV)
Sound of Mull, No.2 (TB CCLXXV)
Inverness (TB CCLXXVII)

26A Transmitted light image of the watermark, W & C / 1825 found in TB CCLXVIII 3 and 6.

26B Transmitted light image of the watermark, …AN & SON / …YFIELD / …827 found in TB CCLXX 3.

26C Transmitted light image of a join in the machine wire found in TB CCLXXVII 48 which also shows the presence of a possible deckle along the top edge of the sheet.

Cat.nos.23–5 show three of the sketchbooks used on Turner's 1831 tour of Scotland but an examination of all the sketchbooks used on this tour shows us the great variety of materials which Turner used on his travels as well as where and when he acquired them. The details of the rest of the sketchbooks used on the Scottish tour of 1831 are as follows:

Bought in England:

TB CCLXIV, *Rokeby and Appleby* (cat.no.23).

TB CCLXVI, *Minstrelsy of the Scottish Borders* (cat.no.25).

TB CCLXVII, *Abbotsford* and TB CCLXIX, *Stirling & Edinburgh*, are from the same source as TB CCLXVI. Both contain the same white wove made by Joseph Jellyman (see notes to cat.no.25).

TB CCLXXI, *Loch Long*. Blue wove paper-covered boards, Foolscap Octavo (6¼ × 4) containing three folded sheets of an off-white double-faced laid writing paper watermarked Britannia and countermarked W TURNER / 1828. Made by William Turner at Chafford Mill, Fordcombe, Kent.[1] There is no evidence that William Turner ever supplied stationers other than in London and the home counties.

26C

TB CCLXV, *Berwick*. Red leather pocket book with brass clasp and pencil holder, 65 × 100 × 10 (2½ × 4 × ⅜), containing a white wove writing paper watermarked C WILMOT / 1830, made by Charles Wilmott at Shoreham Mill, Kent. Willmott's known watermarks vary in their spelling: WILMOT, WILMOTT and WILLMOTT are all found.

Bought in Scotland:

TB CCLXXVI, *Fort Augustus* (cat.no.24)

TB CCLXVIII, *Edinburgh*. A red leather-bound Post Octavo (7⅛ × 4⅜ inches) notebook with wallet, containing white wove paper watermarked W & C / 1825. This book bears a rectangular label on the fly leaf: 'Sold by JOHN THOMSON / St Andrew's Square, EDINBURGH' and the price, '3/6', on an inside page. The Edinburgh stationers were generally being supplied by the flourishing Scottish paper mills on the Rivers Esk, Tay, and Don. It would be unlikely that this paper was of English manufacture. The W & C watermark has not yet been identified with any particular maker, either Scottish or English. Hills lists several possibilities in his recent survey of Scottish Paper Mills and their operators.[2] Makers with the surname W working in 1825 were:

Robert Walker	Balerno Bank Mill
Jasper Watson	Duntocher Mill
Robert Weir	Herbertshire Mill, Denny
Alexander Wilson	Dalbeattie Mill, Mount Pleasant

TB CCLXX, *Stirling and the West*. Green parchment-covered boards, Post Octavo (7¹⁵⁄₁₆ × 4⅞ inches) containing four different papers:

(a) White wove paper watermarked …AN & SON / …YFIELD / …827 and made by Alexander Cowan & Sons at Valleyfield Mill, Pennicuik, Midlothian, Scotland. (b, c and d) Three different batches of a white wove paper, one watermarked J WHATMAN / TURKEY MILLS / 1829 another watermarked …ATMAN / …Y MILL / …28 and a third Whatman paper with an 1827 date. All made by the Hollingworth brothers at Turkey Mill, Maidstone, Kent. Despite the presence of the Whatman paper it is likely, given the use of the Scottish-made paper as the endpapers of this book that it was at least bound in Scotland and probably purchased there. By 1820 Valleyfield Mill had already installed a Fourdrinier paper machine, but the Valleyfield paper in this book is handmade, showing that at least one vat was still in operation. Most of Cowan's ouput at this date was actually designed for printing rather than any other use.[3]

TB CCLXXVII, *Inverness*. Marbled paper-covered boards with red leather spine, 163 × 125 × 19 (6⁷⁄₁₆ × 4⅛ × ¹¹⁄₁₆) containing an off-white wove from an unknown maker. One curious feature of this book can be found on pages 39 and 48 where the join in a machine wire can clearly be seen. Page 48 also shows the presence of a possible deckle. The combination of the two would suggest that this was made on a cylinder mould machine. The only maker operating such machines in Britain at this date was John Dickinson of Apsley and Nash Mills, Hertfordshire. But despite the probable English origin for this paper a label on the cover shows that it was purchased in Scotland from 'D MORRISON & CO / Booksellers, Stationers

/ & Bookbinders / INVERNESS'.

Unknown Origin:

TB CCLXXIV, *Sound of Mull, No.1* and TB CCLXXV, *Sound of Mull, No.2.* The two *Sound of Mull* sketchbooks, with very few pages and marbled paper covers, each containing the same low quality unwatermarked white wove, were probably picked up by Turner on his travels rather than brought from London.

TB CCLXXII, *Loch Ard.* No covers, Post Octavo ($4^5/8 \times 7^1/4$ inches) unwatermarked off-white wove from an unknown maker. There is a note at the front of the sketchbook:

> This sketchbook was evidently made-up by the artist himself from sheets of small foolscap-size paper, each measuring $14^1/4 \times 9^1/4$ inches, folded down the centre lengthways then roughly cut up the lower folds and stitched at two points in the centre of the gathering.

This is not accurate; small Foolscap writing is actually $16^1/2 \times 13^1/4$ inches, not $14^1/4 \times 9^1/4$. Some details of the very fine wire profile of the forming surface, visible within the sheet, suggest that this may well be a machine-made paper.

TB CCLXXIII, *Staffa.* Paper-covered boards, red leather spine and corners, Large Post Octavo ($7^3/8 \times 4^9/16$ inches), unwatermarked white wove paper from an unknown maker. This sketchbook has been rebound, not necessarily in the right order. It has not proved possible to identify the maker of this paper. Whilst there are several similarites to some of the papers produced by both the 'Whatman' Mills, Turkey and Springfield, it may well be that this paper was produced at one of the Scottish Mills, several of which were making some very fine papers by the 1830s.

1 See also *Gandolfo to Naples* sketchbook (TB CLXXXIV) for another example of William Turner's paper used by Turner.
2 Richard Hills, 'Scottish Paper Mills 1825–1995', *The Quarterly*, no.19, July 1996, pp.11–16.
3 Valleyfield and Whatman papers can be found together in another sketchbook in the Bequest: see *Rome C. Studies* sketchbook (TB CLXXXIX) which Turner used on his 1819–20 tour of Italy.

27 ?Study for 'Longships Lighthouse, Lands End' *c.*1834

339×490 ($13^{15}/16 \times 19^3/16$)
White wove
Watermark: J WHATMAN/TURKEY MILL/1826
Made by: The Hollingworth brothers
Mill: Turkey Mill, Maidstone, Kent
Watercolour

TB CCLXIII 41
D25163

27A Transmitted light image of the watermark.

27B Micrograph of the paper surface at × 20 magnification.

The examination of the Whatman watercolour papers used by Turner and many other artists during the 1820s appears to show that from the middle of the decade onwards the Hollingworth brothers, at Turkey Mill, had developed a range of watercolour papers that was proving more popular than that of the other

27B

maker of Whatman paper, William Balston at Springfield Mill. Whether this was truly so or merely the result of clever selling to the London colourmen and stationers by the Hollingworths or their agents is difficult to determine but, whatever the reason, more of their paper was being used for watercolour at this period than Balston's.

The various watermarks illustrated here show that Turner regularly used watercolour papers from several different makers during the 1820s for his colour

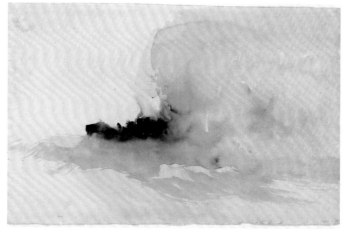

27

27A

beginnings, studies and for finished works. These included papers from both Balston and the Hollingworths (see cat.nos.20, 21) but, judging from the respective numbers of their 1820s watermarks found in the Bequest, there is a definite bias towards the papers produced by the Hollingworths. This particular work has been executed on a half sheet of Super Royal, nominally $27^1/_2 \times 18^1/_2$ inches. There are a very large number of part sheets of Super Royal papers in the Bequest: Turner seems to have appreciated the slightly different proportions that half and quarter Super Royal sheets produce in comparison with either Royal (24×19 inches) or Imperial (30×20 inches).

Most of the papermakers who were producing specialist watercolour papers at this period were making a fairly standard product: the same basic furnish was used to produce two or three sizes. Both the Hollingworths and Balston were using a range of slightly different furnishes to produce a much greater range, not just of sizes, but also, particularly in the case of the Hollingworths, weights and tones. Some of the variations may well be the result of inconsistencies in the supply of rags, but others are so distinctly different as to suggest a deliberate, designed choice. White Hollingworth watercolour papers used by many different artists have been found in some nine different sizes ranging from Demy (20×15 inches) to Antiquarian (52×21 inches). During the 1820s the range produced by Balston is smaller, concentrating on the popular Royal, Super Royal and Imperial sizes.

The relative popularity of either Hollingworth's or Balston's Whatman paper ebbed and flowed throughout the fifty years that the two companies were producing fine handmade watercolour papers. Eventually Thomas and John Hollingworth decided to move entirely into production by machine and in 1859 relinquished all rights to the Whatman name to the Balstons, preferring to concentrate on producing the finest writing, ledger and printing papers. However, it was not long before they began to produce drawing papers by machine as well: in 1862 they are described as 'makers of Superfine Drawing, Ledger and Writing Papers, Machine made'.[1]

1 Kent's *Directory of Paper Makers*, 1862.

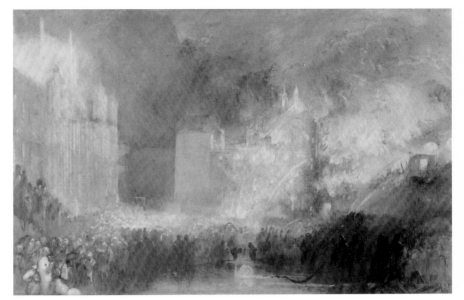

28

28 Burning of the Houses of Parliament 1834

302×444 ($11^7/_8 \times 17^1/_2$)

White wove watercolour paper
No watermark
Unknown maker, probably William Balston

Watercolour

TB CCCLXIV 373
D36235

28A Micrograph of the paint layers and texture of the sheet at × 15 magnification.

Turner's depictions of the burning of the Houses of Parliament can be found in two sketchbooks, two loose sheets and two large oils. The smaller of the two sketchbooks (TB CCLXXXIV) contains only a few brief pencil sketches, made on the spot as the fire raged. Despite the energy and drama of the works in the larger sketchbook, TB CCLXXXIII, there has been some doubt expressed as to whether Turner actually used it on the river itself.

This large work is at one and the same time a distillation and dramatisation of a scene 'most splendid' and 'of the most terrific grandeur'.[1] Although this work was executed in the studio, that fact that Turner was at the scene at the time of the fire is attested to by Waller's description: 'some of the students [from the RA schools] who were on the river were in the same boat as Turner and Stanfield, indeed it must have been a magnificent study for them.'[2]

1 Extract from the shorthand diary of John Green Waller, transcribed by William J. Carlton, London University Library, Carlton College MS 317 ff.54 et seq.
2 Ibid.

28A

29 Trento Cathedral 1833
From the *Venice up to Trento* sketchbook

Olive-green paste-paper covered boards, with green ties and pockets inside both covers
203 × 120 × 23 (8 × 4³/₄ × ⁷/₈)
Page size: 203 × 108 (8 × 4¹/₄)

This sketchbook contains two different papers:

Paper 1:
Lilac-red double-faced laid paper, used as endpaper.
Chain lines: 32 mm (1¹/₄ inches) apart
Laid lines: 6 per cm (15 per inch)
Watermark: P G
Maker: Pietro Galvani
Mill: Pordenone, Fruili-Venezia-Giulia, Italy

Paper 2:
White laid double-faced paper
Chain lines: approx. 29–30 mm (1³/₁₆ inches) apart, variable
Laid lines: 8–9 per cm (20–24 per inch) variable
Watermark: Crescent moon with a face in profile
Countermark: C G
Maker: Cartiera Galvani
Mill: Pordenone, Fruili-Venezia-Giulia, Italy

Pencil

TB CCCXII 77
D31746

29A Transmitted light image of the P G watermark in the endpaper.

29B Composite transmitted light image of the watermark and countermark in the white paper. Taken from TB CCCXII 34, 35, 71, 72.

29C Micrograph of the fibres in the endpapers at × 30 magnification. *Illustrated on page 71*

29D Micrograph of the graphite and paper surface in TB CCCXII 77 at × 30 magnification.

I have described the endpapers in this book as lilac-red, because originally their colour would have been more blue than we see now. Such 'red' papers were not particularly common and were not easy to make. The size, make-up and papers used in this sketchbook show that it comes from the same binder as the *Venice* sketchbook (TB CCCXIV), which also con-

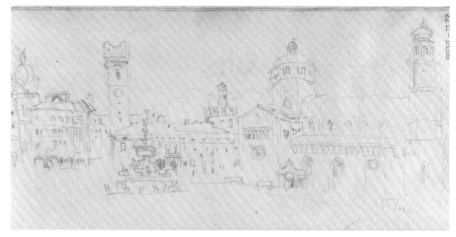

29

29B

29A

29D

tains the same lilac-red laid paper used as endpapers. The endpaper in TB CCCXIV carries the other part of the P G watermark seen in this book: a crowned double-headed eagle bearing a shield on its breast with the letters F I.

Both sketchbooks could have been bought almost anywhere in northern Italy or those parts of the Austro-Hungarian Empire close to Venice. Galvani was an old-established Lombardy papermaking business which had specialised in sending a large part of their output to the Islamic world, but their papers were well respected throughout Italy.[1] Given the subject matter of the two sketchbooks they are most likely to have been bought in Venice.

1 Galvani papers were still available in the near east in the early years of this century: late nineteenth-century Galvani papers were purchased in Cairo before the First World War by the artist James McBey. See Cohen 1981, watermark 37.

30 Strong Sky over a Valley with a River *c.*1835

178 × 227 (7 × 8⅞)

Off-white machine-made cartridge paper
No watermark
Unknown maker

Watercolour

TB CCLXXX 65
D27582

30A Micrograph of the surface of the sheet at × 20 magnification.

30

The group of works catalogued by Finberg as *Studies for Vignettes* contains several groups of works executed on the same papers. This study for an unidentified vignette is typical of a relatively large group that has been produced on a low grade machine-made paper.[1] Turner had generally avoided machine-made papers but as the quality improved we start to find examples in the Bequest. See for example cat.no.41, for a different, much better quality, machine-made paper, where Turner has used watercolour as well as crayon and pencil.

All the sheets in this group have been worked on the felt side of the paper. The felt side has slightly more 'tooth' or 'nap' than the wire side, allowing better adhesion of both pigment and graphite to the surface of the sheet.

Finberg has the following note:

The following 32 studies were contained in a parcel endorsed by Mr Ruskin – 'AB 40 PO Vignette Beginnings, once on a roll. Worthless.'[2]

This relatively low-grade paper is unlikely ever to have been part of a roll sketchbook as many have thought. It has come from a roll of machine-made drawing paper which could be bought from colourmen, cut to any length that might be required.

It is difficult to be certain about the exact date when such continuous drawing papers first came on the market. By *c.*1840 Winsor & Newton were selling cheap machine papers for drawing, but they may well have been available earlier. The Winsor & Newton product was described as

COLOSSAL DRAWING CARTRIDGE PAPER. This paper is 4ft 6ins wide, and of any required continuous length, being the Largest Drawing Cartridge ever made; it bears the action of India rubber well, and is admirably adapted for Cartoons, Engineering plans, Designs or Large Watercolours.[3]

Machine-made papers were not watermarked at this date. Watermarking of such paper did not come into general usage until well after the development of the Dandy Roll in 1825–30 by the paper engineers, T. & J. Marshall of Stoke Newington, working with the patent holders, John and Christopher Phipps.[4] Despite attempts by many different papermakers and engineers it was not until 1839 that William Joynson of St Mary Cray Mill, Kent, perfected a method of watermarking machine-made paper using a Dandy Roll. On the Continent however, Ferdinand Leistenschneider successfully produced some watermarked machine papers as early as 1813. These sheets were watermarked with a portrait head of Napoleon with the words NAPOLEON EMPEREUR ET ROI and countermarked with the Imperial Eagle. Along the bottom of the sheet Leistenschneider added the watermark: PAPIER DE MECHANIQUE FAIT PAR FERDINAND EN 1813.[5]

The *Studies for Vignettes* have mostly been executed on handmade 'London', 'Bristol' or Drawing boards but the group does contain some further machine-made papers, including another slightly inferior, and probably cheaper, grade of machine-made cartridge paper, used in TB CCLXXX 39 and 71–76. Again, all these sheets have been worked on the felt side of the paper. TB CCLXXX 19,

Tower on Hill: Moonlight, is on an unwatermarked cream wove drawing paper from an unknown maker, possibly John Dickinson at Apsley Mill, Hertfordshire. Details of the deckle edge still visible on part of this sheet show the characteristic evenness of a cylinder mould deckle, rather than that seen in handmade papers.

1 Comprising TB CCLXXX 2 and TB CCLXXX 40–70.
2 Finberg 1909, p.894.
3 1840 Winsor & Newton *Trade Catalogue*, Winsor & Newton Archives, London.
4 See TB CX and TB CCX for papers made by Phipps at Crabble Mill, Kent, and used by Turner.
5 Such a sheet is illustrated in André 1991, p.90.

30A

31 Two rough sketches of Copenhagen from the Sound, one showing the Tower of the Church of the Redeemer 1835
From the *Hamburg and Copenhagen* sketchbook

Pocket book, bound in dark plum boards with views of Bad Ems on the Lahn and Bingen on the Rhine

Page size: 151 × 95 (6^{1}/$_{16}$ × 3^{13}/$_{16}$)

This sketchbook contains two or possibly three different papers:

Paper 1:
Corrected white laid writing made on a double-faced mould
Chain lines: 28–9 mm (1^{1}/$_{8}$ in) apart, variable
Laid lines: 10 per cm (25 per inch)
Watermarked: Orb ornamented with laurel leaves / JORDAN
Made by: Jordan
Mill: Either Hasserode Mill or Ilsenberg Mill, Magdeburg, Germany[1]

Paper 2:
Corrected white laid writing made on a double-faced mould
Chain lines: 27–9 mm (1^{1}/$_{8}$ in) apart, variable
Laid lines: 9–10 per cm (23–5 per inch)
Watermarked: Portrait head of Frederick William III in a patterned oval / FR. WI. DIII
Made by: Jordan
Mill: Either Hasserode Mill or Ilsenberg Mill, Magdeburg, Germany[2]

Paper 3:
Highly glazed white wove hand-coated card
Unknown maker

Pencil

TB CCCV 3 V, TB CCCV 4
D30827, D30828

31A Composite watermark of Paper 1 in transmitted light. Taken from TB CCCV 2, 3, 9, 13. The counter-mark taken from TB CCCV 18.

31B Composite watermark of Paper 2 in transmitted light. Taken from TB CCCV 27, 28, 29, 30

31C Micrograph of the surface of Paper 1 in raking light. Taken from TB CCCV 3 verso at × 20 magnification.

31

31A

31D Micrograph of the surface of Paper 3 in raking light showing impressed laid line texture and air bubbles in the surface of the coating. Taken from TB CCCV 4 recto at × 20 magnification.

These two brief sketches of Copenhagen straddle the two distinctly different papers that make up this sketchbook, and show the behaviour of graphite on different surfaces: the coated paper produces a harder, crisper line than the more diffuse,

broader marks seen on the laid writing paper.

This sketchbook is the first of a group of five used by Turner on his 1835 tour of Germany, a tour which also included time in Denmark, Prague and Saxon Switzerland, and it was probably purchased on Turner's arrival in Hamburg at the beginning of September 1835. Despite the presence of watermarks in all but one of these sketchbooks, the *Hamburg and Copenhagen* sketchbook shown here is the only one where the maker and mill that produced the paper can be identified with any certainty. What can be said, however, is that many of the characteristics of the different papers and the various binding styles show them all to be of continental origin, purchased at different points in his journey.

The four other sketchbooks, in order of use as listed by Powell, are as follows:[3]

TB CCCVII, *Copenhagen to Dresden*, watermarked with a beehive surrounded by garlands and bees + Double X mark / CFW&S. A German copy, by an unidentified maker, of a Dutch watermark used by Cornelis Honig.

TB CCCVI, *Dresden and Saxon Switzerland*, unwatermarked. Unidentified maker.

TB CCCI, *Dresden, Teplitz and Prague*, watermarked CFAF. As yet unidentified maker.

TB CCCIV, *Prague, Nuremberg, Frankfurt and Rhine*, watermarked with the Lion of the Seven Provinces / JH&Z + JAN HONIG & ZONEN. Details of the mould construction, when compared with known Jan Honig and Zonen papers from the 1820s onwards show this paper was unlikely to have been produced by the Dutch paper-maker Jan Honig. There had long been a tradition of forging foreign papermakers' watermarks, including Dutch and English makers in the Austrian possessions (see cat.no.35).[4]

Although the laid and chain line measurements vary slightly for the two corrected white papers listed above, the blue toning, which may well have been added after production, and the presence of similar quantities and distribution of specks and shives in the sheet suggest a similar origin for these two papers. The variations may well be the result of two versions of a basic watermark design on two pairs of moulds, with slightly different wire profile measurements, being

31B

31C

31D

used at more than one vat. It is also possible that the moulds in use were each designed for making two sheets rather than one.

The style of watermarking seen here originated in French paper mills during the first Empire: many examples exist with a more or less ornamented portrait of Napoleon centred in one half of the sheet and an imperial eagle centred in the other. During the period of French control of parts of Holland, the Rhineland and southern Germany this watermark style was copied by German papermakers, who, after the departure of Napoleon began to introduce similar portrait marks of their rulers.[5] Marks typical of south German production with similar ornamented medallions can be found well into the 1840s.[6] From the south the style spread throughout Germany.

This sketchbook also contains a very highly calendered hand-coated card. It would appear from close examination of the surface of this sheet that the laid line texture visible was applied after the sheet was made, as the heavyweight paper used as the base for the coating is in fact wove. The very chalky surface, perhaps mixed with starch or gelatine was also applied after the paper was made. Hand-

coated papers have a long history; many of the earliest examples are found in the Islamic world, from Persia and Turkey and make their first appearance in Europe in Italy as early as the fourteenth century.

So-called 'velvet' papers with a white foundation, specifically intended to be used for drawing, were already known in Germany between 1480 and 1500, where they were used by many artists including Hans Holbein the elder.[7] Coated papers of the type seen here, first make an appearance in the late eighteenth century, but the use of an isolated sheet in a book is relatively unusual at the date of this sketchbook.[8]

A description of hand coating from 1843 describes the paper as being made by

brushing on to ordinary stock a mixture consisting mainly of china clay and colouring matter [absent in the sheet in this sketchbook]. First the coating was laid on by hand with a laying-on brush, (similar to a very delicate distemper brush). Next it had to be smoothed with a clearing brush (made from pure badger hair rather like a large shaving brush, nine inches across). This brush was worked across each section of the sheet in turn with a rotary action of the wrist, the hairs just kissing the surface of the sheet and not pressing on it at any point. In the hands of a skilled craftsman this produced a sheet with a perfectly even finish.[9]

Paper mills in south Germany and Austria produced a considerable range of decorated paste papers at this date, many of which experimented with very different pigments: chalk, clay, coloured earths and pigments, mixed with starch or gelatine, as well as flour and water based pastes. These papers are usually coloured and patterned using combs, brushes, rags and fingers. Several examples can be seen in the Turner Bequest, as the covers of sketchbooks of continental manufacture.

1 It is not known which mill produced this paper. Both Hasserode and Ilsenberg are listed, under the Jordan name, by Barbara Wenig in 'Die Historische Wasserzeichensammlung in der Stiftung Zanders', *Papiergeschichte(n)*, Wiesbaden 1996, p.174. A Maria Barbara Jordan is also mentioned in Schmidt 1994, p.664.
2 See n.1 above.

3 Powell 1995, pp.231–40.
4 Eineder 1960, p.169, describes the beginnings of this tradition in the Italian possessions of the Austrian Empire, with the forgery of Dirk and Cornelis Blaauw's papers by Valentino Galvani of Pordenone in the 1760s.
5 The most common forms of these Napoleonic marks consist of simple wiremarks: a circled eagle with the words EMPIRE FRANCAIS and a date, most commonly 1811, in one half of the sheet accompanied by a circled portrait of Napoleon and the legend NAPOLEON EMPEREUR DES FRANCAIS ROI D'ITALIE. The Arches, Montgolfier and Johannot mills in France were still producing versions in the 1820s particularly for Charles X.
6 E.g. Bower Collection 9225AF: Circled sceptre and sword crossed / FUR GOTT UND FADERLAND accompanied by a crowned and laurelled portrait medallion of Ludwig of Bavaria / LUDWIG KOENIG VON BAIERN and the maker's name ROEDTER. The same maker also produced a similar portrait watermark for MAX IOSEPH KOENIG VON BAIERN (Bower 9227AF).
7 Judith Stanley, Derek Priest and A.E. Macdonald, 'The Deterioration and Conservation of Coated Papers', *The Edinburgh Papers*, SBPH, vol.IV, in preparation.
8 Such 'art' papers are common from the late nineteenth century onwards in books.
9 See 'Hand Coating at Home Park Mill, Hertfordshire', *The Quarterly*, no.20, Oct. 1996, p.17.

32 Paper Sample 99, made from wheat straw and linen 1838
From Ludwig Piette, *Die Fabrikation des Papiers aus Stroh und vielen andern Substanzen in Grosen*, Verlag von Dümont-Schauberg, Cologne 1838

Private Collection of Professor Nicholas Wiseman, UMIST Department of Paper Science

Illustrated on page 68

32A Transmitted light image showing details of the mould used to form the sample.

32B Micrograph of the surface of the sample, at × 20 magnification showing both the surface texture and the fibres.

32C Micrograph of the surface of the page paper at × 20 magnification.

Throughout the eighteenth century one major problem faced all European papermakers: the need to find a consistent supply, both in terms of quantity and quality, of their basic raw material, rag. Since the 1760s various makers, such as Schäffer[1] in Germany and Koops[2] in London, had experimented with new

materials to solve this problem, one exacerbated by the increasing demand for paper and the rapid rise in the number of mills operating. The basic fibres needed – linen, hemp and the more recently introduced cotton – were becoming more and more difficult to obtain.[3] Several makers were experimenting with the use of other fibres, including straw, either on their own or mixed with rag, as the basis for a range of papers.

This extraordinary book has recently come to light, and is as far as known the only surviving copy. It documents the researches of Ludwig Piette de Rivage, papermaker of Dillingen in the Saarland, into the use of straw and other alternatives to rag. Dillingen is some twenty-five miles south of Trier and not far from the route of Turner's 1839 tour. Indeed some of the samples in this book bear considerable similarities to the papers found in TB CCXC, the *Trèves to Cochem and Coblenz to Mayence* sketchbook (see cat.no.33) used on that tour and Turner may well have acquired the TB CCXC sketchbook at some point along the Meuse or Mosel.

Although the details of this wheat paper sample are not quite the same as those found in TB CCXC, there are sufficient similarities between the moulds used for some other samples and those used for the sketchbook paper for one to assume a common origin for the two papers. No one else was experimenting with the production of fine papers based on various straw fibres in the 1830s. Most such experiments were producing rough straw-coloured sheets similar to the pages the sample has been stuck down on. These facts and the closeness of the Dillingen mill to the route of Turner's travels in 1839 all point to Piette being the maker of the TB CCXC paper.

Piette's *The Manufacture of Paper from Straw and Many Other Materials in Bulk*, was not his first published work. An earlier work had appeared in 1834: *Handbuch der Papierfabrikation* was published in German, translated from Piette's original French text by Dr Carl Freidrich Alexander Hartmann.[4] Hartmann's preface to this book describes Piette as being a Frenchman by birth who had begun his working life as a lawyer, but was later forced to abandon his career and to become head of the papermill at Dillingen. In trying to inform himself of the papermaking process he had found very little suitable published material so had

set to work to write such a manual himself. Piette had come to Dillingen from Luxembourg in 1819 and operated the mill until 1854 when he moved to Belgium. The mill itself ceased to exist in 1860, although some ruins remain.[5]

Although the title page of this book reads as follows:

> The Manufacture of Paper from Straw and Many other Materials in Bulk, described according to many trials and illustrated with 160 samples of various paper qualities, containing a description of the newest invention in Paper Manufacture for Manufacturers and all Friends of Progress in Culture and Industry.

this particular copy actually contains 185 samples, made from a wide range of materials, either alone or in combination. These include straw from rye (Piette's preferred choice), wheat, barley, oats and maize; stems from peas, beans and lentils; reeds; hay; grass; rushes; nettles; thistles; broom; hemp; and bark from acacia, lime and elm. He goes into considerable detail about straw, describing the many different types, the manner of pre-treatment, methods of bleaching, and making paper from different mixtures of straw and rags. The samples themselves are remarkably well preserved and show the various cereal straws to advantage. Examination of the various samples in transmitted light show that several different laid and wove moulds were used to form the sheets.

In his introduction Piette describes his researches as 'tiresome and time consuming but finally successful trials' and states that it is

> our wish that enterprising manufacturers check them and use them according to their own ideas and local circumstances … The progress of civilisation forces us to do everything to avoid obstacles due to the imminent shortage of paper-making raw materials and, at a moderate price, to put into the hands of the poor also this indispensible material for all cultural developments in art and sciences.[6]

Piette's researches proved prophetic. By the 1860s various straws and grasses were in common use in European papermaking, with Esparto grass proving more popular in Britain and straws on the Continent.

32A

32B

32C

1 Paper made from straw with small amounts of linen can be found in vol.II of Jacob Christian Schäffer, *Vesuche und Muster Ohne alle Lumpen oder mit eiem geringen Zusatze derselben Papier zu machen*, Regensburg, 1765–1771.

2 Some copies of Matthias Koops, *Historical Account of the Substances which Have Been Used to Describe Events and Convey Ideas from the Earliest Date to the Introduction of Paper*, London 1800, were printed on straw paper.

3 For further discussion of straw as a papermaking raw material see Richard L. Hills, 'The Use of Straw in Papermaking', Peter Bower, 'Straw in 19th Century Papermaking', and James Brander, 'Straw', all in *The Oxford Papers*, SBPH, vol.I, London 1996, pp.9–13, 15–22 and 35–42 respectively.

4 Ludwig Piette, *Handbuch der Papierfabrikation*, published by Von Gottfried Basse, Leipzig, 1833. Translated from the original French by Dr Carl Freidrich Alexander Hartmann.

5 Piette's biographical details are taken from two sources: G. Ullmann and P. Bean of the East Lancashire Paper Mill, Ratcliffe, Lancashire, 'Early Efforts in Papermaking from Straw', unpublished typescript, 1951 and an unpublished letter dated 14 February 1951 to G. Ullmann from the librarian of the Institute of Paper Chemistry, Appleton, Wisconsin.

6 Translation by G. Ullmann, Ullmann and Bean 1951, p.8.

33 Several sketches of Trarbach and the Grevenburg 1839
From the *Trèves to Cochem and Coblenz to Mayence* sketchbook

Quarterbound marbled boards with leather spine
$166 \times 112 \times 15$ ($6^{1}/_{2} \times 4 \times {}^{5}/_{8}$)
Page size: 103×100 ($6^{3}/_{8} \times 3^{15}/_{16}$)
Flecked off-white wove
Double-faced mould
Formation: fair, very strong, some 'tears'
No watermark present[1]
Made by: Ludwig Piette
Mill: Dillingen Mill, Saarland, Germany

Worked in pencil on both surfaces

TB CCXC 21V, TB CCXC 22
D28392, D28393

33A Micrograph of the surface of the sheet showing the graphite at \times 20 magnification.

33B Transmitted light image showing the mould construction.

Turner used five sketchbooks, all of a very similar size, on his 1839 tour of the Meuse and Mosel, of which one at least, the *First Mosel and Oxford*, containing white wove drawing paper, he had brought with him from England.[2] The other four are all of continental manufacture, three of them containing writing paper rather than drawing paper.[3]

This sketchbook, which is no longer in its original order, has been made up using a paper that contains straw. Shortages in raw materials had led several makers to experiment with the use of other fibres, including straw, either on their own or mixed with rag, as the basis for a range of papers. The paper in this sketchbook bears considerable similarities with some of the samples seen in Ludwig Piette's extraordinary *The Manufacture of Paper from Straw and Many Other*

Materials in Bulk, published in Cologne in 1838 (see cat.no.32)[4]. Piette's mill was at Dillingen in the Saarland, some twenty-five miles south of Trier and not far from the route of Turner's 1839 tour.

Although the details of this wheat paper sample are not quite the same as those found in Piette's samples, there are sufficient similarities between the moulds used for some of the samples and those used for the sketchbook paper for one to assume a common origin for the two papers. No one else was experimenting with the production of fine papers based on various straw fibres in the 1830s. Most such experiments were producing rough straw-coloured sheets similar to the pages the sample has been stuck down on. These facts and the closeness of the Dillingen mill to the route of Turner's travels in 1839 all point to Piette being the maker of the paper in this sketchbook.

As can be seen from those pages, some of these straw-based papers produced a very suitable drawing paper. This sketchbook contains several drawings of the Trarbach area where Turner may well have acquired the rich blue Bocking paper that he also used on this tour (see cat.no.55).[5]

1 Although possible traces of unidentified parts of two different watermarks can be found in some sheets.

2 TB CCLXXXIX, *First Mosel and Oxford*, white wove drawing paper, watermarked J WHATMAN / TURKEY MILL / 1834. Made by the Hollingworths at Turkey Mill, Maidstone, Kent.

3 (a) TB CCLXXXVII, *Spa Dinant and Namur*. Quarterbound marbled boards with vellum spine. White wove writing paper, watermarked JOHN FELLOWS / 1810, with some pages having an additional small single wire letter R. Made by John Fellows at Eynsford Mill, Eynsford, Kent. The lettering design of this watermark is slightly old-fashioned for 1810. This sketchbook also bears a label reading: P J HEYVAERT PAUWELS / Imprimeur, Papetier / Rue de la Madleine, Sect 7, No 445 / A BRUXELLES / Tient magasin de BRONZES, showing that it was bought in Brussels. It is unusual to find a sketchbook or notebook being used nearly thirty years after the paper was made.

(b) TB CCLXXXVIII, *Givet, Mezieres, Verdun, Metz, Luxembourg and Trèves*. Quarterbound marbled boards with leather spine and wallet. Cream laid writing paper, watermarked Pro Patria with a G rather than a Gate. Probably of Dutch manufacture.

(c) TB CCXCI, *Cochem to Coblenz* (see cat.no.34)

4 Piette 1838.

5 TB CCXC 9v, 20v, 21r, 21v, 22r, 22v, 23r, 25r, 25v–26r, 26v.

33

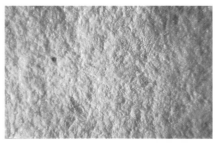

33A

33B

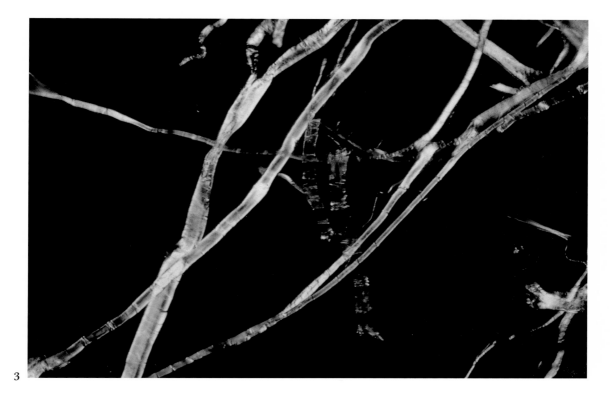

3

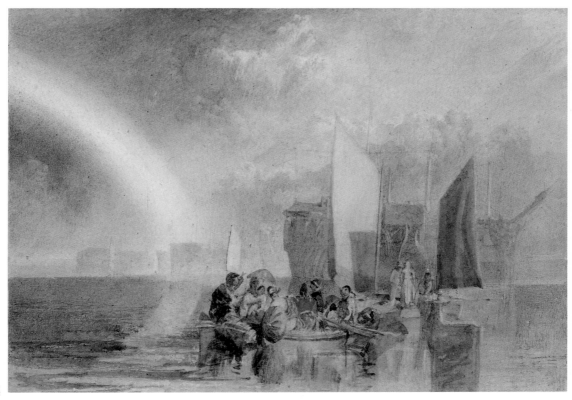

14

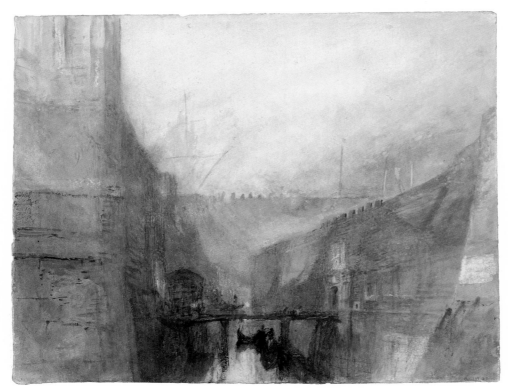

36

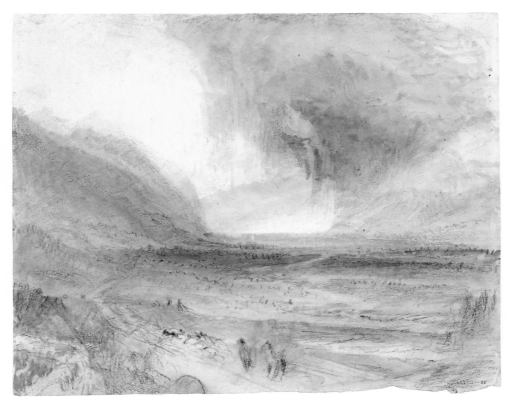

41

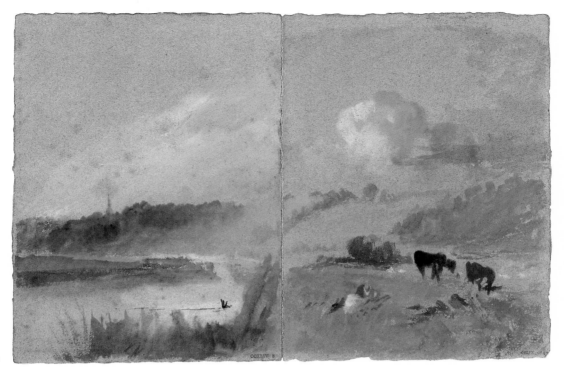

50

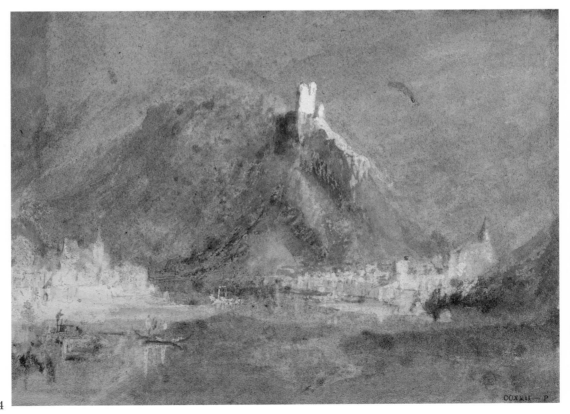

54

55

32

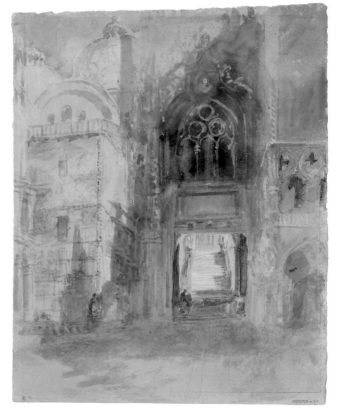

63

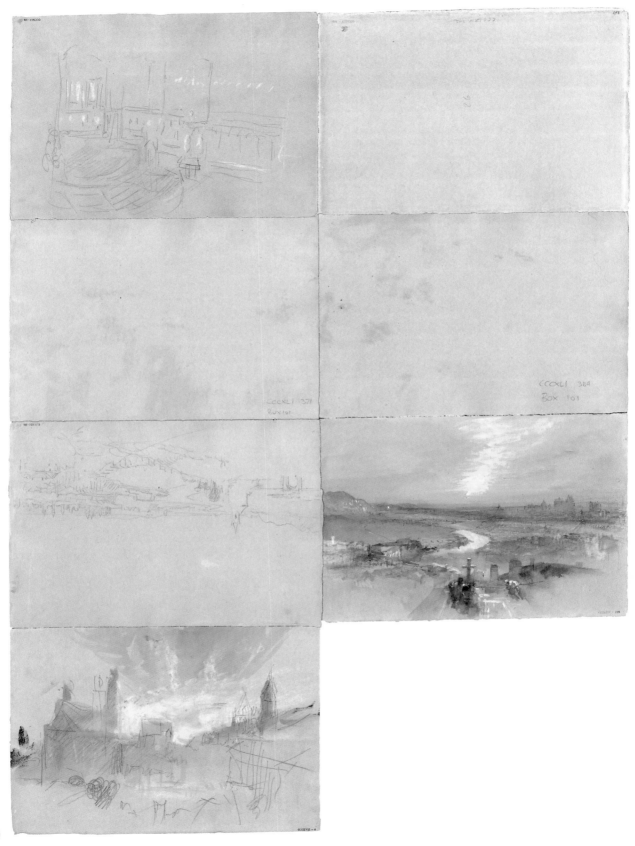

59

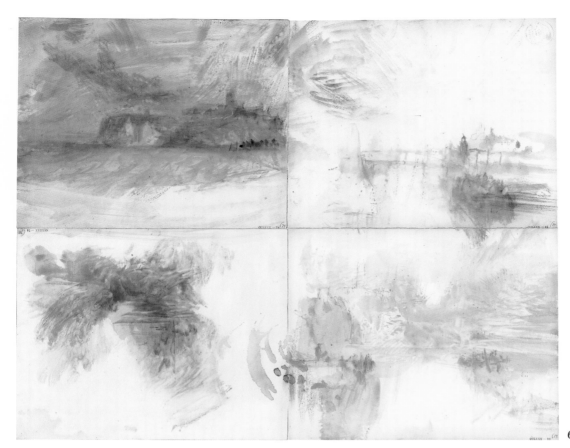

68

80

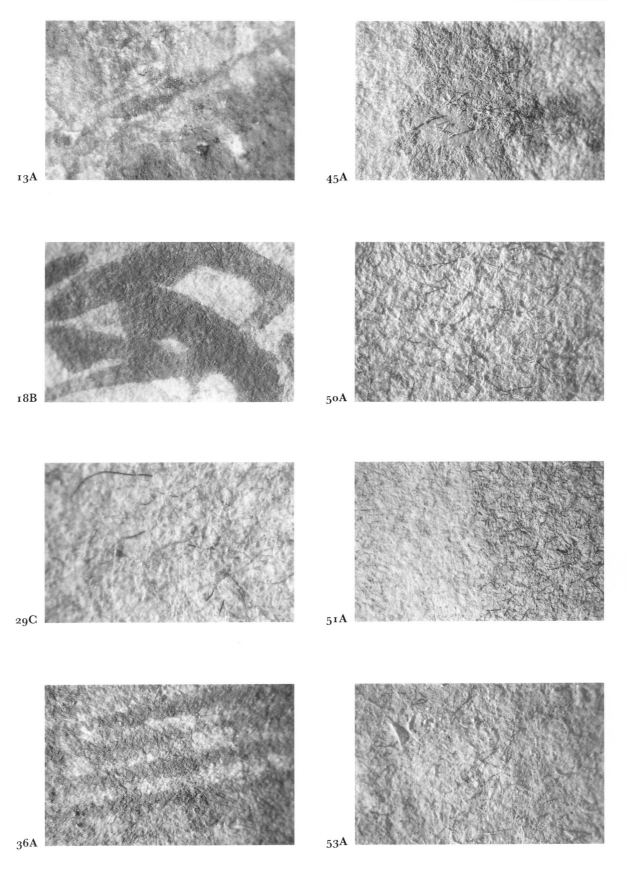

13A

45A

18B

50A

29C

51A

36A

53A

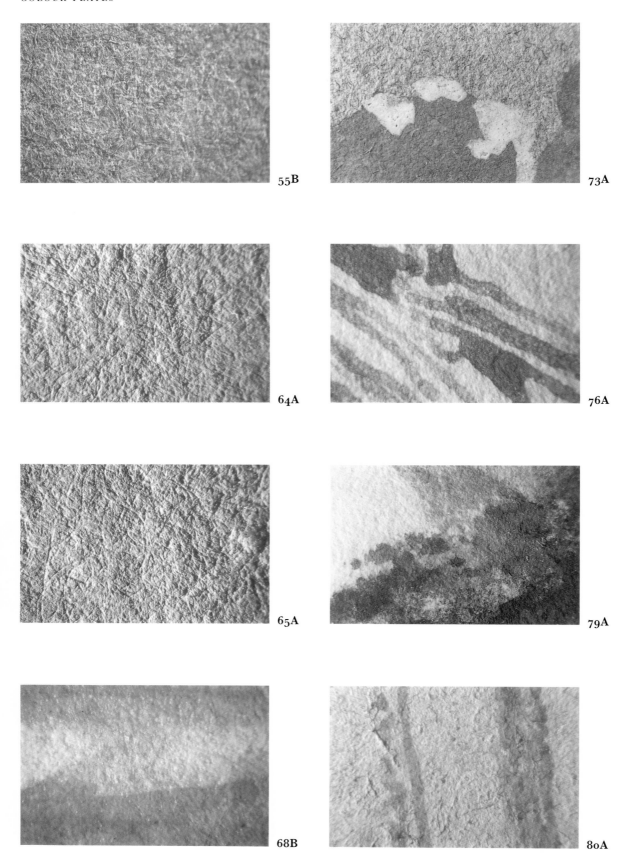

55B

73A

64A

76A

65A

79A

68B

80A

34

34A

34 Burg Treis 1839
From the *Cochem to Coblenz and Home* sketchbook

Quarterbound marbled boards with brown leather spine
161 × 106 × 10 (6⁵/₁₆ × 4³/₁₆ × ³/₈)
Page size: 158 × 100 (6³/₁₆ × 3¹⁵/₁₆)
Cream laid writing paper made on a double-faced mould
Chain lines: 25–6 mm (1–1¹/₁₆ inches) apart
Laid lines: 9 per cm (24 per inch)
Watermark: French imperial eagle with N on his breast
Countermark: V D MEULEN / & COMP.
Unidentified mill and maker
Pencil

TB CCXCI 10
D28884

34A Transmitted light image of the composite watermark from TB CCXCI 1, 2, 6, 8.

34B Transmitted light image of the composite countermark from TB CCXCI 4, 5, 10, 11.

34C Micrograph of surface at × 7 magnification.

It has not yet proved possible to identify which mill van der Meulen & Company were operating when this paper was produced. The paper may well have been made some years before Turner used it. Another of the sketchbooks used on this 1839 tour, *Spa Dinant and Namur* (TB CCLXXXVI 1), contains a white wove writing paper, watermarked JOHN FELLOWS / 1810 and made at Eynsford Mill, Eynsford, Kent, which was nearly thirty years old when Turner used it. A label inside the sketchbook shows that Turner purchased it in Brussels from the printer and stationer P.J. Heyvaert Pauwels.

The paper in this sketchbook may well be of Dutch, Belgian or even German origin. The imperial eagle watermark appears to be a version of the Napoleonic imperial eagle; carrying a sword and a sceptre and surmounted by a crown, it has a capital N on its breast. Parts of the low countries were an 'Independent' Republic after 'liberation' by French Republican armies and several Dutch mills made various 'Napoleonic' papers until 1815. However, the binding style is more like that seen in the Rhineland and

southern Germany and the small butterfly-shaped paper label on the cover is very typical of those found on ledgers and notebooks used for the annual Births, Marriages and Deaths Registers held by each small town in the Rhineland during this period.

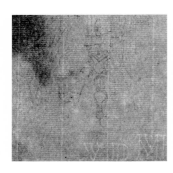

34B

34C

35 Two views of Trieste 1840
From the *Trieste, Graz and Danube* sketchbook 1840

Buff wove paper-covered boards
203 × 136 × 12 (8 × 5³/₁₀ × ½)
Page size: 198 × 127 (7¹³/₁₆ × 5)
Cream double-faced wove paper
Watermarked: J. WHATMAN
Unknown maker

Pencil

TB CCXCIX 57 V, TB CCXCIX 58
D30110, D30111

35A Raking light micrograph of felt texture and fibre surface of TB CCXCIX 57 verso at × 7 magnification.

35B Transmitted light image of watermark, also showing the regular mottling. Taken from TB CCXCIX 6, 7.

This sketchbook is one of a group of three sketchbooks, the others being *Passau to Wurzburg* (TB CCCX) and *Venice and Botsen* (TB CCCXIII), which Turner bought in Austria on his way to Venice in August 1840.[1] Although the watermark in all three sketchbooks reads J WHATMAN and the paper is all from the same batch, these sheets were not made by either William Balston or the Hollingworths, both of whom had the rights to the Whatman name. In fact the papers are not of English manufacture at all.

Western European papermakers have always used and appropriated each other's marks. Sometimes this was through the sub-contracting of particular orders, where the moulds themselves would be lent to the other mill, for example in the late nineteenth century when J. Green & Son made some Whatman papers for the Balstons.[2] But on other occasions makers stole another maker's mark because that mark had come to signify quality.[3] A very complex result of this is the plethora of marks in forged Whatman paper made on the Continent in the first half of the nineteenth century.

During his travels searching for watermarks, the late E.G. Loeber realised from the different shapes in the letters and other details that some of the papers with Whatman watermarks were not made by W.R. Balston at Springfield Mill, Maidstone, but were manufactured on the Continent with forged marks.[4] All the forgeries found so far are in wove rather

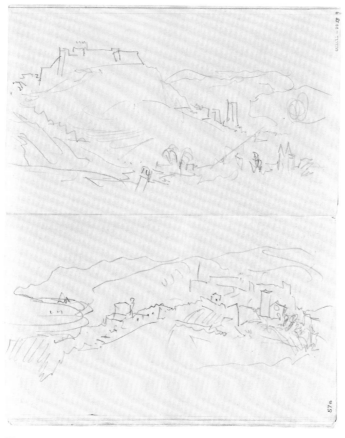

35

35A

35B

than laid papers. Loeber's collection of forged Whatman marks all appear to be from documents found on the Continent, but as we can see from these Turner sketchbooks some of these papers can be seen in England.

These fake Whatman papers were produced in France, Germany and Austria during the early part of the nineteenth century. The reasons for such production were different in each country. In France, for example, it was essentially a question of cashing in on the name and reputation of Whatman,[5] whereas in Austria such 'foreign' papers were deliberately manufactured 'in order to render the Country independent of the seemingly indispensable foreign types and qualities'.[6]

Austrian manufacture of such papers was based at three mills. Gabriel Ettel ran the Pelsdorf Mill on the Elbe, Bohemia, which in 1817 was producing the finest 'foreign' papers and 'Whatman' wove.[7] The Ettel family also operated the Hohenelbe Mill on the same river. Gabriel Ettel ran the mills from 1786 until 1830, when he was succeeded by Johann Gabriel Ettel. At this date the mills employed eighty people producing 1,150 bales (11,500 reams) annually.

Peter Weiss produced fake Whatman at the Scurelle Mill, Val Sugana in the Torrente Maso, Southern Tyrol, from 1826 onwards. The business transferred from father to son (of the same name) in th e 1830s and continued to be operated by the Weiss family until 1917.[8]

The third mill was the Klein Neusiedl mill on the river Fischa in lower Austria. In 1793 I. Th. von Pachner had founded the largest handmade paper factory in Austria, devoted to making 'foreign' papers.[9] From 1815 onwards von Pachner was producing banknote, security and other papers which his contemporaries thought were in no way inferior to the famous English Whatman papers. This may well have seemed to be the case at the time, but time has not dealt kindly with some of the Austrian Whatman forgeries, many of which are now somewhat yellowed and brittle. Pachner died in 1814, to be succeeded by his son Anton, who worked the mill until 1837 when it was bought up by Georg Borkenstein. By 1840 the mill operated four vats and three machines and employed some 380 people including rag pickers. It has

not proved possible, so far, to determine which of these three mills made this paper, but as further examples of these forgeries come to light this may yet be resolved.[10]

The detection of these forgeries is not just a question of studying the water-marks; it also involves the examination of the fibres, sizing and finishing techniques used, as well as the actual paper sizes found. Some of the forgeries are conti-nental, rather than English, paper sizes. It is also possible that some of these fakes were made in Germany. In one especially crude example, the W in particular is very similar in style to marks from Roedter and Gossler, who each operated a small mill at Neustadt and Frankeneck in the Rhineland.[11]

It must be said that none of the Austri-an 'Whatman' papers that I have seen, could, in their present state, be mistaken for the genuine article. The weave tex-tures of the felts are generally more regu-larly marked than in Whatman paper and, where the sheets have been hot pressed, the felt weave is still very visible, despite the glazing. In transmitted light a curious regular criss-cross pattern of diff-erent densities of pulp is very apparent, which can also be seen in the pages of this sketchbook. They are also usually of a deep cream to light buff colour, quite unlike any of the white or toned What-man papers made by either William Bal-ston or the Hollingworths, although judging by the comments above, they may well have looked better when they were first made. The tones of the Austri-an 'Whatman' papers used by Turner do, however, approximate to some of the fine artists' papers produced by Thomas Creswick, which Turner occasionally used himself and which were also used to great effect by De Wint and others, and this similarity may well be what attracted Turner to them.[12]

1 Powell 1995, p.143.
2 On a recent exploration of part of the Paper Collections at Hayle Mill, Kent, one of eleven large cardboard boxes each labelled 'Old Paper, mostly working samples' was sampled. This box contained twenty-two packages, each tied up with string, which judging by the ties and the dust had not been opened since they were put aside in the 1880s. Two of the packages were opened and examined and one labelled 'Sundry Sheets 1887', which contained seventeen differ-ent sheets of paper, each folded into eight and annotated, included an example of a 'Corrected White' (blue) laid Demy sheet watermarked with a fleur-de-lys and the Whatman cypher and countermarked J WHATMAN / 1887. It was annotated 'J Barcham Green & Son'.
3 See Bower 1995, pp.66–7, where the origins of two separate sets of continental makers' initials found in an IV + fleur-de-lys / 4WR mark are discussed (illustrated on p.75).
4 For illustrations of some of Loeber's forged Whatman watermarks see Peter Bower and Richard Hills, 'British Watermarks: Forgeries of Whatman Watermarks', *The Quarterly*, no.17, Jan. 1996, pp.1–4. See also Balston 1992, II, pp.vi, vii. Plate 16 illustrates seven further marks from Loeber's collection, including (mark 7) a dark mark from a Hague document of 1835. Gravell and Miller 1983 illustrates a 'Whatman' mark with a subscript L that is also very suspect, no.769, date of document 1828.
5 Visiting the Canson Montgolfier mill, at Annon-ay in the Ardêche, I was surprised to see, hang-ing in a corridor outside one of the offices a mould of very obviously French construction, watermarked J WHATMAN / 1814. They also had another French-made mould, dating from the same period with a J Green watermark. The mill was quite open about having made 'What-man' paper in the early nineteenth century.
6 Eineder 1960, p.45.
7 Ibid., p.126.
8 Ibid., p.100.
9 Ibid., pp.45–6.
10 There are many examples recorded by Loeber dating from 1829 onwards and found in docu-ments in use in Naples, Amsterdam, Hanover, etc. Two marks of particular interest are another example of a J. WHATMAN watermark with the full stop found in documents dated between 1832 and 1836, from Gottingen, Loeber 23 KBH 2926 / FI 10038 and another watermark found in a document dated 1840, Dresden, which is similar to, but not quite the same as, the Austrian fakes used by Turner, Loeber DLA 171 / FO 2453 / FI 7861. This probably comes from the same source, but from a different mould.
11 Loeber DLA 158 / FO 2421 / FI 7853. Document dated 1839, Naples.
12 Some years after Creswick's retirement, on the urging of various artists' colourmen, the Bal-stons at Springfield began to produce a What-man 'Imitation Creswick'. By the 1860s they had dropped the word 'Imitation' and the paper was just known as 'Creswick'.

36 Venice: The Arsenal 1840

242 × 305 (9½ × 12)
Royal Quarto
White wove
No watermark
Unknown maker, probably Balston at Springfield Mill, Maidstone, Kent
Watercolour and bodycolour

TB CCCXVI 27
D32164
Illustrated on page 66

36A Micrograph of the surface and complex paint layers at × 15 magnification.
Illustrated on page 71

There are hundreds of works in the Turner Bequest for which no definite identification of origin can be given. But close examination of the fibres used, degree of beating, sizing and surface tex-tures can suggest probable origins. This sheet corresponds most closely with the Whatman papers made by William Bal-ston & Co. at Springfield Mill in the late 1830s.

By the 1820s the differences between many of the white and off-white water-colour papers being made by Ansell, Ruse & Turner, Bally, Ellen & Steart, Thomas Edmonds, Balston and the Hollingworths were becoming less imme-diately obvious and there are many examples of Turner using sheets from these makers almost interchangeably. There were still differences between the papers but many of these only became apparent during use. Sizing in particular was one area where the papers often var-ied and the Whatman papers made by Balston are consistently used by Turner for works of this nature where very heavy working and washing of the surface are required. The way the surface has responded to the demands made upon it, with no sign of breaking up, has allowed Turner to keep all his marks, whether made with a fine brush or washed in complex layers, well defined and quite distinct.

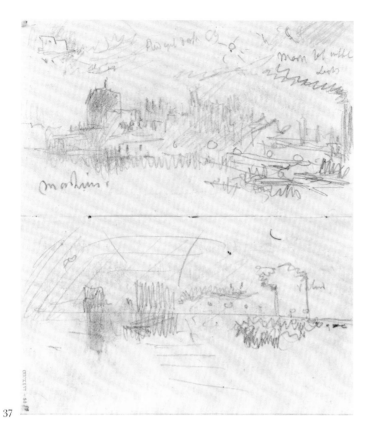

37

37A

37B

37C

37 Sunset at Mannheim 1841
From the *Berne, Heidelberg and Rhine* sketchbook

Paste-paper covered boards and flecked blue edge painting
185 × 118 × 15 (7¼ × 6⅝ × ⁹⁄₁₆)
Page size: 179 × 108 (7¹⁄₁₆ × 4¼)

This sketchbook contains two different papers:

Paper 1:
'Blue' corrected white double-faced wove writing paper
Watermark: J L BRISTLEN / A NYON in an ornamental cartouche surmounted by a shield and L P monogram
Unknown maker

Paper 2:
Pale buff wove
No watermark
Unknown maker

Pencil

TB CCCXXVI 49v, TB CCCXXVI 50
D32975, D32976

37A Transmitted light composite image of the watermark from TB CCCXXVI 6 and 8. The weave of the wire cloth on which the paper was formed can clearly be seen.

37B Raking light micrograph of the graphite and surface texture of Paper 1 at × 15 magnification.

37C Raking light micrograph of the graphite and surface texture of Paper 2 at × 15 magnification.

The watermark in most of the paper, pages 1–78, in this sketchbook is quite unusual: no papermaker called Bristlen has so far been identified and it may well be that the mark is that of a merchant or stationer rather than that of a papermaker. Nyon is on the shores of Lake Geneva, about twelve miles north of Geneva. If Bristlen was a merchant rather than a papermaker then the L P monogram is probably that of the papermaker. Analysis of the paper shows that there are sufficient similarities between this paper and those seen in cat.nos.32 and 33 to suggest the possibility that this is another paper from Ludwig Piette's mill at Dillingen.

Turner has hardly touched the second paper, pages 79–90, which is heavily flecked with specks, shives and process dirt. This paper, which has a proportion

of non-rag fibre in it and has probably discoloured slightly over time, is machine-made and may well be from the same source. The evidence of the papers seen in both cat.nos.32 and 33 show that Piette was working a paper machine as well as at least one vat.

38 View of a Town *c.*1841–2
From the *Rhine, Flushing and Lausanne* sketchbook

Marbled paper-covered boards with parchment spine
182 × 118 × 22 (7³/₁₆ × 4⁵/₈ × ⁷/₈)
Page size: 176 × 109 (6¹⁵/₁₆ × 3⁷/₈)
Lightweight 'blue' corrected white wove
Double-faced mould
Formation: good, very strong, some specks and shives
Watermark: Bell
Countermark: CHAPUIS / A LA BATIE
Made by: Chapuis Mill: Moulin de St Claude et Lessard, St Claude, Franche Comte, France

Pencil

TB CCCXXX 10V, TB CCCXXX 11
D33253, D33254

38A Transmitted light composite image of the watermark and countermark from TB CCCXXX 2, 3, 4, 7, 9.

38B Micrograph of the surface of the sheet showing the prominent feltmark and the graphite at × 15 magnification.

The paper used to make up this sketchbook is very variable: weights, tones and textures are subtly different, with the last part of the book being made up with a somewhat creamier, unwatermarked wove paper with a smoother surface.[1] The precise relationship between the three elements of the watermark are difficult to determine because the book appears to have been bound using cut half sheets rather than whole sheets folded in signatures.

Gaudriault records two members of the Chapuis family working at St Claude at different periods: J. François Chapuis worked the Les Pérrières mill from 1776 to Revolutionary Year 2 and another member of the family, but with no first

38

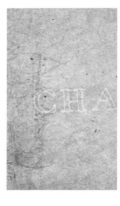

38A

name given, worked the St Claude et Lessard mill after 1813.[2] St Claude is in the Franche Comté about twenty miles north of Geneva.

1 TB CCCXXX 82–134.
2 Gaudriault 1995, p.186.

38B

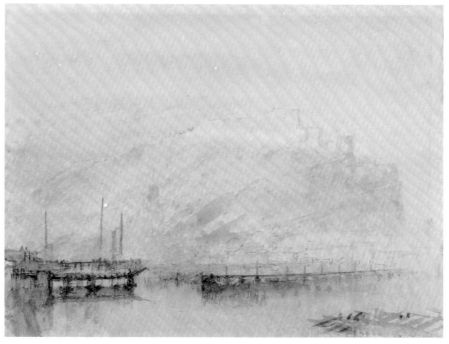

39

39A

39B

39 Ehrenbreitstein 1841

245 × 305 (9⅝ × 12)

Royal Quarto
Cream wove watercolour paper
Watermark: C ANSELL / 1828
Made by: John Muggeridge
Mill: The Paper Mill, Carshalton, Surrey

Watercolour over pencil

TB CCCLXIV 309
D36166

39A Transmitted light image of the watermark.

39B Raking light image of the paint layers and surface of the sheet at × 9 magnification.

40 Ehrenbreitstein 1841

$242 \times 302 \ (9^{1}/_{2} \times 11^{7}/_{8})$

Royal Quarto
White wove watercolour paper
Watermark: J WHATMAN / TURKEY
MILL / 1822
Made by: T. & J. Hollingworth
Mill: Turkey Mill, Maidstone, Kent

Watercolour over pencil

TB CCCLXIV 319
D36177

40A Transmitted light image of the watermark.

40B Raking light image of the paint layers and surface of the sheet at × 9 magnification.

These two works come from a group of sketches of Ehrenbreitstein that Turner produced while staying at Coblenz in 1841. They offer very specific insights into his working practices. Turner appears to have drawn the various scenes lightly in pencil and from a range of different viewpoints. The watercolour has been painted later: Powell suggests perhaps at Turner's hotel.[1] As with so many other works in the later years of his career, several of these works were originally parts of the same sheets.

Turner used parts of three different sheets of paper, all dating from the 1820s, for his series of atmospheric and masterly studies of Ehrenbreitstein in various moods. Examples of all these three papers can be found in use by Turner for a wide variety of other English and continental subjects over a period of many years.

The highly distinctive torn edges of these works have allowed some of the sheets to be reassembled. With these three papers Turner seems to have shown no particular preference for either the wire or felt sides. He appears to have torn the sheets in half longways before folding them and working on them, using them in the manner of sketchbook pages.

Another part of the Ansell sheet used for TB CCCLXIV 309 can be found in TB CCCLXIV 285, which has been painted on the other surface of the sheet. The two papers used for the works illustrated here are both quarter sheets of Royal watercolour papers with a nominal full sheet size of 19 × 24 inches. The first is a cream wove watermarked C ANSELL / 1828, made by John Muggeridge at The

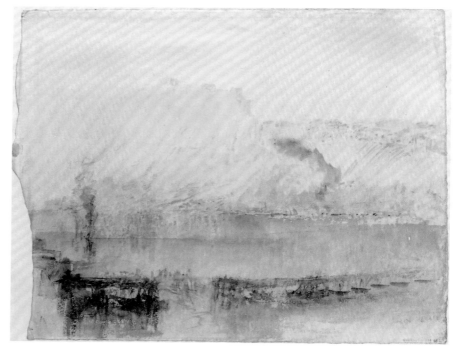

40

40A

Paper Mill, Carshalton, Surrey, and the second a white wove, watermarked J WHATMAN / TURKEY MILL / 1822, made by the Hollingworth brothers at Turkey Mill, Kent. The third sheet is a white wove Super Royal watercolour paper, nominally $19^{1}/_{2} \times 27^{1}/_{4}$ inches, watermarked J WHATMAN / TURKEY MILL / 1825 and also made by the Hollingworths.

The date of manufacture of a very large amount of the paper used towards the end of Turner's life, with the bulk of papers having watermark dates in the 1820s, suggests that he had made considerable purchases of paper during that decade. The manufacturing dates of the

40B

white and coloured Bally, Ellen & Steart papers used by Turner all lie within the 1820s, but as with these works he continued to use them until very much later in life.

Despite the Ansell name in the watermark, no members of the Ansell family were still making paper in 1828. There were two paper mills, Lower Mill and The Paper Mill, at Carshalton: James Ansell ran The Paper Mill from 1819 until his bankruptcy in 1815[2] when his brother Charles, who had previously run the Lower Mill,[3] took over the mill, in partnership with Nathaniel Muggeridge. This partnership was dissolved in 1820[4] and from then until 1894 the mill, at some point renamed Vandelis, continued to be run by different members of the Muggeridge family, always using the c ANSELL watermark in their papers. The mill finally closed in 1905.

1 Powell 1995, p.190.
2 *London Gazette*, 2 Sept. 1815.
3 *London Gazette*, 14 May 1816.
4 *London Gazette*, 27 May 1820.

41A

41 A Storm over Lago Maggiore, from near Magadino ?1842

From the so-called *Bellinzona, Sion, etc.* sketchbook

A sheet found in a Royal Quarto roll sketchbook cover of green, yellow, red and black marbled paper
227 × 287 (9 × 11 5/16)

Page size: 220 × 271 (8 11/16 × 10 1/2)

Possibly Large Post Quarto
Very lightweight machine-made white wove paper
Formation: some specks and shives
No watermark
Made by: Zürcher Papierfabrik an der Sihl AG
Mill: An der Sihl, Zurich, Switzerland

Pencil, watercolour and crayon

TB CCCXXXVII 28
D33631
Illustrated on page 66

41A Micrograph of the surface showing watercolour and crayon at × 15 magnification.

The pages of the so-called *Bellinzona, Sion, etc.* sketchbook, are in fact a collection of 29 loose sheets, of five different papers, none of which were ever the pages of any sketchbook. This work is part of the largest group in the book, TB CCCXXXVII 9–29, all on a lightweight machine-made white wove containing many specks and shives, and of continental origin. TB CCCXXXVII 29, also of the head of Lake Maggiore is likewise worked in crayon and watercolour. This paper is a perfect illustration of the surface strengths and versatility of many lightweight rag papers designed for use with a steel nib but very capable of quite rigorous working in watercolour and other media.

One of the inside covers carries a small rectangular printed label on green paper, reading G ROWNEY & CO / 51 RATHBONE PLACE / LONDON, showing the source of many of Turner's Roll sketchbooks in the later part of his life.

The other papers found between the covers are as follows:

1. TB CCCXXXVII 4, 6 and 7. An unwatermarked heavyweight cream wove drawing paper, 9 × 11 1/4 inches (228 × 285 mm), made on a double-faced mould, probably a Whatman paper from Balston and Co. at Springfield Mill,

Kent. These three sheets are the only ones that could possibly come from this 'sketchbook' as there are great similarities between them and the paper used as the inside covers.

2. TB CCCXXXVII 1, 2 and 3. A heavyweight 'not' finish cream wove drawing paper, approximately 8 1/2 × 11 1/2 inches (216 × 292 mm), made on a double-faced mould. TB CCCXXXVII 1 is watermarked J WHA… / TURK… / 18… and was made by T. & J. Hollingworth at Turkey Mill, Maidstone, Kent. These three part sheets were never part of a sketchbook. They were all originally part of the same sheet and still retain a deckle on one edge and have no trace of stitching.

3. TB CCCXXXVII 5. An unwatermarked lightweight cream wove drawing paper, approximately 9 × 11 1/2 inches (228 × 292 mm), made on a double-faced mould. Unknown maker, possibly a Whatman paper. This single torn-down sheet was never part of a sketchbook. It still retains a deckle on one edge and has no trace of stitching.

4. TB CCCXXXVII 8. An unwatermarked hard sized white wove paper, prepared with a grey wash on the verso. Approximately 7 11/16 × 9 7/8 inches (195 × 250 mm), made on a double-faced mould. Unknown maker, probably a Whatman paper. This single torn-down sheet was never part of a sketchbook. It still retains a deckle on one edge and has no trace of stitching.

The Zürche Papierfabrik an der Sihl AG who made this paper, operated the An der Sihl mill and the Auf den Werd mill, Zurich, from 1837. Auf dem Werd, which began operation in 1470, had a paper machine installed on its takeover by the An der Sihl mill, in 1837. By 1850 An der Sihl was operating three machines.[1] Which of the two mills produced this paper is impossible to say but An der Sihl is the most likely given the blind-embossed stamp.

1 Tschudin 1991, p.152.

42 Small 'homemade' sketchbook containing views of lakes and mountains 1842

132×108 (5¼ × 4¼)

Very lightweight machine-made white wove paper
Formation: some specks and shives
No watermark
Made by: Zürcher Papierfabrik an der Sihl AG
Mill: An der Sihl, Zurich, Switzerland

Pencil

TB CCCXLIV 271–289
D34717–34725, D34727–34736

42A Micrograph of graphite and paper surface, taken from TB CCCXLIV 279 verso at × 25 magnification.

42B Raking light image of the SIHL blind-embossed stamp on TB CCCXLIV 276

This paper, the same as that used for cat.no.41, *Storm over Lake Maggiore*, gives us the clue to the origins of these light-weight machine-made papers. One of the leaves of this tiny 'sketchbook' is stamped with a blind-embossed mark with SIHL in a rectangular lozenge, the mark of the Zürcher Papierfabrik an der Sihl AG, a company formed in 1837.

Nicholas Serota first recognised that the pieces making up this tiny and rather tatty series of sketches were connected to the papers used for cat.no.41 and many other works in the Bequest, describing them as belonging to a new Sihl sketch-book which chronicled Turner's journey from Lucerne into Austria concentrating on Lakes Como and Lugano.[1] It is, how-ever, unlikely that they ever formed part of a bound sketchbook. The practice of blind embossing stamps onto the corner of sheets is restricted to loose sheets, not bound books. It is more likely that Turn-er bought a block of writing paper and keeping some of the sheets full size, tore or cut others down for use for quick jot-tings such as can be seen here.

1 Nicholas Serota, 'J.M.W. Turner's Alpine Tours', unpublished MA report, Courtauld Institute of Art, 1970, pp.36, 135–7. The complete listing of the SIHL papers, many of which bear the blind-embossed stamp is as follows: TB CCCXXXVII 9–29; TB CCCXLIV 183–186, 202–205, 271–289, 407–409; TB CCCLXIV 68–79, 122, 124, 155–169, 238, 322, 327, 403–405.

42

42A

42B

43 **Reassembled sheet made up of pencil sketches of Godesburg and the Ahr Valley** ?1840s

Imperial
Hard sized white wove drawing paper
Folded into sixteen irregular sized pieces, each approximately 140 × 194 (5½ × 7½), this Imperial sheet is now in nine separate pieces
Formation: good
Watermark: T EDMONDS 1825 + NOT BEACHE__D__.
Maker: Thomas Edmonds
Mill: Rye Mill, Wycombe, Buckinghamshire

Pencil

TB CCCXLIV 23, 34, 35, 36, 37, 39, 43, 44, 45, 46, 99, 100, 101, 102, 103, 104, 105, 106, 339, 340
D34366, D34377–34380, D34383, D34388–34393, D34458–34465, D34811, D34813

43A verso of the sheet, showing that Turner worked on both surfaces.

43B Transmitted light images of the two parts of the watermark taken from TB CCCXLIV 340, 44 and 37, 35.

43C Micrograph of graphite on the prepared surface of the sheet taken from TB CCXLIV 44 at × 25 magnification.

The reassembly of many of the hundreds of small drawings in the Bequest into their original whole sheets has facilitated the identification of some of the sites involved and helped towards the dating of many of the works. Half of each side of the sheet was prepared with two different tones of grey wash before the paper was used. The use of these grey tones when sketching outside was helpful in reducing the sun's glare relecting off the white surface of the sheet.

This sheet was originally folded down into one-sixteenth Imperial, approximately 7 × 5 inches, was probably cut into half before both halves were folded and used. It is currently in nine irregular pieces, arranged as follows:

43

43A

CCCXLIV 340	CCCXLIV 44	CCCXLIV 37	CCCXLIV 35
CCCXLIV 339	CCCXLIV 23	CCCXLIV 36	CCCXLIV 34
CCCXLIV 102/103	CCCXLIV 100/106	CCCXLIV 45	CCCXLIV 46
CCCXLIV 101/104	CCCXLIV 99/105	CCCXLIV 43	CCCXLIV 39

43B

The use of the words NOT BEACHE^D in the watermark is a reflection of the reaction, by both customers and the paper trade, to the over-enthusiastic use of chlorine bleaching powders in the early years of the nineteenth century, based on the work of James Watt, Charles Tennant, Hector Campbell and others.[1] The discovery of chlorine gas by Karl Wilhem Scheele in 1774 and Berthollet's discovery of its bleaching properties in 1785, were to have far-reaching effects on the paper industry, effects that are still reverberating through the industry in this century as environmental concern has led to the discontinuation of its use in many mills and will eventually lead to a total cessation. The papermaker James Whatman the younger, who conducted considerable experiments with various methods of chlorine bleaching in the early 1790s, proved far-sighted when he told the American papermaker Joshua Gilpin that 'he did not think highly of bleaching. Thinks there is a waste of rags in the process [and] that it does not take the size well.'[2]

Chlorine is a strongly oxidising agent, capable of damaging cellulose even while it whitens it, affecting both the strength and durability of the fibre, even under the carefully controlled conditions of modern paper manufacture. Despite chlorine's ability to whiten even heavily coloured material, it has no essential function in papermaking; both hydrogen peroxide and oxygen-based bleaching processes are just as effective and far less damaging to both the cellulose fibre and to man.

In the early years of the nineteenth century the combination of the increasing use of inferior cotton rags and the new chlorine powders were to cause great problems to both makers and users. John Murray, writing in 1824, recorded

I have in my possession a large copy of the Bible printed at Oxford, 1816 (never used) and issued by the British and Foreign Bible Society, crumbling,

literally, into dust ... specimens there are [of paper] that being folded up, crack at the edges and fall asunder: ... One letter which I had forwarded by post, fell to pieces by the way.[3]

Edmonds, like other makers such as Whatman and, later in the century, Arnold and Foster,[4] refused to use such techniques and advertised the fact in his paper. That he did so must mean that there was a sufficient understanding of the problems among users of his paper to justify the expense of adding the words to his watermark.

Thomas Edmonds was both papermaker and flour miller, working Rye Mill, High Wycombe, in both capacities for nearly sixty years. Although not common, there were several other mills in England which at various times carried out these two very different occupations on the same site. He is first recorded as 'Thomas Edmonds, mealman' when he insured his stock and utensils in his paper mill in 1796.[5] In 1799 the mill burnt down but was rebuilt almost immediately.[6] He continued to be described as both miller or corn miller as well as papermaker throughout most of his life.[7] He died in January 1853 and the mill was sold[8] and by 1858 it was being worked by Thomas Harry Saunders whose successors continued to operate the mill until 1917. Saunders became one of the greatest papermakers of the nineteenth century and he and his successors continued to use the T EDMONDS watermark until the 1970s for handmade and mouldmade writings and printings.

1 James Watt introduced chlorine bleaching to Scotland in 1788 (Collings and Milner, 'A New Chronology of Papermaking', *Paper Conservator*, vol.14, 1991, p.58). William Simpson of Edinburgh patented the bleaching of rags with chlorine, Charles Tennant patented 'Bleaching Powder', a simple and economic form of chlorine bleaching which was rapidly taken up by the industry from 1798 onwards. See also Hector Campbell, Patent No.1922, Dec. 1792, and Campbell 1802.
2 A.P. Woolrich, 'The Travel Diaries of Joshua Gilpin: Some Paper Mills in Kent, 1796', *The Quarterly*, no.20, Oct. 1996, p.23. Details of Whatman's experiments can be found in Balston 1957, pp.103–8.
3 Murray 1824.
4 Makers of the famous 'Unbleached Arnold' watercolour papers at Eynsford Mill, Kent.
5 *Sun Fire Insurance Policy*, 656046, 2 June 1796.
6 H. Kingston, *History of Wycombe*, 1849, p.192.
7 See Simmons, Rye Mill, entries for 1838, 1842, 1844, 1847, 1851, etc. Science Museum Library Archives.
8 *Aylesbury News*, Jan. 1853.

43C

44

44 Ship at Sea

189 × 272 (7⅛ × 10¾)

White wove watercolour paper
Part watermark: T EDM...
Maker: Thomas Edmonds
Mill: Rye Mill, Wycombe,
Buckinghamshire

Watercolour, bodycolour and pencil

TB CCLXIII 226
D25348

44A Raking light detail of the paint
layer and the surface of the sheet at
× 20 magnification.

44A

45

45 On the Sea Shore

192 × 277 (7½ × 10⅞)

White wove watercolour paper
No watermark
Maker: Thomas Edmonds
Mill: Rye Mill, Wycombe,
Buckinghamshire

Watercolour and bodycolour

TB CCLXIII 224
D25346

45A Raking light detail of the paint
layer and the surface of the sheet at
× 15 magnification.
Illustrated on page 71

These two works are from a group of
seven sketches of sea and sky each exe-
cuted on an eighth part of an Imperial
watercolour sheet from the same batch of
Edmond's unbleached paper as that seen
in cat.no.43. The other five works from
this sheet are all sea and sky sketches,
TB CCLXIII 225, 272, 273, 274 and 275.

The curious grey spotting visible in
both these works, and some of the others
in this group, can also be seen in
cat.no.43. If this occurred at the same
time then the dates suggested for these
works should perhaps be reconsidered.
Shanes[1] has dated two of these works to
very different periods: c.1825 and the
early 1830s, but all the internal evidence
of the paint layers and pigments used
indicate that they were all produced at
the same time, and in some cases when
parts of the sheet were still joined to each
other.

That Turner was using this paper
around 1830 can be seen from his *Study
for Upnor Castle, Kent*,[2] which has been
identified by Warrell as being a study for
the *England and Wales* series, *Castle Upnor,
Kent*; it must therefore date to c.1831.[3]

1 Shanes 1997, pp.40, 41.
2 TB CCLXIII 124, a half sheet of the same white
 wove Imperial watercolour paper, part water-
 marked T EDMONDS / 1825.
3 W 847, Whitworth Art Gallery D.1924.41.

46 Sunrise

237×472 ($9^5/_{16} \times 18^9/_{16}$)

Lightweight white wove watercolour paper
Watermark: B. E. & S. / 1823.
Maker: Bally, Ellen & Steart
Mill: De Montalt Mill, Bath, Somerset

Watercolour

TB CCLXIII 64
D25186

46A Transmitted light image of the watermark.

46B Raking light detail of the paint layer and the surface of the sheet at × 40 magnification.

This sheet of Bally, Ellen & Steart is unusual in Turner's usage. He generally worked on the heavier weights of this maker's papers, and this is a very light sheet for this maker. The watermark differs from many of their other marks in having full stops rather than commas in the punctuation, showing that the sheet was made on a different mould. Turner generally used paper from this mill in Imperial (22 × 30 inches), but the position of the watermark in this sheet suggests that this part sheet was originally part of a Royal (24 × 19) or Super Royal (27 × 19).

46

46A

46B

47

47A

47B

47 River Scene

351 × 508 (14 × 20)

Imperial

White wove watercolour paper
Watermark: RUSE & TURNERS / 1828
Maker: Richard Turner and Mr
Letts
Mill: Upper Tovil Mill, Maidstone,
Kent

Watercolour

TB CCLXIII 101

D25223

47A Transmitted light image of the watermark.

47B Raking light detail of the paint layer and the surface of the sheet at × 20 magnification.

The deep glow within this image gains some of its power from the fact that the verso has been washed in colour, in a similar manner to the verso painting technique Turner used in the 1790s for his large Norham Castle studies.

The RUSE & TURNERS watermark was in use from 1805 until the 1840s. Richard Turner and his brother Thomas, hence 'Turners' in the watermark, had originally gone into partnership with Joseph Ruse in 1805.[1] This partnership continued until Thomas's retirement in 1815 when a new partnership between Ruse, Richard Turner and Samuel Welch was set up, which in turn lasted until Ruse's retirement in 1819.[2] Turner continued with various partners until 1842. In 1828, when this sheet was made he was in partnership with a Mr Letts, but the watermark continued to be RUSE & TURNERS.[3]

1 Data on Upper Tovil Mill, Simmons Collection, Science Museum Library Archives, London.
2 *London Gazette*, 2 Sept. 1815; *London Gazette*, 25 May 1819.
3 As n.1 above.

Coloured Papers (cat.nos.48–67)

For most of English papermaking history coloured papers made up more than half of all the paper being made. These were the blues, browns and drabs made as wrapping papers, but often also used by artists. A few green and reddish-purple papers were also made, but in very small amounts. Some Italian and French makers had produced small amounts of very fine coloured papers for use by artists, but the colour range remained limited. But by the end of the eighteenth century all this changed as several papermakers began to experiment with more adventurous colours.

In 1796 the Oxfordshire papermaker Thomas Cobb took out a patent, which included mention of 'Drawing', for a new

> method of making Coloured Paper Superior For Brightness and Richness of Colour to any made by any other person, and which paper when made after the Manner invented by me may be used as well for the Purpose of Hanging Rooms as for Writing, Drawing and various other purposes of paper.[1]

Thomas Cobb, of Calthrop House, Banbury, operated North Newington Mill on a tributary of the River Sore, in partnership with John Pain and William Judd, from 1792.[2] Besides his experiments with new methods of colouring paper Cobb spent the years 1807–12 developing a completely automatic paper machine utilising mechanically operated moulds for producing individual sheets, very similar to handmade sheets.[3] No handling of the sheets was necessary until they had been pressed and were ready to be dried. The used moulds were washed and returned, by conveyers, to the beginning of the machine ready to go round the system again. The machine apparently worked very well but was not taken up by the industry, probably because of the success of Donkin's Fourdrinier machine and Dickinson's cylinder mould machine. By 1816 Cobb was no longer involved in making paper.[4]

Very few of Cobb's papers have been identified but there was a definite increase in the range of colours available from stationers and colourmen in the early years of the nineteenth century.[5] Both Ackermann in 1802[6] and Edward Orme in 1807[7] listed various coloured papers. By 1810 handmade papers were available in 'all colours' either as sheets coloured in the making or with printed colours.[8] Matthias Koops, heavily involved in the building of his new mill at Millbank and in the development of his production of straw, wood and recycled papers, also produced some very rich golden yellow wove papers at Neckinger Mill, Bermondsey, in 1800, which would not have borne

much working in watercolour but would have taken chalks and graphite very well.[9]

Much of this coloured paper would have been of no use to Turner. The examples that survive show very little of the surface strength necessary for rigorous watercolour work. The pale greens, canary yellows, rose pinks, and lilacs found in so many albums and small commonplace books were suited to the pen or a pencil; some could take a wash but the glazed surfaces lacked the 'grain' needed for watercolour. There are, however, some pale green and blue wove papers produced by Smith & Allnutt in 1812 that definitely would have taken watercolour very well but so far no examples of artists actually working in watercolour on these sheets have been found, although Turner worked in pencil on some of Smith & Allnutt's green woves (see cat.no.62).[10] Smith & Allnutt and Thomas Creswick (cat.no.61) were among several makers who explored the possibilities of this market, which by the 1820s was strong enough for some makers to specialise in the production of coloured artists' papers. They were so successful that by 1850 Winsor and Newton were advertising both handmade and machine made

> Coloured drawing and crayon papers, Imperial, Extra Stout including a great variety of tints adapted for … sketching in Water Colours. Pattern Books containing samples of all the tints in stock, upwards of 40 in number, and to which numbers are affixed for the purpose of ordering, may be had on application.[11]

Unfortunately for the purposes of research and comparison, no examples of these Winsor and Newton paper sample swatches have survived.

Every artist has their favourite papers and Turner was no exception; from the early 1820s onwards he returned over and over again to the papers produced by one particular maker, George Steart. Visually the coloured papers produced by George Steart, of Bally, Ellen & Steart, De Montalt Mill, Combe Down, Bath – particularly the blue, grey and buff papers – owe a lot to the appearance of eighteenth-century wrapping papers, but they were made using the best of the new developments in papermaking technology. Until recently, papers made by Bally, Ellen & Steart were not generally recognised because most of them are extraordinarily opaque and the watermarks are rarely visible in ordinary transmitted light, even on a light box. Most of the B E & S watermarks found in the blue, buff and brown papers that Turner used, are only visible using a fibre optic light source or by x-ray.

Most discussions of the blue papers used by Turner and made by George Steart merely describe the colour and concentrate on Turn-

er's use of bodycolour as well as watercolour. They avoid the crucial question, particularly when considering an artist's actual working practice, of why, when several other fine blue watercolour and drawing papers were available to him, did Turner choose to use Steart's papers, over and over again? What made his coloured papers so different from other papers?

The answer lies not just in the particular tones of blue (or grey or buff) that Steart produced, but in the very different internal and surface strengths that Steart achieved in his coloured sheets by his unusual working methods. Steart had been interested in the 'finishing' of paper, those processes that give a sheet its final workable surface strength and stability, since the 1790s, long before he became involved in papermaking.

Although much of Steart's production was probably intended for the flourishing amateur market, research into the paper usage of other professional artists of this period shows most of the 'greats' were also using Bally, Ellen & Steart papers for some of their work: John Varley (1778–1842), Richard Parkes Bonington (1802–1828), Peter De Wint (1784–1849) and David Cox (1783–1859) are examples. Most of the buff wove paper favoured by John Sell Cotman (1782–1842) later in his career can be identified, despite the lack of watermarks, from various internal details as having also been made by Steart. John Constable (1776–1837) also used several examples of Steart's paper for pencil drawing, choosing not his artists' drawing papers but the lightweight 'Bath Wove Post' writing paper.[12] Steart's drawing papers were very popular with practising artists, their popularity shared only with 'Whatman' and 'Creswick', names which had become almost generic for watercolour papers. What all these papers have in common is that they are essentially simple papers: pure linen, gelatine sized, made with great care and attention, precisely the attributes that George Steart brought to his endeavours.

The end of the eighteenth century and the early years of the nineteenth century saw a sharp rise in the building of purpose-built paper mills in England. Before that date most of the papermills had been sited in converted flour or fulling mills. Many of these newly built mills were purely speculative ventures by groups of entrepreneurs who, knowing little of the intricacies of papermaking, were to fail in the last years of the Napoleonic Wars or in the slump that followed the end of the conflict. At first sight, De Montalt Mill appeared likely to be just such an enterprise but, as we shall see, it was blessed with a man of unusual skill and vigour, whose ability led to the mill surviving those difficult years. When it finally closed it was probably only because the three old gentlemen involved in running the business had all retired.

The mill was built in 1805, with stone from the nearby Combe

Down quarries, by the De Montalt family, after whom the mill was named[13] and operated by a partnership between John Bally, bookseller, printer and stationer of 11 Milsom Street, Bath[14]; William Ellen, who had a china & glassware shop at 22 Milsom Street[15] and a certain George Steart. The mill originally comprised one large two-storey building of traditional papermaking layout, housing the vat room and the wheel, the residence of the papermaker, a drying loft and salle. It was built in warm-coloured Bath stone with the living quarters being given a collonaded front. A second, single-storey addition appears to have been used for raw materials. The fifty-six-foot diameter waterwheel was housed between the mill and a store, with the water supply being taken from an artificial lake constructed on the hillside above the mill. One unusual feature of this mill was the chimney stack, also of Bath stone, built to accommodate the boilers and steam engine provided by Boulton and Watt. It was sited some distance from the mill itself, on higher ground some 110 yards away where the prevailing winds would take the smoke well away from the mill, ensuring the cleanliness of the finished paper, for newly formed wet sheets will pick up any dirt that is around. The gases were conducted to the stack through an underground flue.

Of the three partners, it was George Steart who had the running of the mill, with the two other partners providing the initial capital. Little is known of George Steart's early life or what qualified him for this new position. The only reference to his activities before the opening of De Montalt Mill that I have found so far dates from 1797 when he wrote, from Bath, to Matthew Boulton 'in respect of a pair of rolls for the purpose of rooling and giving a gloss or smoothness to writing papers'. In this letter he describes himself as a 'Printer, Bookseller and Stationer', and suggests 'You may hear some account of me at Mr Pearson's Printer'.[16] The grasp of technical detail in the letter, even at this early date, gives every indication of the sure understanding and concern for excellence that were to characterise the whole of his career at De Montalt Mill.

The earliest papers produced by Bally, Ellen & Steart appear to have been writing and specialist papers: in 1809 they are described as 'The only Manufacturers of the fine rolled Bath Vellum Papers'.[17] This Bath Vellum was a heavyweight paper particularly designed for mounting prints and drawings.[18] By 1816 they were advertising their, by then, famous Bath writing paper, sometimes known as Bath wove Post paper.[19] They also produced a black-edged 'Funeral Paper' for the writing of letters of condolence.[20]

The mill flourished under Steart's capable direction until February 1832 when William Ellen retired and the original partnership was dissolved.[21] Bally and Steart continued in business together and by the

Fig.11 George Steart's De Montalt Mill, near Bath, showing 'the largest waterwheel in England' and the mill chimney, served by an underground flue, sited on the hillside above the mill.

middle of 1833 had taken William Ellen's son into partnership.[22] But in 1834 the company ceased to operate and the mill was on the market. The reasons for this were probably the retirement of the two senior partners, but further research is needed to unravel the final events. Although various schemes, such as the production of gutta-percha[23] and a laundry business,[24] were proposed for the now empty mill, none seem to have actually come to fruition. Two members of the Allen family tried to continue the paper business but by 1841 it was lying idle and for sale.[25]

When George Steart died in 1837 a brief announcement of his death in the local press stressed his interest in the technical side of his business:

> March 6, at his house on Combe Down, Mr George Steart, well known throughout the West of England as of the firm of Bally, Ellen and Steart, paper manufacturers. By his active and intelligent mind he brought into great repute the establishment of De Montalt Mills, which were much visited by the curious to inspect the waterwheel, the largest in England. The New Church on Combe Down was erected through his unwearied exertions and to it he largely contributed. He was particularly distinguished by his fondness for chemical and mechanical pursuits and possessed a large fund of general information. He was as highly esteemed as extensively known.[26]

This curiosity for 'chemical and mechanical pursuits' had led him to develop a range of some of the finest papers designed for use by artists, papers which had been used by some of the greatest artists of his time. Perhaps the greatest compliment he could have been paid however came from the paper industry itself, which after his death continued to produce versions of his papers, because the real thing was no longer available (see cat.no.73).[27]

Despite the importance of Steart's paper to the development of Turner's work throughout the 1820s and 1830s some of his most dramatic uses of coloured papers are on those he bought on his continental tours. The rich deep colours of the papers used for a wonderful series of works on Richard Bocking's blue paper (see cat.no.55), or the Venetian night scenes on brown papers made by Miliani (cat.no.64) and at least one other as yet unidentified Lombardy papermaker (cat.no.65) were mostly not available in Britain.

When using Steart's paper Turner generally worked on part sheets, torn down from full Imperial (22 × 30 inches) sheets. They can be found as half (15 × 22), quarter (11 × 15) and eighth Imperial (11 × 7) but the majority are found as one-sixteenth Imperial (7 × 5 inches).

The following listing shows the watermark dates found in Turner's

works and indicates a number of different batches of paper based on weight and furnish differences. The sheets are generally watermarked once in the bottom right corner of the sheet with the initials B, E & S. with a date below. It should be stressed that in many of these sheets the watermarks and their dates are not easily visible in normal transmitted light. These watermarks have been identified by using a fibre optic light source.

Table: Watercolour papers made by Bally, Ellen & Steart found in the Turner Bequest

COLOUR	DATE in WATERMARK	Different WEIGHTS	Different TONES	Different FURNISHES
White	1823	3	2	2
	1827	1	1	1
	1829	1	1	1
Cream	1827	2	1	1
	1829	1	1	1
Blue	1823	3	3	3
	1827	2	2	2
	1828	3	2	2
	1829	3	3	3
Olive	1827	1	2	2
Grey	1829	2	3	3
Sand	1829	2	1	1
Buff	1829	2	2	2

1 Thomas Cobb, Patent No.2147, 19 Nov. 1786.
2 SFIP 597515, 5 March 1792.
3 Thomas Cobb, Patent No.3580, 16 July 1812.
4 Frances Wakeman 'Papermaking in the Oxford Area', *The Oxford Papers*, 1996, p.27.
5 COBB & CO / 1796, COBB & CO and COBB PAIN & JUDD watermarks have been identified from the 1790s. See Gravell and Miller 1983, watermarks 156–8.
6 Rudolf Ackermann, *Instructions for Painting Transparencies*, London 1802, pp.39–40.
7 Advertisement placed by Edward Orme in Clark, *A Practical Essay on the Art of Colouring and Painting Landscapes in Watercolours*, London 1807.
8 Edward Orme, *An Essay on Transparent Prints*, London 1807, p.30.
9 Papers in the Bower Collection (NB48–50), watermarked NECKINGER MILL / 1800. Another single sheet of a very similar furnish and colour, watermarked MILLBANK / 1802 may have come from Koops' new mill.
10 Bower Collection (BM107–114) all watermarked SMITH & ALNUTT / 1812.
11 *Illustrated List of Colours and Materials for Drawing and Water Colour Painting manufactured and sold by Winsor & Newton*, p.16, bound in with Thomas Rowbotham, *The Art of Sketching from Nature*, London 1850.

12 See Peter Bower, 'The Evolution and Development of "Drawing Papers" and the Effect of this Development on Watercolour Artists 1750–1850' in *The Oxford Papers*, Studies in British Paper History, 1, London 1996, pp.63–74, for further discussion of some of the developments in artists paper usage during this period.
13 Brian Attwood, 'The BIAS Paper Mills Survey', *Journal of the Bristol Industrial Archaeology Society*, vol.3, 1970, p.17.
14 Local rate books put him at this address between 1805 and 1825.
15 *Gye's Bath Directory* for 1819 shows that he later moved to 7 George Street, Bath.
16 Letter from George Steart to Matthew Boulton, 21 Sept. 1797: Boulton & Watt Collection, Birmingham, Box 8/11/58. In 1808 Steart commissioned Boulton & Watt to build him a steam engine to supplement the power from the water wheel: Boulton & Watt Collection, Birmingham, PF 844–8.
17 *Bath Directory*, 1809. Between 1809 and 1833 the company is listed in various trade directories under names and spellings including Bally, Ellen & Steart, Balley, Allen and Steart, etc. e.g: *Pigot's Directory* for 1822–3 gives John Bally & Co.
18 J.S. Bartrum, *The Personal Reminiscences of an Old Bath Boy*, 1891, p.16. Bartrum's father had been

in business at 10 MilsomStreet, in another partnership with John Bally as Bally & Bartrum, Auctioneers, Appraisers and Upholsterers.

19 *West Briton*, 14 June 1816 and 27 Dec. 1816. Bath writing, or Bath wove Post, was made by several different makers besides Bally, Ellen & Steart. Sheets are generally blind-embossed with various designs of oval or circular stamps, usually including a crown and reading BATH or SUPERFINE BATH.

20 A blank folded sheet of this greyish mourning stationery, watermarked: B. E. & S. BATH 1824. survives in Bath City Library, A.L.832.

21 *London Gazette*, 24 Aug. 1832: 'Co partnership between JOHN BALLY, WILLIAM ELLEN & GEORGE STEART, carrying on trade as paper mfgrs at De Montalt Mill, at Combe Down, and Wholesale Stationers at Bath, both Co of Somerset, dissolved 14 February 1832.'

22 *Excise General Letter*, 1 July 1833.

23 *Bath & Cheltenham Gazette*, 22 March 1834: 'We are glad to hear that the paper mill on the southern declivity of Combe Down, formerly known as De Montalt Mills has been taken by a firm who intend devoting it to the manufacture of Gutta Percha'.

24 Prospectus issued by The Bath Washing Company Ltd in 1834: 'the premises formerly used as a paper mill … have been recently fitted up for the purpose of washing and finishing on the most approved principle, articles of every description for personal or domestic use.'

25 *Excise General Letter*, 26 Oct. 1838 has William Jennings Allen in occupation and describes the mill as a 'Millboard and Pasteboard Mill'. The *Excise General Letter* of 10 Sept. 1839 gives John Goodland Allen, with the two other partners providing the initial capital. The 1841 sale particulars describe the property as those 'Valuable Leasehold Estates … comprising that well known and beautiful estate called the De Montalt Mills … To be sold by Thomas Mason on 20th April 1841 at Garroways Coffee House, London'.

26 *Bath Chronicle*, 9 March 1837. *Silverthorne's Bath Directory* for the same year describes his old partner, John Bally as a '"gent" retired at 11 Pierrepoint Street' and his widow as still close to the mill at 5 De Montalt Place, Combe Down.

27 Besides the Winsor & Newton version seen in cat.no.73, several continental mills produced versions of Steart's blue papers, e.g: Miliani at Fabriano in Italy, Canson Montgolfier at Vidalon in France.

48 Letter from George Steart to the Royal Society of Arts

4 March 1820

From *RSA MSS Transactions 1820–1*

Royal Society for the Encouragement of Arts, Manufactures & Commerce

Steart's papers were of crucial importance to Turner: most of the blue, grey, buff and brown papers, as well as many of the white and cream papers used from the 1820s onwards, for some of his most dramatic works, were produced by George Steart, of the papermakers Bally, Ellen & Steart of De Montalt Mill, near Bath. The letter shown here is part of the correspondence between George Steart and the Royal Society of Arts regarding his new method of making a watercolour paper, which eventually led to Steart being awarded the Society's Silver Isis Medal.

The *Transactions* of the Royal Society of Arts give a full account of the Society's award of the medal and the detail with which Steart describes his processes is worth quoting in full for the differences between his manufacturing methods and those of other makers are precisely what made his papers so attractive to many artists.[1] The RSA's Committee of Polite Arts met several times to consider

Steart's communications regarding his new paper, and various members of the committee, including Cornelius Varley, painted and drew on the samples that Steart had submitted.[2] Opinions about the paper were generally favourable:

> Mr Varley produced a specimen of drawing on these Tablets and stated that he had found them to be a material pleasant to work on, from its absorbent quality which enables the colours to be laid on with great evenness; it also allows the colour to be washed off quite clean; but there are some unsound parts which absorb colour and injure the general effect of the drawing.[3]

Varley's criticism would appear to refer to an uneven take-up of gelatine by the paper during sizing, something which can be seen in some of the batches of Steart's papers used by Turner, but did not hinder the general decision of the committee that Steart had come up with a drawing paper that was 'new and Likely to be useful, particularly to Artists sketching from nature'. Mr Samuel stated 'that he has used the tinted tablets during the last summer and considers them to be the best material on which to make sketches from nature.'[4] The committee recommended that Steart be awarded the Isis Silver Medal 'on condition of his communicating to the Society a complete account of the process of his manufacture within two months and relinquishing all pretension to a patent'.[5]

Part of the delay between Steart's first letter of 12 February 1819 and the final decision to award him a prize, nearly two years later in January 1821, appears to have related to several postponements of any decision until Bryan Donkin, the engineer who had developed the first successful production paper machines some fifteen years earlier (see cat.no.11) had had a chance to give his opinion on both the paper and the methods used to manufacture it.

The complete text, published by the Society on the award of the medal to Steart is as follows:

> The small or ISIS SILVER MEDAL *was this Session voted to Mr.* GEORGE STEART, *of the Montalt Paper-Mills, Coomb Down, near Bath; for his* LINO-STEREO TABLETS, *or* SOLID LINEN TABLETS FOR DRAWING ON, &c. *The following communication has been received from Mr. S. on the subject, and specimens of his Tablets, both plain and tinted, are placed in the Repository of the Society.*

De Montalt Paper Mills, Coomb Down near Bath, Feb.12th, 1819.

SIR;

I BEG you will lay before the Society of Arts, &c. the six dozen Lino-Stereo Tablets inclosed, invented and manufactured by me, for their inspection. If the Society should be pleased to consider my improvements in an article at present in great request worthy their patronage, I shall feel much pleasure in receiving it, and also in communicating any further information if required.

I am, Sir,
&c. &c. &c.
GEORGE STEART.

A. Aikin, Esq.
Secretary, &c. &c.

The Tablets are of two sorts, *rough* and *smooth*; the former finished with a grain or tooth, the more effectually to receive the full touch of a pencil, chalk, or crayon, for which kinds of drawing they are principally intended; while the latter have a much more level surface, for painting in watercolours, or for more delicate works.

The Tablets will be sold to the public at the usual prices charged for the *pasted* card boards. I have already manufactured many thousand dozens for that purpose.

The extra-stout Drawing-Papers, or Card-Boards, as they are usually denominated, are always made by pasting several sheets of paper together, in the manner of a common paste-board, and afterwards bringing them to a smooth face by pressing and rolling. The pasting is a dirty operation, and the occasion of many defects, some of which are fatal to the degree of perfection and nicety required in a good drawing-board; for it often happens that, let the workmen be ever so careful, the boards are contaminated by a portion of the paste being left on the surface in handling the sheets; and although this may at first escape the eye of the Artist, yet it will be discovered, perhaps when too late, in finishing the picture. But a far more serious accident than this frequently occurs, which it is impossible to foresee or avoid; for after the artist may have spent many days and even weeks upon a favourite drawing, having occasion perhaps several times to re-wet a particular part of it, in order to produce a desired effect in the finishing, the adhesive qualities of the paste are destroyed, a separation of the sheets takes place, and blisters rise upon the surface, to the ruin of his labours. It has been often remarked, also, that drawings made upon pasted boards, and exposed in rooms where fires are seldom kept, have very soon been spoiled, whilst a print or a drawing on a single sheet of paper in the same situation, has remained quite perfect. This is readily accounted for, from the great tendency of paste to mould or mildew. A fourth great defect, is, that the far greater part of the drawing and writing papers now in use in this country are of a hollow or spongy texture: this arises from their being made of an indiscriminate mixture of linen and cotton, the greater elasticity of this latter preventing its fibres from closely uniting with those of the flax: the consequence is, an irregular surface, and a porous spongy substance, very different from that which an adherence to the good old-fashioned practice of using fine linen rags only in the manufacture of superior papers would produce. Another serious evil is, that some manufacturers having recourse to the aid of chemistry for bleaching or whitening rags of very inferior quality , by means of the oxymuriate of lime, supply a drawing-paper sufficiently fair to the eye , but which, as it retains a part of the muriatic acid, speedily destroys the fine and delicate tints laid upon it.

The Lino-Stereo Tablet is entirely free from these objections, for the following reasons:- 1st, It is not composed of several sheets pasted together, but is moulded from the pulp, of any required thickness, in one entire mass; thus the risk of pasting is avoided, and no separation of the component parts can possibly take place, though wetted ever so often. 2ndly, instead of being compounded of

linen and cotton, it is wholly and solely manufactured from the best and purest white linen rags, most carefully selected; and consequently without the aid of the oxymuriate of lime, or any bleaching process whatever.

De Montalt Mills, Bath,
March 4th, 1820

SIR

In compliance with your favour of the 28th ult. I herewith transmit some samples of the grey and other tinted Tablets, manufactured from linen rags, previously dyed in the pulp, which I shall thank you to lay before the Committee of Polite Arts for their inspection. I believe the colours are permanent, having made many experiments to prove the stability of the colouring materials. The whole were manufactured last Summer, and I regret I cannot at present send more samples, from the circumstance of the stock being nearly all disposed of.

I am, Sir,
&c. &c. &c.

GEORGE STEART.

In describing the manufacture of the Lino-Stereo Tablet, it may be necessary, in the first place, to point out the requisite materials, or utensils, and then explain their uses, confining myself to the technical phrases employed by manufacturers in Paper Mills, in order to be more clearly understood.

The Utensils.

1. A mould of the required dimensions, similar to those used for making paper, but considerably stronger, and well supported by additional bars underneath, so as to enable it to carry, or bear a considerable weight or pressure on the face of it, without bagging; with a deckle from 1½ to 2 inches in depth, to retain the fluid pulp on the face of the mould, and to regulate the required thickness of the sheet or tablet; 3 or 4 of these deckles, of different depths, will be wanted for thinner or thicker substances.

2. A second mould or compresser, in every respect like the first, but so much smaller, that it will fall into and fill the deckle upon the face of the first mould.

3. A light press, very similar to a napkin press, large enough to admit the mould and its compresser, which is to be placed in the most convenient station, near the vat; or in lieu of it, a weight suspended by a pulley over the bridge, laid on the vat; but I consider the press most desirable.

4. A set of felts of the very finest manufacture possible to be procured, of the required size, are indispensably necessary.

5. A pair of rolls or cylinders of large dimensions, such as are used by the rollers of fine metals, made either of iron or brass, fitted up with the greatest truth, and highly polished on the surface, must also be provided, exclusive of all the other requisites in a well-conducted paper manufactory.

The Process:- In selecting the raw materials for the manufacture of the Lino-tablets, great care is taken to reserve the *best and purest white linen rags only*, rejecting all the muslins, calicoes, and every other article made of *cotton*. The linen rags are then carefully sorted, overlooked, and cleansed, washed, and beaten into pulp in the usual manner practised by paper manufacturers of the first class.

The pulp being ready, and diluted in the vat by the proper proportion of pure water, the workman dipping his first mould into the vat, takes it up filled with pulp to the top of the deckle, and holding it horizontally, and gently shaking it, causes the water to subside, leaving the pulp very evenly set upon the face of the mould; having rested it for a moment or two on the bridge of the vat, the compresser with its face downwards, is now carefully laid upon the sheet or tablet, and both together placed in the small press close at hand, where it is submitted to a very gentle pressure, in order to exclude a great proportion of the water remaining in the sheet;- it is then withdrawn, the compresser and the deckle are both taken off, and another workman couches it, by very dexterously turning the mould upside down and pressing it pretty hard with his hands on one of the fine felts previously laid upon a very level pressing plank, by which means the tablet is left on the felt. The mould is

then returned to the vatman, who repeats the process as before. The coucher in the mean time lays another felt upon the sheet or tablet just couched, whereon the second sheet is to be laid in the same manner, and so on, till all the felts are occupied, over which another level plank is placed, and the whole drawn away on a small rail-road waggon to the great press, where it undergoes a pretty severe pressure.

The tablet will now be found to have sufficient adhesion to bear handling with care, and are separated from the felts, and placed one upon another, so as to form packs; these packs are to be submitted again to the action of the press, till more water is expelled, then are parted sheet by sheet, pressed and parted again, and this is repeated as often as necessary, taking care to increase the pressure every operation, until the face of the tablets is sufficiently smooth; they are then carefully dried, sized, picked, sorted, &c. carried to the rolling-mill, and several times passed between the polished cylinders, to give them their last finish. The above is the process for the plain or white tablets. In making the tinted tablets, the following additional particulars are to be attended to:-

The rags are cleansed, washed, and beaten into half stuff in the usual way, the water being drained off, the pulp is put into a vat with a solution in water of acetate of alumine, or sulphate of iron, as a mordant or ground to fix the colour, according to the colour intended to be made; the whole is well incorporated, and suffered to remain for half an hour or more, when the colouring tincture, previously prepared, is added; after which, the whole being returned to the engine is beaten into fine pulp, and then wrought into tablets.

The dyeing materials I chiefly make use of are Mangrove bark, Quercitron bark, best blue Aleppo galls, sulphate of iron, and acetate of alumine. A due combination of these materials produces a great variety of drabs, greys, sand-colours, &c. and I believe more permanent or fixed, than can be produced by any other means.

The advantages to be obtained by

this mode of manufacture over all others, are sufficiently explained in my former letter.

> I am, Sir,
> &c. &c. &c.
>> GEORGE STEART.

A.Aikin, Esq
Secretary, &c. &c.

Before this date all such heavyweight drawing 'boards' and papers had been produced by lamination, but Steart's new method of manufacture, although time-consuming and laborious, did not die with him. Versions of the mould he had developed continued to be used for making boards throughout the nineteenth century and both Green's, of Hayle Mill, Kent, who made RWS watercolour paper, and Arthur Millbourn and Co., of Tuckenhay, Devon, photographs of whose mill can be seen in cat.nos.1, 4, 5 and 9, used a very similar technique when producing their 'pasteless' watercolour boards throughout most of this century.

1 RSA, *Transactions*, vol.39, pp.43–9.
2 See RSA, *Minutes of the Society's Committee of Polite Arts*, 14 Feb. 1820, 28 Feb. 1820, 14 March 1820, 4 April 1820, 25 Jan. 1821.
3 RSA, *Minutes of the Society's Committee of Polite Arts*, 28 Feb. 1820.
4 RSA, *Minutes of the Society's Committee of Polite Arts*, 14 March 1820.
5 RSA, *Minutes of the Society's Committee of Polite Arts*, 23 Jan. 1821.

49

49 Sample of a 'Lino Stereo' tablet submitted to the RSA by George Steart

Blind-embossed stamp reading BATH / LINO STEREO / TABLET / BALLY ELLEN & STEART on an oval, supported by a lion and unicorn

Royal Society for the Encouragement of Arts, Manufactures and Commerce

[Not exhibited]

Steart submitted various samples of his new white and coloured papers to the RSA for their evaluation. This small sample carries a splendid example of a blind-embossed mark. Such marks were increasingly being used by papermakers, artists' colourmen and stationers to mark their wares and other examples of such

marks can be seen in this catalogue.

Steart also informed the Society of the following wholesale prices for his new papers. He produced his Lino Stereo tablets in several weights, ranging from what he called 'equivalent to 2, 3, 4, 5, or 6 sheets of drawing paper in substance.'[1] This sample is a six-sheet example. Examination of the Steart papers used by Turner suggests that he generally used the two- or three-sheet weights.

It will be noted that the list below does not show prices for Imperial (22 × 30 inches) sheets, the size of Steart's paper that Turner habitually worked on. It is presumed that Steart started producing the larger Imperial sheets following the success of the smaller sizes: no examples of Steart's Imperial sheets have a watermark date earlier than 1823.

With an average weekly wage of some 12s per week at this date, it can be seen that these papers were not cheap. Turner seems to have preferred the two and three sheet weights, although one or two examples of later flecked blue woves are heavy and dense enough to qualify as four sheet papers. Weight and cost both probably played a part in his choice.

1 *RSA MSS Transactions 1920–21*, letter from George Steart, 4 March 1820.

Wholesale prices of Lino Stereo tablets

Size	Weight	Price
Demy (18 × 14½ inches)	2 sheet	4/- per dozen
	3 sheet	6/- per dozen
	4 sheet	8/- per dozen
	5 sheet	10/- per dozen
	6 sheet	12/- per dozen
Medium (20 × 16½ inches)	2 sheet	6/- per dozen
	3 sheet	9/- per dozen
	4 sheet	12/- per dozen
	5 sheet	15/- per dozen
	6 sheet	18/- per dozen
Royal (22 × 18 inches)	2 sheet	8/- per dozen
	3 sheet	12/- per dozen
	4 sheet	16/- per dozen
	5 sheet	20/- per dozen
	6 sheet	24/- per dozen
Super Royal (25 × 18 inches)	2 sheet	10/- per dozen
	3 sheet	15/- per dozen
	4 sheet	20/- per dozen
	5 sheet	25/- per dozen
	6 sheet	30/- per dozen

50 Reassembled sheet, showing Petworth Church from the River 1830

Flecked blue wove watercolour paper, each sheet 190 × 141 (7½ × 5½) making a sheet 191 × 281 (7½ × 11)
No watermark
Made by: Bally, Ellen & Steart
Mill: De Montalt Mill, Combe Down, Bath, Somerset

Waterclour and bodycolour

TB CCXLIV 8, TB CCLIX 47
D22670, D24612
Illustrated on page 67

50A Micrograph of the verso of TB CCLIX 47 at × 22 magnification.
Illustrated on page 71

Turner produced some of his most stunning works on the blue papers produced by George Steart. Besides the Petworth group, from which this work comes, his series of watercolours on the Loire, Seine, Meuse and Moselle are all executed on batches of Steart's blue wove papers. During his lifetime Steart was very well known and his work merited mention in many different publications:

> The manufacture of stout and beautiful drawing boards has occupied the special attention of Mr George Steart, of De Montalt paper mills, Coomb Down, Bath.[1]

Many whole sheets in the Bequest can be reassembled, but it is rare to find a complete image that has been torn down right through its centre. Despite the individual histories of these two works and their different mounting histories, the tears match exactly and the palette and strokes used all relate to each other.

These two sheets, each one-sixteenth of an Imperial sheet, were separated at some point. The majority of the Petworth works on blue paper are on two different batches of this blue paper, both watermarked B, E, & S. / 1823.

Only one other Petworth work is a similar size to this, the work traditionally called *The Meet*, on the same batch of blue paper and measuring 192 × 278 (7½ × 10¹⁵⁄₁₆).[2] This work has the central fold, showing that it too would originally have been part of a folded Imperial sheet. Ruskin describes the bulk of the Petworth sheets as 'double sheets', implying that at the time he catalogued them,

many, though showing their folds, had not yet been torn down. The image of the church on the left was perhaps torn down for exhibition.[3]

One other Petworth work can be definitely identified as coming from the same Imperial sheet: TB CCLIX 41, *Fittleworth Mill on the River Rother*, the bottom edge of which butts exactly to the bottom edge of TB CCLIX 47.

1 'Paper Manufacture', *The Engineers and Mechanics Encyclopaedia*, 1836, p.255.
2 TB CCXLIV 104.
3 TB CCXLIV 8, *Petworth Church from the Lake* was exhibited as 702b, National Gallery, London. See Finberg 1909, vol.2, p.744.

51 Breaking Wave on a Beach

190 × 279 (7½ × 11)

Flecked blue wove watercolour paper
No watermark
Maker: Bally, Ellen & Steart
Mill: De Montalt Mill, Bath, Somerset

Watercolour and bodycolour

TB CCCLXIV 306
D36163

51A Micrograph showing the detail of the fading in some fibres and the yellowing of others in comparison with an unfaded area at × 15 magnification.
Illustrated on page 71

This particular paper from George Steart has faded dramatically as a response to its exposure to light, probably as a result of its exhibition in the National Gallery in the nineteenth century.[1] It comes from the same group of works as cat.no.52, *Storm Clouds over the Sea*, but is not actually from the same batch of paper. Examination of the verso shows that this particular batch of paper contains a range of rather different blue fibres to those usually found in Steart's papers, as well as a very small amount of red fibre. The verso has not been affected by light like the recto but some of these blue fibres are much paler in colour than usual. It is these fibres that have lost their colour, although the red fibres are much paler where they have been overexposed to light.

Compare cat.no.53, a sheet from another batch of Steart's paper, containing red fibres, and also exhibited at the National Gallery, which has not reacted to light in nearly the same way. Steart

51

generally used coloured rags in the beater but sometimes, perhaps when supplies were short, experimented with dyeing white rags in the beater. Dyeing rag in the beater is a specialist art and it would appear that in this instance too little blue dye was probably added to the furnish, too late in the beat, for it to really bite into the fibre. It is likely, given the fading visible in the red fibres, that they too were dyed in the beater rather than made from red rag.

The different batches of Steart's paper probably looked fairly similar to each other when new. Knowing that different artists would be attracted to different blues, he altered the batches quite often, deliberately producing slightly different tones of blue, darker, lighter, some warmer, some colder than others, by the addition of different amounts of other coloured fibres to the furnish. Small amounts of red linen rag, old tarred hemp rope, or yellow fibre all changed the colour of the finished sheet.

1 Exhibited drawings No.574a, National Gallery, London.

52

52 Storm Clouds over the Sea

192 × 276 (7¹/₂ × 10⁷/₈)

Flecked blue wove watercolour paper
No watermark
Maker: Bally, Ellen & Steart
Mill: De Montalt Mill, Bath, Somerset

Watercolour and bodycolour

TB CCCLXIV 420
D36288

52A Micrograph showing the detail of the fibres used in the furnish at × 15 magnification.

This sheet is of a deeper, greyer blue than most of the Bally, Ellen & Steart flecked blue woves used by Turner. Besides the usual blue and white linen rags that Steart generally used this batch of paper also contains some black and brown fibres, which are particularly visible in the verso. The origin of the black fibres has not yet been determined, but the brown fibres originate from old tarred hemp rope.

The work comes from a group of sheets catalogued by Finberg as seeming 'to have been made on the Southern Coast of England',[1] but there are several other works from TB CCCLXIV that must by their paper type, format, palette, handling and subject matter also belong to the same group: see cat.no.51 for just such an example. Unlike that work, the paper in this example, having been made from a very different furnish, has kept its colour very well indeed.

Steart experimented continuously with all sorts of furnishes, particularly with his flecked blue woves, producing a great variety in the tones, weights and colours of blue produced. Many of these different batches contain the same watermark dates, so many in fact that it may well be that Steart did not change his watermarks yearly as had been required by the Excise, but only used new watermark dates when pairs of moulds were replaced: the new mould pair being given the current year date, even if it were a year or three, or five, since the moulds were last replaced.

1 TB CCCLXIV 407–420, Finberg 1909, vol.2, p.1211.

52A

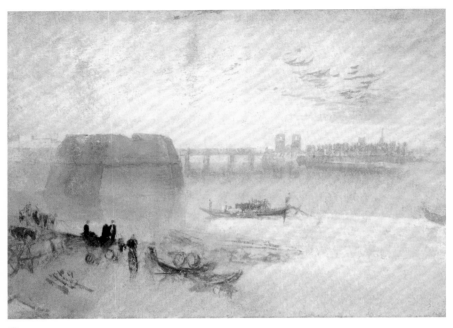

53

53 River with Bridge and Fortifications

138 × 180 (5⁷/₁₆ × 7¹/₁₆)
Flecked blue wove watercolour
paper
No watermark
Maker: Bally, Ellen & Steart
Mill: De Montalt Mill, Bath,
Somerset

Bodycolour and watercolour

TB CCLIX 100
D24665

53A Micrograph showing the paint layers and the detail of the fibres used in the furnish at × 25 magnification.
Illustrated on page 71

This so far unidentified subject, probably part of the the *French Rivers* series, is on yet another batch of Steart's paper containing red fibres, but of a very different type to that seen in either cat.no.51 or 52. This example is neither as bright a blue as TB CCCLXIV 420 nor as faded as TB CCCLXIV 306, despite having been exhibited during the nineteenth century when most of the fading seen in Turner watercolours occurred.[1]

Unlike many of the works on blue paper this sheet has been trimmed, losing its deckle and torn edges, leaving little

possibility of relating it to other works originally on the same sheet. Most of the torn-down sheets Turner used folded up as small 'blocks' of paper, which were torn down after use, but most of the blue papers appear to have been torn down into part sheets before being worked on. Comparisons of the edges suggest that he probably tore several sheets at a time, tearing against a wooden rule. This often produced quite ragged tears, but with several sheets in a pile each has very similar tears, making it impossible to reassemble the sheets correctly.

Most of the blue paper works are approximately Imperial 16mo (5¹/₂ × 7¹/₂ inches), but there are some examples of Imperial Octavo (7¹/₂ × 11). George Steart watermarked his Imperial sheets with the Letters B E & S plus the date of manufacture in the bottom right or bottom left of the sheet. When the sheet was torn or folded 16mo the watermark would be torn through dividing the mark approximately in half. With Imperial 16mo pieces one would expect to find two out of sixteen works containing half of the watermark; with Imperial 8vo to find a complete watermark in one in eight sheets.

1 Exhibited drawings, No.124. National Gallery, London.

54 Traben, Trarbach and the Grevenburgh *c.*1839

138 × 187 (5⁷/₁₆ × 7³/₈)
White wove paper, worked to make it appear to be part of a 'blue paper' series
Unknown maker, possibly John Muggeridge at Carshalton Mill

Watercolour

TB CCXXII P
D20275
Illustrated on page 67

54A Micrograph of the paint layer, at × 20 magnification, showing how Turner has approximated the effect of a blue paper.

Until 1991 and the preparations for Cecilia Powell's exhibition *Turner's Rivers of Europe: The Rhine, Meuse and Mosel* this work had always been assumed to have been executed on the same Bally, Ellen & Steart flecked blue wove watercolour paper used for all the other works in the series. But when the work was removed from its old backing it was found to have been worked on a white wove watercolour paper, very similar to those made by John Muggeridge at Carshalton Mill, Surrey (see cat.no.39), and that Turner had made the sheet part of a blue paper series by giving the visible background of the sheet a mottled blue appearance, approximating the blue of Steart's papers.

Although Turner worked on prepared papers with various coloured grounds, particularly pale greys, throughout his career, this is the only known example of him 'faking' a paper.

54A

55 On the Mosel 1839

186 × 232 (7³⁄₈ × 9³⁄₁₆)

Blue laid made on a double-faced mould
Chain lines: 1¹⁄₈ inch (28 mm) apart
Laid lines: 25 per inch (10 per cm)
Part watermark: Basle crozier on shield (top half)
Maker: Richard Bocking & Company
Mill: Kautenbach, Trarbach, Rheinland-Pfalz, Germany

Bodycolour and watercolour

TB CCCLXIV 249
D36095
Illustrated on page 68

55A Transmitted light image of the part watermark in this sheet. The complete watermark in the whole sheet reads RICHARD BOCKING / & / COMPAGNIE with a Basle crozier on a shield.

55B Micrograph detail of bodycolour and watercolour and the surface of the sheet at × 25 magnification.
Illustrated on page 72

This distinctive deep blue paper is part of a group of twenty approximately quarter sheets, all around the same dimensions as the work above. Some are worked in pencil and some in colour. All of the part sheets in the Bequest are torn down quarter sheets. They are quite opaque, with a rather wild look-through. Each contains either half the watermark or half the countermark. The complete watermark reads: RICHARD BOCKING / & / COMPAGNIE with a Basle crozier on a shield. The slight variations in the watermarks show that a pair of moulds was in use. Although the use of the Basle crozier (Baselstab) might suggest a Swiss origin for this paper and indeed variations in this mark had been in common usage by many Basle papermakers from the 1580s onwards,[1] over time the use of this mark spread to many German papermills, including the Kautenbach mill run by Richard Bocking (1794–1858), who had followed his father and uncle, Hans and Adolf Bocking, who had founded the mill in 1781.[2]

Powell describes how Turner, on the 1839 tour, voyaged down the Mosel to

55A

Coblenz and then doubled back overland, basing hmself at Cochem, working his way back upriver to Trier, drawing as he went.[3] The *Trèves to Cochem and Coblenz to Mayence* sketchbook contains several small pencil sketches of Trarbach and its neighbourhood (see cat.no.33).[4] It is highly likely that Turner acquired these sheets of rich blue paper in one of the small villages or towns on his journey, perhaps even at Trarbach, only four kilometres north of the Kautenbach mill. Perhaps some local told him of their local mill's blue paper, or gave him some. Although most of Turner's 1839 blue paper Mosel pictures show towns and villages from the river, a few works show that he explored inland as well. Turner spent some time at Trarbach, and drew the *Entrance to Trarbach from Bernkastel*,[5] on the road south out of Trarbach that would have taken him to the Kautenbach mill. A second work, *Trarbach fom the South*,[6] is worked from a viewpoint further up the hill, south along the track to Bernkastel.

These works on Bocking's paper relate very directly, in terms of palette and handling, to Turner's other blue paper Mosel works from this tour, but the larger size and the deeper, richer blue gave Turner a very different ground to explore. Powell suggests that the coloured Mosel scenes, such as this work, which contain no pencil but only paint, are a rare example of Turner working in colour on site, unlike his Bally, Ellen & Steart blue paper works which were painted away from the site, based on pencil sketches from his sketchbooks.[7]

The other Richard Bocking blue papers are TB CCCLXIV 246–250 and 252–258 and TB CCCXLIII 27–34. Although there are twenty quarter sheets

in all, they do not make up five whole sheets, but parts of six different whole sheets, leaving four quarter sheets unaccounted for.

There are no other examples of Turner working on this maker's paper other than the sheets listed above. These works are a very good example of Turner's habit throughout his working life of trying out a few sheets of a particular paper that had attracted him. Whether he would have continued to work on it if he had had more sheets is open to question.

1 See Tschudin 1958 for the history of this mark.
2 Johann Hönl, 'Die Papiermühle in Kautenbach', *Kreisjahrbuch Bernkastel-Vittlich*, 1982, pp.144–7.
3 Powell 1991, p.53.
4 Powell 1991, pp.220–1. TB CCXC 9v, 20v, 21r, 21v, 22r, 22v, 23r, 25r, 25v–26r, 26v.
5 TB CCXXI G, bodycolour and watercolour on B E & S blue paper and TB CCXC 22r, pencil.
6 TB CCXX P, bodycolour and watercolour on B E & S blue paper.
7 Powell 1995, p.124.

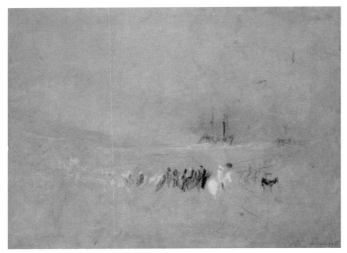

56

56 A Steamer off the Coast *c.*1840s

185 × 245 (7^{1}/$_{4}$ × 9^{5}/$_{8}$)
Lightweight bright blue wove paper, probably machine made, laid down onto a later cream wove paper
No watermark
Unknown maker

Black and white chalk

TB CCCXLIII 35
D34336

56A Raking light detail of the surface of the sheet at × 30 magnification.

As the Victorian Age dawned a fashion grew for brighter – often to our eyes quite garish – papers for certain uses such as the pages of albums, ladies' pocket books, friendship and commonplace books. The style demanded alternating a range of colours such as lilacs, blues, yellows, pinks, oranges and greens throughout the book. However, although the colour of this sheet is typical of such papers, particularly those of French manufacture, there is no evidence that this paper was ever part of an album. It appears to have been part of a much larger sheet, not found elsewhere in the Turner Bequest. Some details of the wire profile seen under high magnification would suggest that it may well be machine-made, but there are no indications as to its origin.

The combination of an extremely lightweight flimsy paper and the black and white chalk has led someone to lay the sheet down onto a heavier off-white wove paper to protect it. It is unlikely that Turner himself mounted this work. Various details suggest that this was done after his death. The backing paper shows some similarity with the 1850s machine-made woves used to mount up several of the papers in the Bequest, such as many of the pages of the so-called *Grenoble* sketchbook of 1802. Twenty of the sheets from this group are mounted on a heavily sized machine-made paper with a distinctive wire profile on one side of the sheet.[1] This paper is very typical of papers produced by the Ardêchois papermakers, Canson Montgolfier at Vidalon and Johannot at La Faya. Finberg notes, after TB LXXIV, that these works 'have been mounted on Cartridge by Mr Ruskin'.[2]

1 TB LXXIV 51–3, 55–82, 95. Three other works from this group have been mounted on a late eighteenth-century French heavyweight white laid printing paper.
2 Finberg 1909, I, p.199.

56A

57 Wurzburg: the Domstrasse, with the Town Hall, Cathedral and Vierröhrenbrunnen 1840
From the *Wurzburg, Rhine and Ostend* sketchbook

Brown marbled paper-covered boards, with pocket on the inside front cover (bound like a banker's pass book)
112 × 176 × 20 (4^{3}/$_{8}$ × 6^{15}/$_{16}$ × 3/$_{4}$)
Page size: 172 × 101 (6^{3}/$_{4}$ × 4)
Flecked pale blue double-faced laid paper
Chain lines: approximately 27–9 mm (1^{1}/$_{16}$ inches) apart, variable
Laid lines: 8–9 per cm (20 per inch) variable
Watermark: Stylised Tree of Liberty
Countermark: Indecipherable maker's name
Unknown maker

Pencil

TB CCCIII 88v, 89
D30631, D30632

57A Transmitted light image of the reassembled watermark from
TB CCCIII I, 2, 3, 8

57B Micrograph of the graphite on the laid surface taken from
TB CCCIII 88v at × 20 magnification.

This sketchbook has been included in the coloured papers section of the exhibition because the blueness of the sheet appears to be quite deliberate, rather than merely the slight blue effect seen in many corrected white papers where smalts, indigo or prussian blue have been added to low grade rags in small amounts to make the paper appear whiter.

Although the maker of this paper has not yet been identified there are several clues as to its origin. Comparisons with various papers in the Bower collection suggest a possible south German origin for the paper and a manufacturing date somewhere in the 1820s.[1] One sheet in particular, dating from the 1820s, a flecked buff laid, watermarked with the Tree of Liberty and countermarked LR, is on a mould of very similar construction.[2] This paper was made by Ludwig Roeder (or Roedter), at Neustadt a d Weinstrasse in Rheinland-Pfalz, some sixty miles or so from Wurzburg[3] and where Powell suggests that this sketchbook was possibly bought. Turner stayed in Wurzburg in September 1840 at the

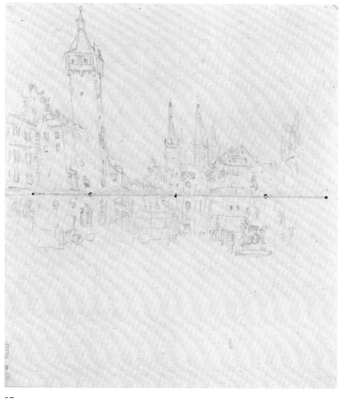

57

57A

57B

Wittelsbacher Hof in the market place, before returning home by steamer down the Rhine and via Ostend.[4]

The Roedter and Gossler families, also from the same village, produced a great amount of paper for ledgers and note-books, used in many parts of Germany from the late 1790s until well into the 1840s. Much of it is of relatively poor quality and like the paper in this sketch-book has a very poor formation, very variable finish and weight, and possibly straw and other non-rag included in the furnish. The brown cover paper is also typical of the covers used on many of the birth, death and marriage registers made up with Roedter or Gossler papers.

The Tree of Liberty watermark originated in southern Germany[5] but its use can be found, particularly in the years immediately following the French Revolution, in France, Holland and Germany.[6] Its use in a notebook nearly fifty years after the event suggests either that the paper was old stock, or that it had been made on a relatively old mould: the Roedter paper mentioned above dated from nearly twenty years before.

1 Bower Collection, 9206–9223, 9225–39.
2 Bower Collection, 9213.
3 Albert Jaffe, 'Zur Geschichte des Papieres und Seiner Wasserzeichen', *Pfälzisches Museum Jahrgang*, 1930, p.77.
4 Powell 1995, pp.144–5.
5 Heawood 1996, see watermark 3949.
6 Gaudriault 1995, watermark 713, records a Tree of Liberty mark from Revolutionary Year 2, made by Thomas Le Maître of Morlaix. Churchill 1935, no.209, also records the use of this image in Holland, by the papermaker Jan Kool, during the period of the Revolutionary Republic of Batavia proclaimed in 1795.

58 St John's College and In Merton Fields 1834
From the *Oxford* sketchbook

Quarterbound sketchbook with marbled paper-covered boards, maroon leather spine and corners and single line gold tooling
154 × 240 × 9 (6¹/₁₆ × 9½ × ³/₈)
Page size: 146 × 234 (5¾ × 9¼)

This sketchbook contains three different papers:

1 Grey wove drawing paper
TB CCLXXV 1 and 6, 8 and 14, 10 and 11, 18 and 19, 24 and 29
Watermark: 1816, in TB CCCLXXV 11, 14, 19, 24
Made by: Probably John Dickinson
Mill: Apsley, Nash or Home Park Mills, Hertfordshire

2 Cream wove drawing paper
TB CCLXXV 2 and 5, 16 and 21, 25 and 28
Watermark: B, E & S / 1828, in TB CCLXXV 21, 25
Made by: Bally, Ellen & Steart
Mill: De Montalt, Combe Down, Bath, Somerset

3 Pale buff wove drawing paper
TB CCLXXV 3 and 4, 7 and 15, 9 and 13, 17 and 20, 22, 23, 26 and 27
Part watermark: E & S / 1828, in TB CCLXXV 3, 9, 15, 27
Made by: Bally, Ellen & Steart
Mill: De Montalt, Combe Down, Bath, Somerset

Pencil

TB CCLXXXV 25 verso, 26
D27932, D27933

58A Transmitted light image of the two parts of the complete B, E & S, / 1828. watermark from TB CCLXXXV 21 and 25.

58B Transmitted light image of the 1816 watermark from TB CCLXXXV 11.

58C Micrograph of graphite on the buff paper, TB CCLXXXV 26 at × 20 magnification.

The pages illustrated here show Turner drawing right across the join on two of the different papers found in this relatively expensive sketchbook: few were quarterbound in this quality. It is rare to find quality coloured drawing papers from Bally, Ellen & Steart in use in sketchbooks. Although the format of this

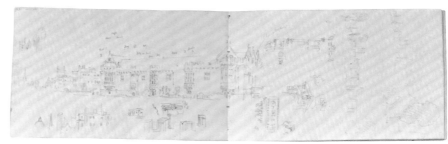

58

58A

58B

58C

sketchbook is not uncommon, the actual construction of the book is quite unusual. The dimensions relate to Super Royal Octavo, but the two Bally, Ellen & Steart papers used here were only made in Imperial, which suggests that five long strips, from the short edge of the sheet, were cut from a pile of sheets and then bound together, rather than folding whole sheets down to the desired size. There are parts of two different sheets of the cream, four different sheets of the pale buff and two or possibly four different sheets of the grey. There were several British papermakers who watermarked their sheets with just a date and no other identifying marks. Details of the size, shape, and position in the sheet suggest that this paper was made by John Dickinson at one of the three Hertfordshire mills he operated at this date: Nash, Apsley or Home Park.

Dickinson made paper using two different methods, by hand and using the cylinder mould machine which he had invented.[1] Most of this cylinder mould paper was produced for printing. The cylinder mould machine produces individual sheets of paper rather than the continuous web formed by a Fourdrinier machine. Dickinson's machine was originally employed in making book and printing papers rather than drawing and watercolour papers. These machines are

still in use, now mostly used for fine security and artists' papers, including watercolour papers, where their relatively slow speed allows the use of much longer fibres than can be easily used on an ordinary Fourdrinier machine.[2] When using date-only watermarking Dickinson usually, but not always at this date, placed two watermarks in each sheet rather than one.

The binding of another sketchbook, of very similar format although very slightly different dimensions (150 × 241 × 19 mm) suggests the same origin as this sketchbook. The *First Mosel and Oxford* sketchbook (TB CCLXXXIX), with identical leather quarterbinding but different marbled papers was used on Turner's 1839 tour of the Mosel, but the Oxford sketches, which clearly pre-date them, probably date from the same period as this sketchbook.[3] The paper used in the *First Mosel and Oxford* sketchbook is a pale cream wove drawing paper watermarked J WHATMAN / TURKEY MILL / 1834.

1 John Dickinson developed various forms of his cylinder mould machine, patenting his improvements in Patent No.3191 of 1809, Patent No.3425 of 1811 and Patent No.3839 of 1814.
2 Mould-made artists' papers are currently made by Inveresk and Whatman in Britain, by Arches, Rives and Lana in France, Fabriano in Italy and by Rising in the United States.
3 Powell 1991, p.218.

59 Reassembled sheet made up of seven different works with views of Regensburg and the Walhalla 1840

Whole sheet size: 762 × 559 (30 × 22) Torn down into eight irregular sized pieces, each approximately 194 × 280 (7½ × 11)
Imperial
Medium-weight grey wove
Watermark: B E & S / 1829
Made by: Bally, Ellen & Steart
Mill: De Montalt Mill, Bath, Somerset

Pencil; pencil and bodycolour; bodycolour and watercolour

TB CCCXLI 360, 363, 364 and 371, TB CCCXVII 6, TB CCLXIV 293 and 296
D34081, D34084, D34085, D34093, D32185, D36159 and D36153
Illustrated on page 69

59A Verso of the reassembled sheet.

59B Transmitted light image of the watermark, found in two halves in TB CCCXLI 364 and TB CCCLXIV 293.

59C Micrograph of the paint layers and paper surface at × 10 magnification.

Nineteen either whole or part sheets have so far been identified among the large group of Bally, Ellen & Steart grey wove papers in the Turner Bequest. Many of them can be reassembled in the manner shown here. Turner had many different ways of treating different papers. Some were torn down into smaller pieces in batches of two or three sheets at a time, using a rule. This technique produces very similar tears in each sheet in the pile at similar points in the sheet. Most of the flecked blue papers from Bally, Ellen & Steart appear to have been treated in this manner. Such sheets are not really worth reassembling as it seems likely that the small sheets were worked on in no particular order in relation to the sheets of paper from which they originally came.

This sheet was folded prior to working and torn down later. It can be reassembled thus, but with one-eighth of the sheet still unaccounted for:

CCCXLI 363v	CCCXLI 371	CCCXLI 360v	CCCXVII 6
CCCLXIV 293v	CCCXLI 364	CCCLXIV 296	[]

These views of Regensburg and the Walhalla are all within walking distance of each other. Powell describes *Regensburg from the Bridge* and the *Distant View of Regensburg from the Dreifaltigkeitsberg*, the two finished works in this sheet, as being on Turner's 'early morning walk to the Walhalla' so what we have here is essentially a record of a walk Turner took in September 1840.[1]

Turner's method of working on these sheets was to fold them into eight or sixteen (and sometimes into even smaller pieces) and refold them as and when a new working surface was required. There is evidence that sometimes these relatively heavyweight and dense Imperial sheets (nominally 30 × 22 inches) were in fact torn in half before they were folded, but in many cases both halves were then

59B

59A

59C

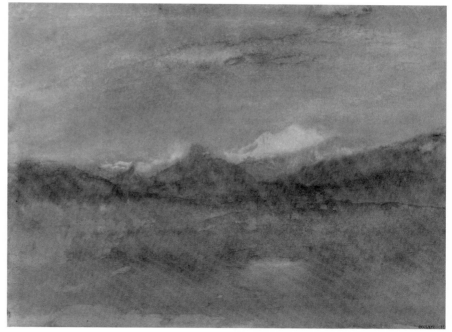

60

taken out to work on. The sheets were not always refolded to the original fold: some of the sheets bear the traces of several folds, being finally torn down along one or other of them, or sometimes in a slightly different position altogether. The original folds are particularly visible in another of the reassembled sheets and can be seen running across the surfaces of TB CCCXLI 358, 375, 377 and 376.[2]

1 See Powell 1995, pp.165–8 for a discussion of these works.
2 This whole sheet consists of another 1829 Bally, Ellen & Steart medium-weight grey wove watercolour paper, torn down into eight irregular sized pieces, each approximately 7½ × 11 inches (194 × 280 mm), and made up of
CCCXLI 358 CCCXLI 375 CCCXLI 377 CCCXLI 376
CCCXLI 372 CCCXLI 374 CCCXLI 355 CCCXLI 357

60 Swiss Lake and Mountains

241 × 313 (9½ × 12¼)

Deep buff wove watercolour paper
No watermark
Unknown maker

Watercolour and bodycolour

TB CCCLXIV 374
D36236

60A Micrograph of the paint layers, texture and process dirt present at × 20 magnification.

60A

61 Valley with Distant Mountains

214 × 320 ($8^7/_{16}$ × $12^5/_8$)

Cream wove watercolour paper
Watermark: CRESWICK / 1818
Maker: Thomas Creswick
Mill: Mill Green Mill, Hatfield,
Hertfordshire

Watercolour and bodycolour

TB CCCLXIV 212
D36058

61A Transmitted light image
showing the CRESWICK / 1818
watermark.

61B Micrograph of the paint layers
and the rough texture of the sheet at
× 10 magnification.

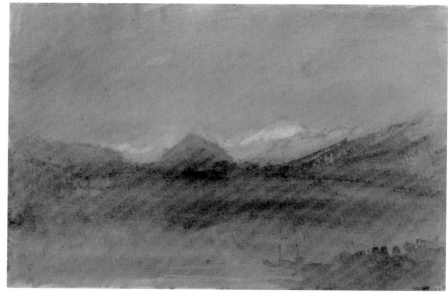

61

The similarity of these two images, the
palette used and the handling of the
paint show these works to have been
done at the same time. But the two
papers are very different. The cat.no.60
sheet is darker in tone and its glazed sur-
face is very much smoother than
cat.no.61.

Rough textured surfaces, of the sort
seen in cat.no.61, are produced by the
texture of the felts during the paper's first
wet pressing after formation. Such sur-
faces became increasingly popular with
some artists from the early years of the
ninetenth century onwards, but it was a
kind of surface that Turner himself rarely
worked on. This warm creamy buff sheet
was made by Thomas Creswick, who
specialised in a range of very distinct sur-
faces. His heavyweight rough-surfaced
watercolour papers were a great favourite
with Turner's contemporary, Peter De
Wint (1784–1849) among others.

One curiosity of this sheet is that it
appears, from the traces of stitch holes on
the left-hand edge, to have come from a
sketchbook, but aside from one other
work, TB CCCLXIV 211, there are no
other sheets of this particular paper
which have so far been identified among
Turner's work. If TB CCCLXIV 211 is
indeed another page from the same
sketchbook the evidence is now lost
because that sheet, damaged slightly on
both short edges, has been slightly
trimmed down.

Although it is possible that both these
papers were made at Hatfield Mill, Hert-
fordshire, by Creswick, who produced a
range of smooth boards as well as rough

61A

61B

surfaced papers, the condition of the fur-
nish used in the manufacture of the sheet
seen in cat.no.60, full of process dirt and
shives, is untypical of Creswick's work.
There are no other sheets in the Bequest
that come from the same source.

62 Reassembled sheet 1840

Imperial
Torn down into sixteen irregular
sized pieces, each approximately
140 × 194 (5½ × 7½)
Medium-weight pale green-grey
wove
Formation: fair
Watermark: SMITH & ALLNUTT /
1827 (the two halves of this mark are
found in TB CCCXLI 89 and 21)
Maker: Thomas Smith and Henry
Allnutt
Mill: Great Ivy Mill, Maidstone,
Kent

Pencil and white chalk

TB CCCXLI 21–25, 64–67, 85, 87–89,
369
D33700–33704, D33743–33744,
D33764, D33766–33768,
D34090

62A Transmitted light image of
the watermark in TB CCCXLI 21 and
89.

62B Micrograph of the graphite
and chalk on the paper surface at
× 25 magnification.

This sheet is one of three Smith &
Allnutt 1827 grey-green woves in the
Bequest.[1] It can be reassembled, with
one work missing, as follows:

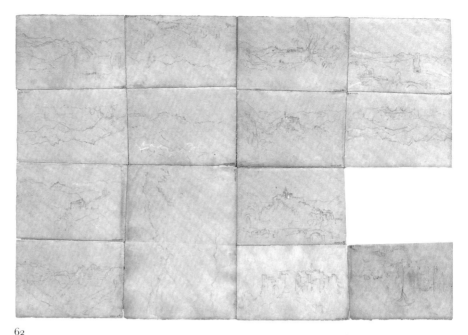

62

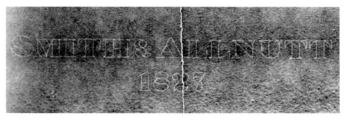

62A

CCCXLI 24	CCCXLI 25	CCCXLI 89	CCCXLI 21
CCCXLI 65	CCCXLI 85	CCCXLI 88	CCCXLI 23
CCCXLI 87		CCCXLI 67	[]
CCCXLI 64	CCCXLI 369	CCCXLI 22	CCCXLI 66

TB CCCXLI 369 is twice the size of the
other pieces, being one-eighth Imperial
rather than one-sixteenth, ie: 7½ × 11 ins
(194 × 280 mm).

Trade directories show Smith and All-
nutt at this date making 'White, Cream
and Fancy papers'. Later in the century,
operating both Little and Great Ivy Mills
as well as Lower Tovil Mill, Henry All-
nutt and Son were makers of 'Drawing,
Chart, Tinted and Coloured Papers'
with one Fourdrinier machine and one
vat.[2]

Researching the origins of different
papers one comes across all sorts of
stories. Often the records tell of accidents
and disasters, bankruptcies and fires, but
occasionally one finds a tale with a hap-
pier outcome. At about the time Turner

was using this paper in 1840 a journey-
man papermaker named Robert
Howard, working for Smith and Allnutt
at Ivy Mill,

> received the unexpected information
> that a Chancery suit, which had been
> pending for 50 years, had terminated
> in his favour, putting him in possession
> of £200,000 – £50,000 of which, by
> an engagement entered into many
> years ago, and which, with the suit
> itself, was almost forgotten, goes to the
> attorney who succeeded in bringing
> the suit to a successful termination.[3]

Turner had worked on Smith and All-
nutt's paper before, and indeed on
papers made at Ivy Mill from the period
before Smith and Allnutt took it over, but

these three sheets are the only examples
of his working on coloured papers from
this maker.[4]

62B

1 The two other sheets, both of which have missing portions, are also watermarked SMITH & ALLNUTT / 1827. They can be reassembled thus:
Sheet 1:

CCCXLI 28	CCCXLI 90	CCCXLI 92	CCCXLI 91
CCCXLI 27	CCCXLI 26	[...]	[...]
CCCXLI 51	CCCXLI 50	CCCXLI 234	CCCXLI 68
CCCXLI 54	CCCXLI 52	CCCXLI 93	CCCXLI 49

Sheet 2: (TB CCXLI 373 is twice the size of the other pieces.)

[...]		CCCXLI 81	[...]
CCCXLI 373	CCCXLI 62	CCCXLI 84	CCCXLI 53
CCCXLI 63	CCCXLI 237	CCCXLI 85	CCCXLI 95
[...]	CCCXLI 235	CCCXLI 236	CCCXLI 82

2 Simmons Collection of Data on Watermills: Kent, Science Museum Library Archives.
3 *Stamford Mercury*, 11 Sept. 1840.
4 Turner was using Edmeads and Pine paper, made by Smith and Allnutt's predecessors at Ivy Mill in the 1790s. See also Bower 1990, pp.114–16 for listings of earlier Smith and Allnutt papers used by Turner on his 1819–20 tour of Italy.

63B

63A

63 Venice: The Ducal Palace: The Porta della Carta *c.*1833–5

294 × 229 (11⁹/₁₆ × 9)
Royal quarto
Pale buff wove
Part watermark: J W
Unknown maker
Watercolour and bodycolour

TB CCCXVIII 28
D32247
Illustrated on page 68

63A Transmitted light image of the part watermark.

63B Micrograph of the felt texture of the sheet at × 20 magnification.

This quarter Royal sheet is unlike any of the other papers used by Turner on this visit to Venice. Despite the similarity of the J W letter forms, found in the part watermark, to J WHATMAN watermarks at around this date, the tone and texture, particularly the surface seen on the verso of the sheet, suggest that a completely different felt, with an unusual weave, has been used in the couching of this sheet. No examples of this weave have been found in any other 'Whatman' papers.

This paper, like that seen in the *Trieste, Graz and Danube* sketchbook that Turner used in 1840 (cat.no.35) is a forgery of a Whatman paper, but probably not made at the same mill that produced the papers in that sketchbook. Whether this fake Whatman is of Austrian or French manufacture has still to be determined, but the colour and texture are more reminiscent of the Whatman papers produced in Austria, by the three different mills involved in this trade and run by the Ettel family, Peter Weiss and Anton von Pachner, than those made by Canson Mongolfier at Annonay in the Ardêche.

Regardless of the source of the paper Turner has responded to its warm tones by leaving large areas of the paper unpainted, using the colour of the sheet itself as a dramatic and important part of the image. This is perhaps appropriate as the work itself shows the Porta della Carta: the Paper Door or Gate. Whilst *carta* generally means paper, it can also mean, by extension, bills or bonds. This doorway was where Venetian merchants traditionally settled their debts.

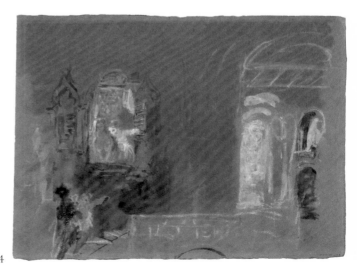

64

64 Venice: The Lovers, a Scene from *Romeo and Juliet* c.1833–5

239 × 315 (9⅜ × 12⅜)
Royal quarto
Red-brown wove
Watermark: M + Laurel leaves /
649 (in the complete sheet)
Maker: Cartieri Pietro Miliani
Mill: Fabriano, Italy

Watercolour and bodycolour

TB CCCXVIII 20
D32239

64A Micrograph of the surface of
the sheet at × 15 magnification.
Illustrated on page 72

The group of Venetian brown paper
drawings that date from 1833–5 are not
all on the same paper. Turner has chosen
to explore some aspects of Venice on a
range of very different papers, most of
which he probably purchased in Venice
to augment the English-made papers he
had taken with him to Italy. Some of the
sheets catalogued by Finberg as brown
are in fact grey papers (see cat.no.65) and
of the brown sheets there are three dis-
tinctly different papers, from makers in
three countries.

As with many of the groups of papers
found in the Turner Bequest, it is possi-
ble to reassemble some of the whole
sheets that Turner used, either complete-
ly or in part. This particular work
formed part of a sheet made up from
different sized pieces taken from works
from three separate Finberg categories:

CCCXVIII 20V	CCCXVIII 11
CCCXLII 71V CCCXLII 70	
	CCCXIX 3V CCCXIX 6V
CCCXLII 69V CCCXLII 68	

This well-formed, rich dark-brown wove
Royal sheet has a full sheet size of 18½ ×
24 inches. It was first torn down into
irregular quarters, each approximately
9½ × 12 inches (241 × 305 mm). Two of
the four quarters have been further torn
down: the TB CCCXLII group of four into
one-sixteenth Royal, all approximately
4½ × 6 inches (114 × 152 mm) whilst the
TB CCCXIX pair are both Royal Octavo,
5¾ × 8⅞ inches (145 × 224 mm).

The number in this watermark is not a
date, but a batch or mould number, a
common feature of some southern
French papermakers such as Johannot
and Canson Montgolfier, both of
Annonay, Ardêche, as well as many
Italian makers. This habit of numbering
moulds seems to have evolved in the
early years of the nineteenth century as
mills got larger and started to increase
the number of vats in operation. Some of
the larger English mills, such as the Kent
mills, Springfield and Hayle, also intro-
duced a form of this numbering much
later in the century.

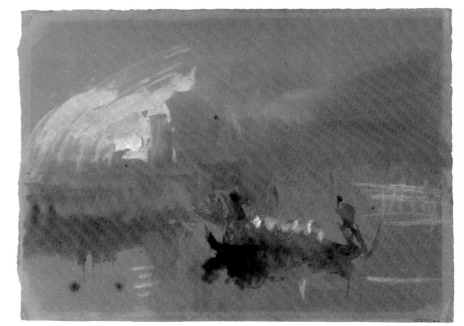

65

65 Venice: Moonlight c.1833–5

215 × 287 (8⁷⁄₁₆ × 11³⁄₁₆)
Grey wove, now heavily discoloured
No watermark
Unknown maker

Watercolour and bodycolour

TB CCCXVIII 3
D32222

65A Micrograph showing the
difference in colour between the true
grey of the sheet and the effect of
light on the surface of the sheet at
× 15 magnification.
Illustrated on page 72

Several of the 'brown' papers that Turner
worked on in Venice are actually on diff-
erent tones of grey, and mostly of Italian
manufacture. Some, including this sheet,
have been badly affected by light dam-
age, turning from grey to various tones of
dark brown.

None of the sheets of this grey paper is
watermarked, but the wire profile and
felt texture seen in the surface sufficiently
resemble those seen in *Venice: Entrance to
the Grand Canal* (cat.no.67) to suggest that
they probably came, if not from the same
mill, then from a mill in the locality that
used the same mouldmaker and felt mak-
ers.

Other sheets from this very opaque
paper include the partly reassembled
sheet:

CCCXIX 9V [...] CCCXIX 7 CCCXIX 4

CCCXIX 8 CCCXIX 3 [...] CCCXIX 10V

Two other different grey papers, both slightly lighter in tone than this sheet, probably come from the same paper-maker[1] and two other works are from sheets of a medium-weight grey wove, made by Bally, Ellen & Steart, water-marked B, E & S / 1829 and made at De Montalt Mill, Monckton Combe, Somerset.[2]

1 TB CCCXVIII 15, 16.
2 TB CCCXVIII 7, 11.

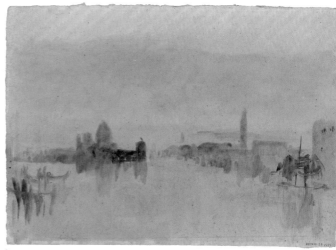

67

66 Venice: A Procession, perhaps in the Piazza *c.*1833–5

225 × 290 (8⅞ × 11⅜)

Lightweight buff-grey wove
Watermark: w
Unknown maker

Watercolour and bodycolour

TB CCCXVIII 14

D32233

66A Micrograph of the surface of the sheet at × 15 magnification.

This quarter sheet is part of a well-formed lightweight buff wove sheet that also includes TB CCCXVIII 13. The sheet was torn down into four irregular sized pieces, each approximately 9 × 11½ inches.

The design for the large outline Roman letter w used as the watermark suggests an English origin for this sheet, but the full sheet size of approximately 17¾ × 22¾ only matches one English paper size, Extra Large Post. This is a sheet size normally used for white writing paper rather than coloured papers. Labarre lists a German paper size, Gross Median (460 × 590 mm) used for coloured writings and blottings, which may perhaps suggest a German origin for this paper.[1]

Another part sheet of this same paper has been erroneously catalogued as part of the *Grenoble Sketchbook* (TB LXXIV C). This is a sheet 215 × 282 mm (8½ × 11⅛ inches) also watermarked w in an outline

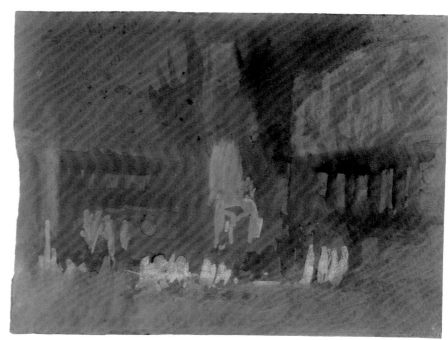

66

capital. The colour difference between TB LXXIV C and the two TB CCCXVIII examples has come from the different histories of the two sheets. Wilton dated this work to 1843.[2]

1 Labarre 1952, p.286. In 1884 the German Federal Council approved a list of standard sizes, regularising existing practice in the German industry which included this paper size and description.
2 Russell and Wilton 1976.

66A

67 Venice: Entrance to the Grand Canal 1840

242 × 305 (9 × 12)
Pale grey-white wove
Part watermark: 72

Watercolour

TB CCCXVI 13
D32150

67A Micrograph of the surface texture of the paper at × 15 magnification.

Turner worked on several different sheets of this paper, which has a very distinctive surface. The sheets range in tone and colour from light brown to almost white and are of very variable quality: in some sheets the furnish is relatively clean, while others are full of specks and process dirt. Some of the sheets are well formed but others show considerable weight and density variations even across the sheet.

TB CCCXLI contains forty-one works on quarter sheets of this paper, most of them containing parts of a very distinctive watermark of the letters CS and laurel leaves, centred along one of the long edges of the sheet with another watermark, of three numbers centred on the opposite long edge. All of these have been torn down from full sheets of Royal, nominally 18 × 24 inches (456 × 608 mm). Several different numbers, denoting pairs of moulds, have been found in the watermarks, including 161, 181, 191, 291, 591, 721.[1]

Eineder records one CS / Laurel Leaves + 591 watermark in a wove paper, dating from 1822, and attributes it to an Austrian source, but comparisons with the CS / Laurel Leaves + Fleur-de-Lys marks that he records in laid paper, all dating from 1830–43, suggest that they are all from the same source, one of the Brescia mills in Lombardy.[2]

Eineder makes the point that, whilst the letter C would in many parts of Italy stand for the initial of a papermaker, in Lombardy watermarking practice 'C Stands mostly for Cartiera'.[3] Unfortunately few of the mills or makers in the Brescia region have been identified. The *National Encyclopaedia of Austria*, published in 1836, states that seventy-two paper-mills were operating in the area around Brescia. Eineder discovered that some

thirty-two of these worked the Toscolano stream running into Lake Garda, but forty mills have still to be identified.[4]

Turner must have purchased these papers in Italy. The prices charged for his papers by another Lombardy maker, Galvani, in 1820 are known and are worth considering:

67A

'In Reams of 480 sheets'

Draft Paper	f2.20 – f3.45	
White Paper	5.30	
Three Hats	3.00	(so-called from the watermark)
Lion	4.00	(so-called from the watermark)[5]
Superfine Cream	6.30	

'In Reams of 461 sheets'[6]

Minister Wove	f11.00	
Minister	8.00	(Boudoir size)[7]
Holland Post	7.00	
Letter Paper	2.30–3.30	(in half sheets)
London Copy Paper	5.00	

In another list, 'In Reams of 500 sheets', Galvani noted down the equivalent prices for imported Dutch and English papers of the same quality and type. These prices are also listed below for comparison.

Music Paper	f11.00		
Three Moons	4.30	(so-called from the watermark)[8]	
Mezzata	6.30		
Royal	8.30–15.00		
Imperial	17.00–30.00		
Great Colombier	50.00–60.00		
Copper plate	20.00–50.00		
Drawing Royal	30.00	Dutch 35.00	English 80.00
Drawing Imperial	60.00	Dutch 115.00	English 200.00
Gran Papale Wove	300.00	English Antiquarian	1,500.00[9]

1 Parts of different three number groups found in the watermarks include:
 1... in TB CCCXLI 288
 16.. in TB CCCXLI 258, 301, 306,
 ...1 in TB CCCXLI 244, 308,
 18.. in TB CCCXLI 239
 19.. in TB CCCXLI 314
 291 in TB CCCXLI 245 and 275, 361 and 444, etc.
2 Eineder 1960, watermark 896, dated to 1822 from Court Archives, Com.1227. Molo. The laid marks he records are as follows, Eineder 633, date of document 1830, Court Archives, Pt Deeds /535. Milan. Eineder 636, date of document 1831, Court Archives, Pt Deeds/539, Rovereto. Eineder 635, date of document 1835, Court Archives. Dom/5, Como. Eineder 639, date of document 1843, Court Archives, Dom/5, Venice.

3 Eineder 1960, p.175.
4 Eineder 1960, p.166.
5 So-called from the watermark of the Lion of St Mark. Equivalent in size and usage to English Foolscap paper.
6 This is an unusual number for a ream and consisted of 425 good sheets and 36 'outsides'.
7 Boudoir, 5½ × 4½ inches, was a folded notepaper size.
8 Three crescent moons, a watermark used originally for papers destined for export to the Islamic market.
9 Derived from Eineder 1960, p.170.

Boards and Other Papers
(cat.nos.68–70)

Some of the sheets Turner worked on were boards rather than papers. Definitions of what constitutes a board or a paper have changed somewhat over time but generally sheets below 150 gsm in weight are definitely paper, sheets over 250 gsm are boards and sheets between 150 and 250 gsm may be either.[1] The picture is further complicated by the methods of production used: paper is generally formed as a single sheet, boards may be formed as a single sheet using a board mould, or may be built up in layers, either on a board machine or as 'paste-less' boards where individual handmade sheets are couched together to form the board. Boards may also be produced by laminating two or more sheets together with glues.

It is arguable that the heavier-weight Bally, Ellen & Steart sheets should more properly be considered boards, given that their process of manufacture, described in the entry to cat.no.42, makes use of a version of a board mould, where the sheet is formed on an oaken mould, with a deeper than usual deckle, and a second 'top mould' is then placed on the newly formed sheet, inside the deep deckle, and then pressed to de-water the sheet.

The main types of board used by Turner were 'Bristol', 'London', and 'Superfine Drawing' boards, although a few examples of other types such as Ivory board and Millboards can be found among his work. Many of these boards were distinguished by the impression of blind-embossed marks in the corner, identifying the type and or the maker of the board. There are examples of several such stamps in the Bequest and each of the three boards shown here carries a different mark.

BRISTOL / Crown / BOARD in a circle (cat.no.70)[2]
EXTRA SUPERFINE / Arms of the City of London / LONDON BOARD in a vertical oval (cat.no.69)
EXTRA SUPERFINE / Crown / DRAWING BOARD in a vertical oval in a cream wove, watermarked J WHATMAN / 1841 (cat.no.68).[3]

The design of these stamps changed over time, particularly as new dies were cut to replace those that had worn out. This can be very useful in dating otherwise undated works of art or documents.

These boards were made up using two, three, four, five, six, or even eight sheets of hot-pressed drawing paper, laminated together and

then given a very high glaze by being placed between two very smooth metal plates and passed through a set of glazing rolls. The finished board was then trimmed. This method of manufacture was originally developed for the production of playing cards, but soon became used for visiting cards and later by artists. Companies such as Reynolds, Turnbull and Creswick produced an increasing variety of products to satisfy a growing sophistication in their trade customers, colourmen like Reeves, James Newman, and Winsor & Newton. Winsor & Newton's earliest trade catalogue offers 'Bristol and London Boards, Plain and Coloured'.[4] The earliest catalogue gives no prices but by the mid-1830s two-sheet Foolscap London boards sold for 2s 7d per dozen and the heavier six-sheet board for 7s 9d per dozen.[5] Three-sheet Demy boards were for sale from Winsor & Newton in 1840 for 5s per dozen. In response to increasng demand the price of such boards dropped throughout the 1840s and by 1851 had fallen to 3s 6d a dozen.[6] The biggest suppliers to the trade of such London, Bristol and Drawing boards to the London market were Turnbulls, of Holywell Mount, London.[7] Their products can be found in use by artists all over Britain and are listed in many of the trade catalogues issued by the London colourmen.

It has often been supposed that the distinction between London boards and Bristol boards, most of which were made by the same manufacturers, lay in the choice of papers: that London boards were made only from the finest Whatman paper and that Bristol boards may have had one ply, the intended working surface, utilising Whatman paper but that the other sheet(s) would be made up using papers of a lesser quality. This may well have been the case in the earliest years of the nineteenth century, but recent research in the Archives of the Royal Society of Arts has shown various examples of such boards that go against this interpretation, being made up of papers by very different makers.[8] The biggest single distinction seems to have been in the quality of the glazing, with more care being taken over the finishing of London boards. The watermarks found in such boards usually fall at random, but occasionally examples can be found where the watermarks in the individual sheets are almost perfectly aligned, seeming to become one mark.[9]

One further type of paper or board is found in the Turner Bequest. Millboards were heavyweight boards originally used for making boxes and in bookbinding but later used by artists for painting in oils.[10] The name millboard comes from their method of manufacture, where the thick solid sheets are given a very hard surface by being 'milled' between heavy iron rollers. They were often made from fibre refuse, waste papers, vat ends,[11] and suchlike. In Turner's time the better grades of millboards were produced from hemp and flax fibres only,

derived from the same materials – such as tarred ropes, old sacking and sailcloth – that were used for making strong brown wrapping papers.

Sometime after the introduction of the paper machine – it is not known exactly when – millboards began to be made on adapted Fourdrinier and Cylinder Mould machines. On these machines the continuous web of thick paper travels from the press section to a mak-ing roll: this is a wooden or iron roll grooved along its length and forming the top roll of a press into which a felt carries the web. The paper wraps around the roll as it revolves and builds up into layers until the desired thickness is reached. At this stage a pointed stick is inserted into one of the grooves and run quickly along the whole length of the roll, cutting the sheet. This sheet is removed, without the machine being stopped, and laid on cotton. Another sheet is formed in the same manner, then another. The resulting pile of wet sheets, interleaved with cotton, is then pressed in the same way as handmade sheets and then dried, either in a loft or in heated drying tunnels, before being conditioned. They are then milled between heavy rollers.[12]

Although the Excise lists and General letters record many mills producing both pasteboard and millboards during the period of Turner's working life, the products of individual mills are impossible to identify: they were never watermarked and have no identifying fea-tures.

The few millboards that survive in the Bequest can be divided into distinct groups. Turner's use of millboards for oils, rather than the prepared papers he used at Knockholt, Kent, c.1801 and on his Devon Tour in the summer of 1813,[13] seems confined to his later years. It seems likely, given the few examples known of his working on them and the small number of millboards recorded in his studio after his death that they were not in common use.[14] The two main groups are firstly, a group of ten small Italian sketches of various sizes, possibly dating from 1828, although good arguments link them to the earlier 1819 tour of Italy, executed on at least three different boards, some of which have been given an extra surface of muslin stretched over the board.[15]

Secondly, there is a group of late oil sketches on board.[16] Of a group of four sea pieces dated to c.1835 by Butlin and Joll, all approximate-ly 9 × 12 (230 × 305) Royal Quarto, two of the works, in the National Museum, Stockholm, and the National Museum of Wales, Cardiff, have not been examined, but the two works in the Turner Bequest are both on the same three-layered millboard, made from hemp rope and some dirty whitish linen.[17] The versos of these boards show several large pieces of tar that had not been cleaned from the rope, as well as

fig.12 **Shore Scene with Waves and Breakwater** c.1835. Oil on millboard, 230 × 305 (9 × 12) irregular. D36680, B&J 486.

fig.13 Raking light image of the verso of the millboard, at × 20 magnification, showing the presence of tar and unbeaten pieces of the hemp rope used to make up the sheet of millboard.

pieces of unbeaten rope. The milling has left a surface still slightly rough to the touch rather than the high glaze seen in some millboards.

One group of three oil sketches, dating from 1840–5, has been executed on a two-ply hemp-grey board laminated with a purple coloured backing paper.[18] A very similar paper has been found in use by Constable over twenty years earlier. Sarah Cove's examination of the support for *Dedham Lock and Mill*, of c.1816,[19] shows it to be on a laminated board consisting of

> a top sheet of brown wove paper and a lower sheet of a purplish-blue wove paper. The purple paper is made of blue and red fibres, flax fibres (from linen rags), a few natural-coloured flax fibres, some woody material, which is probably flax bark and some unidentified fibres.[20]

Like the Turner examples, Constable has cut this piece from a much larger sheet. Unfortunately this work has recently gone missing from the Victoria and Albert Museum so a proper comparison between the two papers cannot presently be made.

Others of the late group appear to be Winsor & Newton's 'Prepared Millboards Strained with stout drawing paper' designed for use with watercolour, rather than millboards for oil sketching. These came in two sizes, 12½ × 8½ inches at 1s 6d each, or 15½ × 11½ inches at 2s 3d each.[21] Winsor & Newton's range of prepared Millboards designed for oil colour was much greater, ranging from 6 × 5 inches at 5d each up to 30 × 25 inches at 7s 6d each.[22] By 1858 'Prepared Mill Boards for painting on' were being sold by Reeves & Son in sizes ranging from 8 × 6 inches (at 6s per dozen) up to 24 × 20 inches (at 53s per dozen).[23]

1 See Labarre 1952, p.26 for a fuller discussion of this area.

2 This stamp is also found as BRISTOL / Crown / PAPER in lighter-weight sheets such as TB CLIV H.

3 Later in the nineteenth century such marks can also be found in writing papers used by hotels and gentlemen's clubs, as well as on personal stationery with an individual's own monogram. Several of the letters Turner wrote from his club, the Atheneum, are on their writing paper with the club's own blind-embossed stamp.

4 Winsor & Newton, *Trade Catalogue*, 1832. Winsor & Newton Archives, London.

5 Winsor & Newton, *Trade Catalogue*, 1836. Winsor & Newton Archives, London.

6 Winsor & Newton, *Trade Catalogues*, 1840, 1846 and 1851. Winsor and Newton Archives, London.

7 'James L. Turnbull and J. Turnbull, Makers of Playing Cards, Pasteboard, Paper Glossers and Pressers and Drawing Board Makers (including London Board)' in Bradshaw 1853.

8 Amongst the uncatalogued drawings entered for various Society of Arts prizes in the RSA Archives can be found two contrasting examples, one made up only with Whatman paper and the other made up using no Whatman paper at all. Both carry identical Turnbulls' blind embossed stamps: TURNBULL / Arms of London / SUPERFINE / LONDON BOARD, on a vertical oval. The first is a two-ply made up of two sheets, both watermarked J WHATMAN / 1827 and the second, a three-ply made up of three sheets each watermarked RUSE & TURNERS / 1839.

9 See TB CCLXXX 96, a two-ply sheet where the two J WHATMAN / TURKEY MILL / 1832 watermarks are almost perfectly aligned.

10 In the last century these boards were also called scale boards, pronounced 'scab board' or 'scabbard'. Labarre 1952, p.234.

11 'Vat ends' is the name used for the pulp left in the bottom of the vat when a batch of paper has been made. The vat ends are stored up, regardless of the type or colour of the paper the pulp was made for and when enough has been collected, a batch of unique paper or board is made.

12 S. Carter Gilmour, *Paper, its Making, Merchanting and Usage*, London 1955, p.65.

13 TB XCV (a) and TB CXXX. For a discussion of

these works see Bower 1990, p.97.

14 See Wilton 1987, p.248.

15 B&J 318–27, all at the Tate Gallery.

16 Unfortunately none of these were available for
exhibition at the Tate Gallery, owing to their
inclusion in a concurrent exhibition, *Exploring
Late Turner*, at the Salander O'Reilly Galleries,
New York, April–June 1999. Full details of this
group can be found in Peter Bower, 'Turner's
Use of Paper and Board as a Support for Oil
Sketches' in the catalogue for that exhibition,
pp.61–78.

17 B&J 483: National Museum, Stockholm.
B&J 484: National Museum of Wales, Cardiff.
B&J 485 and B&J 486: Tate Gallery.

18 *Two Figures on a Beach with a Boat*, *c.*1840–5,
D36681; *Coast Scene with Breaking Waves*, *c.*1840–5,
D36684; *Sea Sand and Sky*, *c.*1840–5, D36683.

19 Oil on paper, 181 × 248 (7¹⁄₈ × 9¾), Victoria and
Albert Museum.

20 Sarah Cove, 'Constable's Oil Painting Materials
and Techniques', in Leslie Parris and Ian
Fleming-Williams, *Constable*, exh. cat., Tate
Gallery 1991, p.499. The verso of this work is
illustrated in colour as fig.161.

21 Winsor & Newton, *Trade Catalogue*, 1849, p.42.

22 The prices quoted here are from 1863, no earli-
er prices for Winsor and Newton millboards
have survived. Winsor & Newton, *Trade Cata-
logue*, 1863, p.118.

23 Reeves & Son, 113 Cheapside, London, *Trade
Catalogue*, 1858. Winsor & Newton Archives,
Harrow.

68 A reassembled sheet made up of four different works after 1841

Three-ply laminated and glazed white Demy Superfine Drawing board made up of three sheets of white wove drawing paper each measuring

356 × 458 (14 × 18)

Each work is approximately

177 × 228 (7 × 9)

Watermark: J WHATMAN / 1841.
This mark is found once in each of the three sheets that make up the board, in TB CCLXXX 79, 83 and 85
Paper made by: William Balston & Co.
Mill: Springfield Mill, Maidstone, Kent
The sheet also bears a blind-embossed mark, reading EXTRA SUPERFINE / Crown / DRAWING BOARD in an oval. Found on TB CCLXXX 85

Watercolour

TB CCLXXX 78, 79, 83, 85
D27595, 27596, 27600, 27602
Illustrated on page 70

68A Transmitted light image of the watermark from TB CCLXXX 78.

68B Micrograph of the glazed surface and detail of the watercolour at × 22 magnification.
Illustrated on page 72

68C Raking light image of the blind-embossed mark.

Turner has worked this sheet using a method he used throughout his life, pro-ducing four images on the same sheet, only tearing or cutting the individual works apart after they were finished. The tearing through a large part of the top left-hand image raises questions as to when, and by whom, the sheet was torn down: was it by Turner himef, or per-

68C

haps by Ruskin during his examination of the Bequest?

The existence of this sheet and the four apparently unrelated works on it sets up several questions and perhaps broad-ens our understanding of the range of working methods used by Turner. TB CCLXXX 78, at the bottom left of the sheet, and here, owing to the reassembly of the sheet, exhibited upside down, has in recent years been described as a study for *Satan Summoning his Legions*, 'clearly an idea for an illustration to Macrone's 1835 edition of Milton's *Poetical Works*', for which Turner did contribute seven illus-trations, but not this image.[1]

The watermark evidence precludes this work being a study for Macrone's Milton book, because the paper was made six years after that book was pub-lished. However, it is possible that such an image would come to Turner several years after the project was over. Perhaps these are not studies 'for' works as has been supposed, but rather 'remem-brances' of works already done. There are clues as to the validity of this idea in the identification of the subject matter of the other three images on this sheet.

The image in the top left of this sheet, TB CCLXXX 79, which covers more than a quarter of the whole sheet, bears some resemblance to several of Turner's coastal castles produced in the 1820s. Although there are obvious differences in Turner's angle of view, there are real echoes of two works *Off Dover*[2] and *Straits of Dover*.[3] (There has been some uncer-tainty as to Turner's intentions with *Off Dover* and Shanes has pointed out that the topography 'only vaguely resembles Dover').[4] The other two images are

68A

rather more problematical. The long low bridge, in the top left of the sheet, bears considerable resemblance to several late images of such bridges, such as those seen in images of Coblenz, of 1841[5] and Constance, of 1841–2,[6] but it also must be said that such images had recurred throughout Turner's working life.

The resemblance of these works to other earlier works and the restricted palette suggests that Turner may well have been trying out a new paper or even a new brush, using images already deep in him, rather than creating specifically new works. Although such boards were not new, the various boardmakers were always trying out new finishing techniques to create a better product.[7] The brush strokes here move across the perfectly fitting torn edges from one individual image to another. The sheer speed and exuberance of his imagination is unfettered by the scale, the surface or the restricted palette.

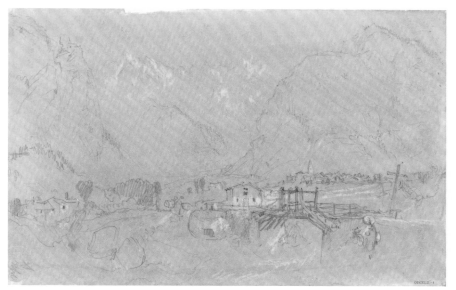

69

1 See Wilton 1978, p.112, and Lyles 1992, p.73.
2 c.1825. w 485. Wilton 1979, Lady Lever Art Gallery.
3 Untraced since 1909, but engraved by William Miller in 1828. See Shanes 1990, p.273.
4 Milner 1990, p.45 and Shanes 1990, p.147.
5 TB CCCLXIV 286, 356.
6 TB CCCLXIV 288 and w 1531, in York City Art Gallery.
7 cf. TB CCLXXX 95 and 96 for a two-sheet London Board made from Hollingworths' Whatman paper of a creamier tone and very different glaze.

69 Town in Valley with Mountains, possibly Geneva 1836 or 1838

200 × 310 ($7^{7}/_{8} × 12^{1}/_{4}$)
Cream wove two-ply laminated highly glazed board prepared with a buff wash
Watermark: CRESWICK
Paper made by Thomas Creswick at Mill Green Mill, Hatfield, Hertfordshire, and made up into board at his Islington mill
Oval blind-embossed stamp: EXTRA SUPERFINE / Coat of Arms / LONDON BOARDS

Pencil and chalk

TB CCCXLII 4
D34188

69A Transmitted light image of the CRESWICK watermark.

69B Raking light detail of the surface of the board at × 25 magnification.

69C Close-up of the blind-embossed stamp.

Creswick was renowned for his drawing papers, but he had started out in 1803[1] as a pasteboard maker, providing a range of different boards of varying weights and qualities. He manufactured these from his paper mill in Hatfield, Hertfordshire, and his horse-powered board mill in Islington, which were both in operation until 1839.[2]

Very few of Creswick's own papers carry a watermark, particularly an undated mark such as this. The two marks generally found are CRESWICK / 1816 and CRESWICK / 1818. He appears to have been in partnership at least in the early part of his career, as several watermarks of C & S plus a date have been found in papers bearing the more usual form of his blind-embossed stamp: IMPROVED / DRAW$^{\text{G}}$PAPER / ROUGH / THOMAS CRESWICK in a circle.

The stamp seen here can be found on papers from many different makers which suggests that as demand increased Creswick was buying paper from other makers to augment his own production at Islington. He was doing so well that he could boast in 1820 that 'in paying £1,600 per annum in excise duty he was paying a greater sum than any other two vat paper mills in the Kingdom'.[3] Like the Bath papermaker George Steart during the same period, Creswick was making sufficient profits from his endeavours to be able to experiment constantly with new equipment and techniques, produc-

69A

ing a bigger range of surface finishes, weights and tones.

After Creswick's retirement the public demand for new supplies of his drawing papers was so great that during the 1840s several colourmen such as Winsor & Newton, Newman, and Rowney, persuaded Balston at Springfield to produce a copy of Creswick's 'Improved Drawing Paper' which they marketed as 'Imitation Creswick'. After some twenty years the word 'Imitation' was dropped and 'Creswick' continued to be made well into the twentieth century.[4]

1 Simmons Collection, data on Mill Green Mill, Hatfield, p.1.
2 *Excise General Letter*, 10 Sept. 1839, records that the 'occupier of Mill no 154 [Hatfield Mill] has left off.'
3 HM Customs and Excise, *Excise-Treasury Letters*, 1814–22, f.402.
4 Further work needs to be done on quite when Balston first produced this paper and when they dropped the word 'Imitation'.

69B

69C

70A

70 The Kingdoms of the Earth

A study for a vignette for Thomas Moore's *The Epicurean*, published 1839

380 × 302 (14^{15}/$_{16}$ × 11^{7}/$_{8}$)

Three-ply laminated Foolscap Bristol drawing board
Watermark: SLADE / 1836
Made by: William & Thomas Slade
Mill: Hurstbourne Priors Mill, Hampshire
Circular blind-embossed stamp:
BRISTOL / Crown / BOARD

Pencil and watercolour

TB CCLXXX 134
D27651

70A Transmitted light image of the watermark.

70B Micrograph of the paper surface at × 15 magnification.

70C The blind-embossed stamp.

This untrimmed three-ply board is part of a group of studies for Moore's *Epicurean* and described by Ruskin as 'Vignette beginnings (Epicurean). Bad.'[1] In the event only four works were actually engraved and published.

Bristol boards were sold by most artists' colourmen. Although laminated using handmade papers they were usually, like this example, sold trimmed to standard sizes from Foolscap up to Imperial. The Foolscap size was nominally 15 × 12 inches but variations have been found from 14½ × 11½ up to 15¼ × 12⅛. There are several variations even in the sheet sizes of this small group of boards,

which have all come from the same source. Three-sheet Foolscap Bristol board was selling in the late 1830s for 3s 6d per dozen sheets, somewhat cheaper than the three-sheet London boards which were generally considered to be made from better quality papers and which sold for 3s 11d per dozen.[2]

As can be seen from this example, many of these sheets have discoloured in very particular ways, usually as a result of the glues rather than the raw materials used in the making of the actual paper. These glues, or pastes, used in the manufacture of both London and Bristol boards varied from maker to maker. One such recipe reads:

Make a paste with fine flour or starch. When it is almost sufficiently boiled, add to it common turpentine in such quantity as shall be equal to about a twelfth part of the weight of the starch or paste. Stir them well together and let them simmer over the fire for 5 or 6 minutes. Use the Paste hot.[3]

All of this group are on the same three-ply Bristol board, watermarked SLADE / 1836. Each three-ply board is watermarked three times, with the marks generally falling in different parts of the board, although there are two examples of overlapping watermarks. Of the whole group, two sheets are half size and probably come from two different boards. If Turner bought the usual dozen sheets then two whole and two part sheets are unaccounted for.

William and Thomas Slade were the

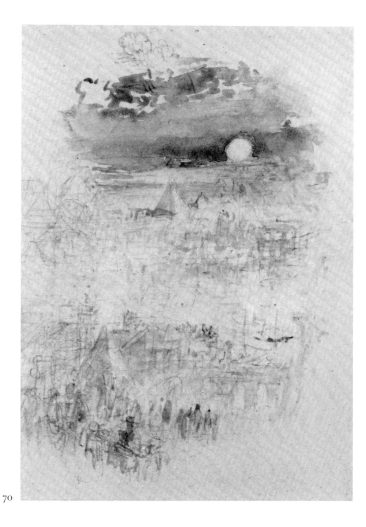

70

70B

70C

successors at Hurstbourne Priors to the well-known papermaker, William Allee. Having run the mill since the 1790s,[4] Allee had put the mill on the market in 1829, when it was

> To be Sold at the White Hart Inn, Whitchurch, Hants on 6th November. All that old stablished well known 2 vat Paper Mill replete with every description of machinery and tackle, known as Hurstbourne Paper Mill. The tenure is leasehold for 99 years under the Earl of Portsmouth. Further details from Mr Allee the proprietor on the premises.[5]

Turner was already familiar with the products of this particular paper mill: he had often used Allee's paper in some of his sketchbooks. It may be that Turner purchased this batch of Bristol board from the stationer who made up so many of his sketchbooks (see cat.no.12). Change of ownership of a mill often had no immediate effect on the trading practice of the mill: the new owners continuing to supply many of the same stationers and merchants as their predecessors.

1 Finberg 1909, vol.2, p.898. The works are TB CCLXXX 126–134 and possibly 138, which is on the same paper.
2 Winsor & Newton *Trade Catalogue c.*1838. Winsor & Newton Archives, Harrow.
3 Bryan Donkin's MSS *Recipe Book 1787–1820*, R.H. Clapperton's transcription, National Paper Museum Archives, Manchester.
4 *Sun Fire Insurance Policy* No.646890, 20 Oct. 1795.
5 *Reading Mercury*, 26 Oct. 1829.

PAPERS USED BY OTHER ARTISTS
(cat.nos.71–80)

This last section examines a group of watercolours and drawings from the Tate's collection that place Turner's paper usage within the context of general artists' usage in the first half of the nineteenth century. The papers have been chosen to show both similarities and differences in the ways artists work on various paper surfaces.

Examination of the papers used by other artists, both professional and amateur, who were Turner's contemporaries, show that there were many papers which were very popular with artists and would have been freely available to Turner but which he seems never to have worked on.[1] Some of these papers, such as the flecked blue wove seen in Clarkson Stanfield's sketch of Vesuvius (cat.no.73) or the 'JDH Pure Drawing paper' seen in cat.nos.74 and 75 were both on sale at Winsor & Newton's where Turner bought many of his materials.

It must also be remembered that the papers found in the Turner Bequest are not the only papers that Turner worked on. Several collections contain works by Turner on other papers: one group of seven seascapes and sunsets dating from the 1830s are all on parts of a very distinct, and now somewhat discoloured, buff wove paper not found anywhere in the Bequest. Three of these works are in the Bacon Collection and are recorded as having originally been one above the other on the same sheet of paper.[2] Three more are in the Victoria and Albert Museum.[3] The torn edges, the paint and the brush strokes of the seventh work, now in a private collection, match exactly one of the Victoria and Albert Museum works.[4]

There are considerable differences in the quality of the papers used by different people. Although the papers used by some artists were more expensive and generally better made than those used by others, the real criteria for their choices were probably availability, particularly for those artists travelling on the Continent, or to remote places, and differences in the particular working methods of individual artists. Some artists preferred hard-sized smoother papers, others slightly coarser and softer surfaced sheets. The media being used, the speed and pressure of the artist's hand all contribute to the success, or otherwise, of a particular sheet for an individual artist. Cost may also have played a significant part in the choice and purchasing of particular papers for some artists. Despite the often illustrious maker's names seen in the watermarks on show in this exhibition, many of the sheets themselves are not of the finest quality. Quality control varied

greatly from mill to mill and even within a particular mill over time. Many of the sheets seen in these works would have been sold as 'retree' or 'outsides'. These are sheets with something below standard about them, often used as the top and bottom quires of a packed ream in order to protect the good sheets that made up the bulk of the ream. These papers were generally sold at half price. But, despite their imperfections, close examination shows that they are for the most part sound, particularly as regards the sizing of the sheet. What deficiencies they have were obviously never serious enough to inhibit the artist from working on them.

The works in this section have been chosen to illustrate particular choices of paper, methods of working and the often very different aspirations of individual artists working at the same time as Turner. None of these artists was as prolific or travelled as widely, either in Britain or abroad, as Turner so the range of papers available to them was necessarily more limited. Although executed some years after Turner's death, Palmer's *A Dream in the Appenine* has been included to show the sometimes quite personal, and very interesting, choices that artists make in their papers and the way they like to work on them (see cat.no.80).

Many of these artists patronised the same colourmen and stationers, particularly in London, so it is not surprising to find the same papers being used by artists with very different methods of working. For example, both Cotman and Constable used, to very different effect, the same Balston J WHATMAN / 1829 Imperial white wove watercolour paper used by Turner (see cat.no.21).[5] Cat.nos.71 and 72 show Samuel Laurence working on the same buff and grey Bally, Ellen & Steart drawing papers as Turner, but in a completely different manner.

One must, however, be careful of assigning papers with the same apparent watermark to the same batch. The size of sheet, type of mould, furnish, finish, pressing, felts used, sizing, weight and size of sheet can all vary considerably. Each change in any one of these parts of the process imparts a subtle difference to the character and behaviour of the sheet in use. Several authors have recorded information about watermarks found in papers used by different artists, but, as few are versed in paper historical research and such information is often of only secondary importance to the real nature of their researches they have recorded their information in sometimes quite idiosyncratic ways. But although there are sometimes one or two misreadings of individual marks, these listings can be of great use.

Some colourmen, stationers and boardmakers were not merely retailers. Men like James Newman, one of the oldest established artists' colourmen in London, specialised in very particular papers,

many of them 'Whatman' papers, but made to his own design, either by Balston at Springfield Mill or the Hollingworths at Turkey Mill. Newman had Balston make special 'Seamless' drawing papers for him which can be identified by the large copperplate N found next to the usual J WHATMAN / DATE in the watermark. Papers made by the Hollingworths at Turkey Mill for Newman also had the same copperplate N added to the watermark. After the Hollingworths discontinued making by hand in 1859, one sees the Hollingworth J WHATMAN / TURKEY MILL mark with the Newman copperplate N and an additional large outline Roman letter B, presumably to indicate that despite the Turkey Mill in the mark, such sheets were actually made by Balston at Springfield. Balston also made drawing and watercolour papers which did not carry the WHATMAN watermark, but only for Winsor & Newton. Each sheet was watermarked W&N and also carried a blind-embossed stamp of a griffin in one corner.

Another man who continuously refined his various products in response to the market was Thomas Creswick, the papermaker and pasteboard maker who operated a mill at Hatfield in Hertfordshire and a manufactory at Islington in north London, between 1803 and 1839. His papers and boards, which ranged in colour from a warm white to a deep buff, and in finish from a very high glaze to a very rugged rough surface, were renowned and the rougher surfaces were particularly favoured by De Wint (see cat.no.77).

However good the products of the various suppliers, many artists preferred to prepare their paper to suit their particular ways of working, by re-sizing sheets, tinting them with coloured washes, stiffening them by laying them down onto other sheets, changing the surface by abrasion, rubbing with a rough cloth, or polishing them to make them smoother. Turner for the most part seems to have been happier to prepare his papers himself rather than buy already prepared sheets, particularly when he wanted a coloured tint or tone on the sheet. Many people developed their own methods of preparing papers for different media. Bryan Donkin recorded one such method in his *Recipe Book* after one of his regular visits to the Society of Arts:

> Take three sheets of drawing paper, wet them on both sides with
> a sponge and paste them together with weak parchment size.
> Whilst wet lay them on a table; take a slate previously well
> flattened by a stone mason and of a smaller size than the paper
> to be pasted upon it. Lay the slate upon the paper so that the
> edges project beyond the edges of the slate and having pasted
> the edges of the paper, turn them over upon the slate and paste
> them down. When these are dry take three more sheets, wet
> them as before and paste these upon the former one at a time

and cut off the projecting edges. When perfectly dry rub the surface with a piece of coarse sand paper till it be quite flat. Paste on another sheet of paper which ought to be perfectly clean and free from spots. Cut off the edges as before and when quite dry rub it even with fine glass paper, and so to produce a smooth surface. Then take oxide of zink and terra ponderosa mixed with a clean weak parchment size to the consistence of cream and with a large sponge wash the surface of the paper carefully over with this mixture; when dry rub it again with fine glass paper, after which wash it over with weak size only, in the state of a jelly when nearly cold. When dry rub it slightly over with glass paper and you will have a fine smooth surface. NB Plaister of Paris may be used instead of the oxide or the earth as it will answer the purpose equally well and be whiter. But if it be desirable to have the paper nearly the colour of ivory, the oxide of zink must be used.[6]

The amount of work involved in such preparations meant that many of them were rarely used, although artists such as Palmer sometimes went to extraordinary lengths to achieve their desired surfaces (see cat.no.80).

When Turner had begun drawing and painting as a boy there had been no such thing as a drawing paper made specifically for water-colour, but by the end of his life the situation was very different. Winsor & Newton devoted a whole page of one of their catalogues to introducing their new 'Griffin' paper, stressing several important details of that manufacture that were of obvious concern to their knowledgeable clientele:

A drawing paper of very choice and superior quality that may be depended upon for purity of fabric … of large size, good thickness and decided grain. It has been specially made for Messrs Winsor and Newton by Messrs Balston, the manufacturers of the celebrated J Whatman Drawing Papers, and considerable cost, time and attention have been bestowed upon its production.

The purest linen rags, picked with extreme care have alone been used.

No chemical bleach whatever has been employed. The good colour of the paper is due to the fine quality of the linen rags, and the severe washing they have undergone.

Great attention has been paid to the delicate operation of sizing, which will be found free of all greasy symptoms, and admirably suited for taking colour.[7]

The range of papers available to artists had increased enormously, the trade catalogues had changed from listing a few types of paper to devoting pages and pages to lists of different, types, sizes and qualities for every conceivable use. Along with other artists, Turner had taken advantage of those aspects of this development that had suited his needs, but had ignored others, preferring sometimes to take his chances with papers found on his travels and at other times to work with those papers that he knew he could rely on.

1 Although given the fact that previously untraced or unrecorded works by Turner do resurface from time to time, this statement may have to be rewritten in the future.

2 W 1383, 1384 and 1385. Wilton 1979, p.466.

3 V&A P.19.1938, P.20.1938, P.21.1938. W 1388, 1389 and 1390.

4 Not in Wilton; sold at Sotheby's, 13 July 1995, lot no.44.

5 Several examples of such correspondences can be found in the work of many artists: Cotman and Constable both used Balston's J WHATMAN / 1830, 1831 and 1833 white wove Royal watercolour papers. The 1831 paper was also used by William Blake.

6 'Mr Enslie's Process for making Ivory Paper' recorded by Bryan Donkin in 1819 in his MSS *Recipe Book 1787–1820*, R.H. Clapperton's transcription, National Paper Museum Archives, Manchester.

7 Undated (*c*.1848) Winsor & Newton *Trade Catalogue*, p.7. Winsor & Newton Archives, London.

SAMUEL LAURENCE (1812–1884)

71 Study for a Portrait of Julia Octavia Brookfield
before 1846

556 × 376 (22 × 15)
Buff wove watercolour paper
Watermark: B E & S / 1829
Made by: Bally, Ellen & Steart
Mill: De Montalt Mill, Combe Down, Bath, Somerset

Pencil, chalk and watercolour

T09556

71A Transmitted light image of the 1829 watermark, showing the different form, without the punctuation.

71B Micrograph of graphite and paper surface at × 8 magnification.

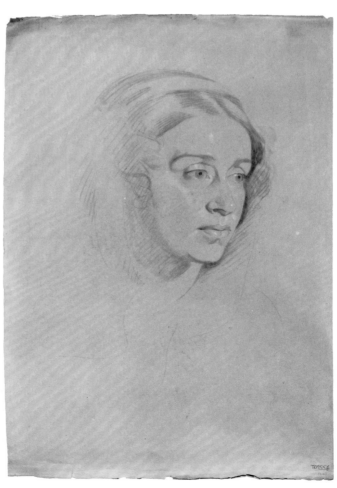

71B

71

SAMUEL LAURENCE (1812–1884)

72 Study for a Portrait of the Reverend William Henry Brookfield *c.*1853

381 × 277 (15 × 11)

Grey wove watercolour paper
No watermark
Made by: Bally, Ellen & Steart
Mill: De Montalt Mill, Combe Down, Bath, Somerset

Pencil and chalk

T09557

Samuel Laurence, despite his present relative obscurity, was during his lifetime a central figure in Victorian social and cultural life. There is scarcely a biography of any well-known mid-nineteenth century man or woman that does not mention him. His sitters included Charles Dickens, William Thackeray, James Leigh Hunt, Anthony Trollope, John Ruskin, Alfred Tennyson, George Eliot, Mrs Gaskell, Robert Browning, James Froude, Thomas Carlyle, William Wordsworth, Sir Richard Burton, Charles Babbage and Henry Cole.[1] Despite this he was not really successful in his own life and his reputation has declined since. Much of this may have come from his refusal to flatter his sitters, unlike his much more successful contemporary, George Richmond. The art critic of the *Morning Chronicle* reviewing the 1844 Royal Academy Exhibition wrote of Laurence's portrait of W. Conyngham as 'the finest portrait in the collection. It is however so grave and and sober in colour and drawing that it has been placed out of the way, lest it should put the simpering and gaudy portraits round about out of countenance'.[2]

These two portrait studies, previously catalogued as *Head of a Young Woman Half Right* and *Head of an Elderly Man, Full Face* have now been identified, through

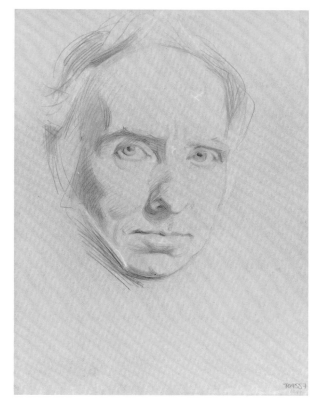

72

research in the archives of the National Portrait Gallery, as Julia Octavia Ellen Brookfield, née Elton (1821–1896), and her husband the Revd William Henry Brookfield (1809–1874) who were married in 1841. Miles describes the couple thus:

> Preferment failed to come his way. He was not a rich man and he moved in a circle of brilliant and wealthy people many of whom outshone him both intellectually and socially. This situation led to frustration on his part and discontent on that of his wife who had clearly expected great things from her husband. There is no doubt they were unhappy together for a long time and that Thackeray considered Brookfield to have ill-treated her.[3]

Julia sat for Samuel Laurence on more than one occasion, first at some point after her marriage and prior to 1846 and then again in 1849. Judging by her age in this drawing the study probably dates from the first sittings.[4] Julia Brookfield was considered a great beauty but 'In common with most people of more than ordinary beauty Mrs Brookfield did not "picture" well. Although a peculiarly picturesque woman, and quite a rare loveliness, Laurence's portraits of her were all failures, and no photograph ever did her justice.'[5] Despite his lack of success with her portrait, Laurence tried again. In 1849 Julia Brookfield wrote to her husband 'Mr Laurence was there and begged I would resume my sittings, so I am to go to him Thursday evening at eight for an hour. He has taken to painting by gaslight and prefers it to day.'[6]

The study of William Brookfield dates from a series of sittings for a portrait some years later in 1853. Some correspondence has survived regarding these sittings. Revd Brookfield wrote to Laurence: 'I enclose a second cheque for ten gns.- not without an uncomfortable consciousness how scrubby is any such recognition of all your pains and skill.'

71A

Laurence replied that the money for the work was quite satisfactory: 'I am quite content I assure you. When you are a Bishop and come to me in a very swell carriage I'll lay it on a little thicker.'[7]

These two works are both on batches of paper that Turner used. The grey wove is a quarter of an Imperial sheet of 1829 Bally, Ellen & Steart from the same batch that Turner used for many of his works – see the reassembled sheet of Walhalla and Regensburg works (cat.no.59) – and the buff wove is a half Imperial sheet from the 1829 batch that Turner used for many small German works.

Given the dates of execution of these works, particularly that of 1853 for the portrait of William Brookfield, which was nearly a quarter of a century after the paper's manufacture and twenty years since Steart stopped making paper, and the fact that many of his drawings from even later than this are on the same buff and grey papers, Laurence must have had considerable stocks.

The way these papers have been used is much more typical of how Steart's papers were generally used than the way Turner worked on them. The RSA Archives have many examples of just these kinds of portraits submitted for various prizes on these tones of Bally, Ellen & Steart paper.

The form of watermark seen here is unusual for George Steart's moulds. The most common form is B, E, & S,, and occasionally one finds B. E. & S. but no punctuation is unusual.

1 Biographical material from *Dictionary of National Biography* and National Portrait Gallery Archives.
2 Quoted by Frank Miles, 'Refusal to Flatter: Samuel Laurence 1812–84', *Country Life*, 27 May 1982, p.1605.
3 Frank Miles, typed mss catalogue of the work of Samuel Laurence, National Portrait Gallery Archives. Entry on the Brookfields, quoting private papers in the possession of W.B. Laurence.
4 Another drawing by Laurence in the Tate Gallery collection, T09555, on another half sheet of Bally, Ellen & Steart buff wove, probably the half sheet to the one shown here is also of Julia Octavia Brookfield, but full face.
5 Charles and Francis Brookfield, *Mrs Brookfield and her Circle*, London 1905.
6 Letter from Julia Octavia Brookfield to her husband, 13 March 1849, quoted in Charles & Francis Brookfield 1905.
7 Transcription of private papers in possession of W.B. Laurence. National Portrait Gallery Archives.

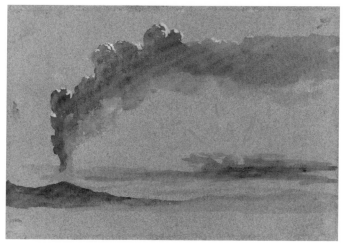

73

CLARKSON STANFIELD (1793–1867)

73 Distant View of Vesuvius by Sunset 1839

128 × 177 (5^1/$_{16}$ × 7)

Flecked blue wove drawing paper
No watermark
Unknown English maker

Watercolour and bodycolour

T08223

73A Micrograph of the paper's surface at × 10 magnfication showing details of the texture and the fibres used.
Illustrated on page 72

This work is part of a group of eight watercolours and chalk drawings of the January 1839 eruption of Vesuvius which were originally attributed to Turner.[1] But although this paper bears great visual resemblance to the blue woves used by Turner for the French rivers Meuse and Moselle and the Petworth and East Cowes Castle works, closer examination shows several differences. Cat.nos.50–3 show examples of Turner's blue paper usage on papers from Bally, Ellen & Steart at de Montalt Mill, Bath. These contained blends of blues, whites and other coloured linen rag, including very small amounts of red, yellow, brown and black fibres in different batches. This paper is made from a blend of two different blue rags and one white rag and contains some cotton. As can be seen from this work and others in the group, the blue has been affected by light.

This appears to be one of the papers made for various artists' colourmen from

the mid 1830s onwards as copies of the Bally, Ellen & Steart paper. Bally, Ellen & Steart ceased production in the early 1830s on George Steart's retirement.[2] This particular example resembles the version produced for Winsor and Newton by an unknown papermaker.

Three other views of Vesuvius by the same hand in the Oppé collection at the Tate Gallery were also examined.[3] They are all on the same unwatermarked flecked blue wove. Each of the four sheets is approximately the same size, being one-sixteenth of an Imperial sheet (nominally 30 × 22 inches).

Following the success of Bally, Ellen & Steart's blue papers many other mills made versions of these flecked blue wove drawing and watercolour papers throughout the nineteenth century. Another work from the Oppé collection, *A Study for Jezebel and Ahab*, by Frederic, Lord Leighton (1830–1896),[4] with a part watermark P / FABR, was made by Guiseppe Miliani, Cartiere Miliani, Fabriano, Italy. Guiseppe Miliani (1816–1890) consolidated the work of his famous relative Pietro Miliani (1744–1817) who had already revitalised the long-established paper industry in the town of Fabriano. He concentrated on broadening the range of specialist fine papers made by the various mills under his control.[5]

1 Aydua Scott Elliott, 'Catalogue of the Oppé Collection', (unpublished), p.238. The three watercolours in Wilton 1979, nos.1039–41, were attributed to Clarkson Stanfield by Eric Shanes in a review of Wilton 1979, *Turner Studies*, vol.1, no.1, 1981, p.47.

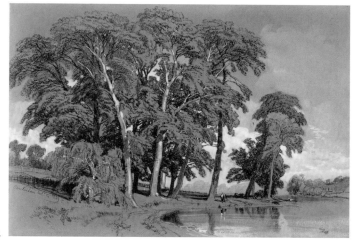

74

2 See Peter Bower, 'Respect your Paper: George Steart's Development of Artists' Watercolour and Drawing Papers', RSA *Journal*, March 1999, pp.120–3.

3 *Vesuvius in Eruption*, T08221; *Vesuvius in Eruption from near the Shore*, T08222; *The Smoke of the Volcano*, T08221. Other works in this group include two sketches in black chalk in the National Library of Scotland, another in coloured chalks in the Victoria and Albert Museum and a fourth in a private collection.

4 T08208.

5 Papermaking has been going on at Fabriano since 1270. See Grimaccini 1985 for a history of this company.

JAMES DUFFIELD HARDING
(1797 or 8–1863)

74 Twickenham 1839

270 × 384 (10⅞ × 15³/₁₆)

Buff wove 'JDH Pure Drawing paper'

Pencil and bodycolour

T00996

74A Micrograph of the papers surface at × 20 magnification, showing the particular distinctive texture that some of the JDH Pure Drawing papers had.

74A

75A

JAMES DUFFIELD HARDING
(1797 or 8–1863)

75 Vicenza 1834

375 × 264 (14¾ × 10³/₈)

Grey wove 'JDH Pure Drawing paper'

Pencil and bodycolour

T00997

75A Micrograph of the graphite on the paper's surface at × 20 magnification.

These two papers are from a range of particular papers initially produced for the artists' colourmen Winsor & Newton.[1] These copies of earlier 'drab' and 'tinted' drawing papers were produced in two sizes, Imperial and Royal. These papers appear to have been made by several different papermakers throughout the nearly eighty years that they were manufactured, although the lack of extant purchasing records means that it has not yet proved possible to identify which mills produced them. The early versions of these papers, particularly the greys, bear considerable resemblances to Bally, Ellen & Steart's greys, but as the century progressed this resemblance lessened.

Winsor & Newton marketed two white papers and various tints, from pale cream to deep buff and grey, as 'JDH Pure Drawing paper', named after the artist James Duffield Harding whose works on this paper are shown here.[2] From some point in the 1840s onwards these papers were sold with a blind-embossed stamp: JDH DRAWING. Pencils were also marketed under Harding's name by Winsor & Newton.[3] Nearly twenty years after their introduction these papers were available in the extra large size, Double Imperial (44 × 30 inches).[4]

These papers proved very popular with many artists, both professional and amateur, and particularly the members of the Royal Watercolour Society and were soon stocked by other artists' colourmen besides Winsor and Newton.[5] They appear to have been discontinued *c.*1910[6] under the pressure from other makes of watercolour paper such as Arnold & Foster, from Eynsford Mill, Kent[7]; the OWP & Co.'s RWS; Whatman's Imitation Creswick made by Balston at Springfield Mill and the influx of continental papers from French makers

such as Canson Frères and Michallet as well as the Italian company Cartiere Miliani at Fabriano.

Other artists who used JDH Pure Drawing paper include John Frederick Lewis (1805–1876),[8] Edward Lear (1812–1888), and David Roberts (1796–1864).

1 Winsor & Newton, *Trade Catalogue*, 1840 advertises these as 'Extra Stout grey and other tints for colours'. They were selling at 5d or 6d a sheet, 8s or 10s a quire for Imperial sheets and 4d a sheet or 6s a quire for Royal sheets.

2 W. Winsor & H.C. Newton, *The Hand-book of Watercolours*, London 1842. 'J D Harding's Pure Drawing Paper, Imperial 7/6 per quire'.

3 Winsor & Newton, *Trade Catalogue*, 1851, pencils 'selected by Mr J D Harding and stamped with his name'.

4 Winsor & Newton, *Trade Catalogue*, 1868.

5 JDH Drawing paper also found in Reeves' *Trade Catalogues* from 1856 to 1878.

6 The last listing I can find for J D Harding's Pure Drawing paper is in a 1910 *Trade Catalogue* issued by James Newman of Soho Square.

7 Peter Bower, 'Two Sample Books from Eynsford Mill, Kent', *The Quarterly*, no.18, April 1996, pp.9–12, discusses Arnold & Foster paper in detail.

8 E.g. *Escorial*, T08166, pale grey wove; *Mosque at Cairo*, T08183, pale buff wove.

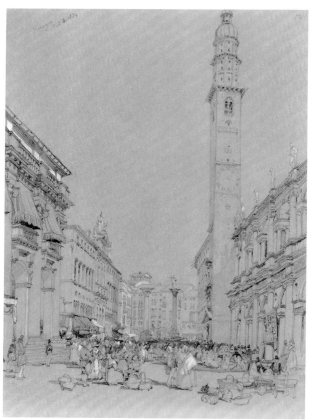

75

JOHN SELL COTMAN (1782–1842)

76 The Ramparts, Domfront *c.*1820

222 × 321 (8³/₄ × 12¹¹/₁₆)

Cream wove drawing paper
No watermark
Unknown maker, probably Balston at Springfield Mill, Maidstone, Kent

Pen and pencil

T00972

76A Micrograph of the pen and the paper's surface at × 15 magnification. *Illustrated on page 72*

Very few watermarks have been found in works by Cotman. Many of his works are laid down onto backings and have not yet been properly examined, and from those that have it is fairly obvious that he liked to work away from the watermark particularly in wove papers, in which, in English papermaking practice the watermark is usually found close to one of the long edges of the sheet, and could be trimmed off after working.

Cotman was an artist who had very

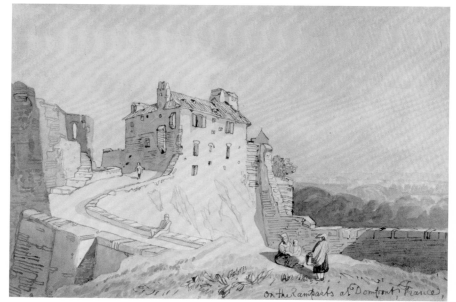

76

decided preferences in papers. Throughout his career he sought those surfaces that were most sympathetic to his various methods of working. He worked on buff, greys, blues and white and cream papers. Many of the buff laid wrapping papers favoured by Cotman earlier in his career were never watermarked and their origin is impossible to determine with any accuracy. Most of the buff woves he favoured after c.1815 can be identified, despite the lack of watermarks, as having been made by George Steart at De Montalt Mill, near Bath.

For his white papers he generally chose the smoother Hot Pressed versions of 'Whatman Paper' from both Balston at Springfield Mill and the Hollingworths at Turkey Mill. On the 1820 tour of Normandy from which this work comes, he took at least three papers with him from England, including both cream and white wove papers, and part watermarks visible in some drawings show that both these papers were made by William Balston at Springfield Mill.[1]

Cotman used Domfront as a base between 20 and 26 August 1820 and despite the almost continuous rain, and being arrested for a suspected involvement in a conspiracy, made many drawings, some of which he worked up as watercolours on his return to England.[2]

Cotman's paper usage is still being examined but several makers have been identified, all of whom were also used by Turner but not necessarily the same papers.[3] These include:

William Balston, Springfield Mill, Maidstone, Kent.

> J WHATMAN / 1813
> [J] WHATMAN / [1814]
> J WHATM[]
> [J WHA]TMAN / [182]9
> J WHATMAN / 1830
> J WHATMAN / 1831
> J WHATMAN / 1833

William Balston and the Hollingworth Brothers, Turkey Mill, Maidstone, Kent.

> 1794 / J WHATMAN

Robert Edmeads and John Pine, Ivy Mill, Maidstone, Kent.

> E&P / 1796

John Green, Hayle Mill, Maidstone, Kent.

> J GREEN / []

T & J Hollingworth, Turkey Mill, Maidstone, Kent.

> J WHATM[AN] / TURKEY [MILL] / []

John Larking, Upper Mill, East Malling, Kent.

> [J LA]RKING = Ornamented Fleur-de-lys / GR

Richard & Thomas Turner, Upper Tovil Mill, Maidstone, Kent.

> RUSE & TURNER / 1834

James Whatman the younger, Turkey Mill, Maidstone, Kent.

> JAMES W[HATMAN]

The use of the Christian name, JAMES, rather than the more usual initial J, shows that this piece of paper has been cut down from a much larger sheet, either Double Elephant (approximately 26¾ × 40 inches, 680 × 1019 mm) or Antiquarian (approximately 31 × 53 inches, 788 × 1347 mm). The Whatman watermarks found in these sheet sizes usually read in full: JAMES WHATMAN TURKEY MILL KENT and are generally dated.

Examples have also been found of Cotman working on unwatermarked sheets which have blind-embossed stamps:

> London board, from an unknown maker, stamped LONDON SUPERFINE BOARD.
> Buff wove drawing paper, from Thomas Creswick, stamped DRAWING PAPER / ROUGH / THOMAS CRESWICK in a circle.

1 E.g.: *West Front of the Cathedral Church of Notre Dame at Sées*, 1820, pencil on white wove, trimmed watermark J WHATMAN. Colman Bequest, Norwich Castle Museum, 304.235.951.
2 Miklos Rajnai and Marjorie Allthorpe-Guyton, *John Sell Cotman: Drawings of Normandy in Norwich Castle Museum*, Norwich 1975, pp.24–5. A watercolour of this subject in a slightly smaller format, 178 × 279, is in the Bacon Collection, II/C/13.
3 Published sources for watermarks found in papers used by John Sell Cotman: Miklós Rajnai and Marjorie Allthorpe-Guyton, *John Sell Cotman, Drawings of Normandy in Norwich Castle Museum*, Norwich, 1975; Miklós Rajnai and Marjorie Allthorpe-Guyton, *John Sell Cotman, Early Drawings in Norwich Castle Museum*, Norwich, 1979; Andrew Moore, *John Sell Cotman, 1782–1842*, Norwich 1982.

PETER DE WINT (1784–1849)

77 Bray on Thames from the Towing Path *c.*1849

371 × 648 (15⅝ × 25½)
Off-white wove watercolour paper
No watermark
Made by: Thomas Creswick
Mill: Mill Green Mill, Hatfield, Hertfordshire

Watercolour and pencil

N03487

77A Micrograph of the texture of the surface at × 15 magnification.

The combination of a long narrow landscape format and Creswick's rough 'Improved' drawing paper is typical of De Wint's work for much of his career. De Wint often worked on Creswick paper when sketching as well as for more finished works but there are also examples of him working on Creswick for a sketch and then another paper for the finished work. For example, his sketch for *Torksey Castle*[1] and his finished work of the same subject[2] are designed for two very different purposes and executed on very different papers. In his swift study the Creswick paper was admirably suited to his confident brush. The much larger finished 'Exhibition' piece has been executed on a Hot Pressed Whatman with a very high degree of gelatine sizing, more suited to the layered and luminous washes De Wint felt were appropriate to the finished view of that particular subject.

This work has sadly suffered very badly from light damage. The indigo used in the sky has vanished, producing a much yellower tone in the paper than it would have been originally. However, Creswick was rarely a true white paper; the warm off-whites and pale buffs favoured by De Wint, even when unaffected by light, are unfortunately very reminiscent of the tones seen in light-damaged works on paper. Because of this similarity they are often assumed to have suffered from damage, even when they are in fact in very good condition and sometimes they have been cleaned to a much whiter shade than they were originally. This interference with the integrity of the work ignores the artist's intention: he chose to work on a particular tone which gave very specific colour balances to his painted marks. Changing the base colour of the sheet distorts these relationships.

Creswick papers are rarely water-marked but marks found in works by De Wint include

c & s / 1811[3]
c / 1813
CRESWICK / 1816
CRESWICK / 1818

Compare the surface seen in this sheet with one of the Creswick papers used by Turner (see cat.no.61)

1 *Torksey Castle (Study)* c.1835, 298 × 466 (11³/₄ × 18³/₈), Usher Art Gallery, Lincoln, U.G.71/88.
2 *Torksey Castle, Lincolnshire*, c.1835, 460 × 770 (18¹/₈ × 30¹/₄), Usher Art Gallery, Lincoln, U.G.86/13.
3 This c&s watermark, and the c mark have both been found in papers with Creswick's blind-embossed stamp for IMPROVED DRAWING PAPER. It has not yet proved possible to identify to whom the 's' refers. No record has come to light of Creswick working in partnership with anyone.

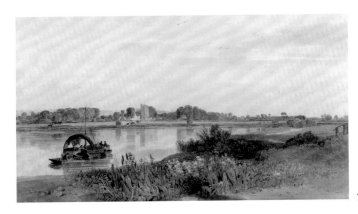

77

77A

78A

DAVID COX (1783–1859)

78 Tour d'Horloge, Rouen 1829

343 × 257 (13¹/₂ × 10⁴/₈)

White wove paper
No watermark
Unknown maker

Watercolour and pencil

T00977

78A Micrograph of the graphite and paint layer on the paper's surface at × 15 magnification.

Cox had very specific preferences when it came to his materials, particularly the tones, absorbancy and strengths of his working surfaces. He liked papers that allowed him to work fast with a heavily loaded brush. During his working life Cox had three papers which he returned to over and over again. One was what he called his 'old favourite cartridge'[1] which he continued to use throughout his life and the source of which has never been satisfactorily identified. The second was a paper which he acquired from his brother-in-law, Gardener, who:

had the sale of the Government Ordnance Maps [and] was commissioned to get some superior paper made for them at the paper mills at Uxbridge. Some sheets were made beyond the order, and these and

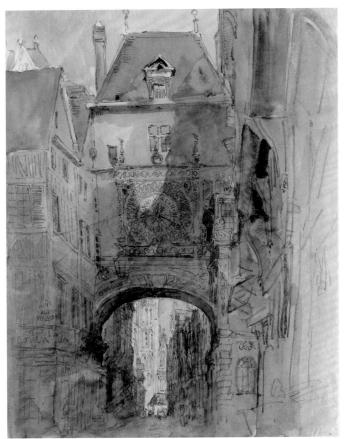

78

some cuttings of the paper were obtained for Cox, who prized them as being superior[2]

Unlike Turner, Cox only made three journeys to the Continent, to Belgium and Flanders in 1826, northern France in 1829, from which this work comes, and the French northern ports in 1832. It was Gardener who was instrumental in getting the normally very insular Cox to travel abroad at all: Gardener had been commissioned by his employers to travel to Brussels to examine a map of the world that had recently been published and he suggested that Cox accompany him to Belgium.[3]

The paper used for this work has certain characteristics that suggest that it is one of those 'sheets made beyond the order' that he had been given by Gardener. While in France during 1829 Cox did purchase at least some paper in Paris: a small sketchbook now in a private collection carries a label 'Werner / MD Papetier / Rue Vivienne No 2 bis / Paris'.

In 1836 Cox found the third of his favourite papers and one paper which will forever be associated with his name: what he, from then on, called 'Scotch Wrapping'. It was made from bleached linen sailcloth and designed for wrapping reams of better quality paper. He had obtained a few sheets by chance from the paper merchants Grosvenor Chater[4] and was told by them that the Excise Mark 84B indicated that it was manufactured at Dundee.[5] Impulsively he ordered a ream which to his amazement weighed 280lbs

and cost eleven pounds. Cox could not actually afford the eleven pounds but was helped in paying for it by an old friend, the amateur watercolourist William Roberts, who also had to help Cox carry the ream away from Grosvenor Chater's office.

Cox's initial dismay at the cost of the paper soon turned to regret that he did not order more, as the paper exactly suited his needs, and he could never find any more of equal quality. Its ready absorption of colour and the particular nature of the rough texture were admirably suited to his vigorous strokes made with a full wet brush. The paper also contained many small black and brown flecks.[6] On one occasion when asked what he did with these specks if they fell awkwardly, say in the sky, he is reputed to have replied 'Oh, I just put wings on them and they fly away'.[7] A particularly fine example of his use of this paper is his picture *Sun, Wind and Rain* of 1845.[8]

1 Letter to his son, the artist David Cox junior in 1845. N. Neil Solly, *Memoir of the Life of David Cox*, London 1873, p.131.
2 Ibid., p.81. I have, as yet not been able to discover which mill this would have been.
3 Trenchard Cox, *David Cox*, London 1947, p.56.
4 Grosvenor, Chater and Company, Wholesale Stationers (founded by William Grosvenor *c.*1690), occupied No.11 Cornhill, London, from 1765 to 1851 before moving to Cannon Street. Grosvenor Chater did not start making papers themselves until the 1850s when they acquired Abbey Mill, Flintshire (1854) and Glory Mill, Buckinghamshire (1859). They had previously had papers made for them by various makers including both Balston at Springfield Mill, Maidstone and the Hollingworths at Turkey Mill, Maidstone.

5 The only Dundee Mill I can find records of did not begin operation until 1850. It is possible that the story of a Dundee origin for this paper is incorrect. The Excise number 84B is also unusual, this is the only example I have seen with a letter in addition to the usual number.
6 The flecks come from the larger hemp fibres from old tarred ropes.
7 Trenchard Cox, *David Cox*, Phoenix House British Painters Series, 1947, p82.
8 Birmingham City Art Gallery.

JOHN CONSTABLE (1776–1837)

79 Netley Abbey by Moonlight
*c.*1833

146 × 200 (5³⁄₄ × 7⁷⁄₈)

White wove watercolour paper
No watermark
Unknown maker, probably Balston
Watercolour and pencil, with some scratching out

T01147

79A Micrograph of the paint layer and paper surface (including scratching out) at × 10 magnification.
Illustrated on page 72

Constable first drew Netley Abbey on 11 October 1816, while on his honeymoon staying with an Aunt Mary Gubbins at Southampton, but this nostalgic moonlight recollection dates from many years later when he was engaged in one or two other moonlight works as he developed his ideas for a series of illustrations to Gray's *Elegy*.[1]

Constable's choice of papers is revealing: less adventurous in his choices than Turner, he generally preferred smoother papers such as this sheet for his smaller works, but was prepared to work on rougher sheets for larger ones. The maker of this sheet was probably William Balston at Springfield Mill. Although Constable used the products of both Turkey Mill and Springfield Mill throughout his working life, all the Whatman papers he used in the 1830s were made by Balston rather than the Hollingworths.

Some work has been done researching Constable's papermakers, many of whom are the same as those used by Turner, but the coincidence of similar watermarks, as described in various catalogues, often hides a more complex situation: in many instances papers used by Turner and

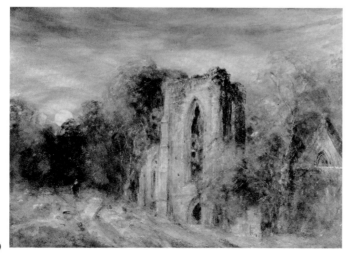

79

Constable apparently having the same watermark, are often very different, having come from sheets of different sizes and sometimes having been designed for very different uses.

Watermarks so far recorded in works by Constable are listed below:[2]

William Balston, Springfield Mill, Maidstone, Kent.

J WHATMAN / []
J WHATMAN / 1810
J WHATMAN / 1811
J WHATMAN / 1813
[J WH]ATMAN / [18]18
J WHATMAN / 1829
J WHA[] / 182[]
J WHATMAN / 1830
[J WHA]TMAN / [18]31
J WHATMAN / 1832
J WHATMAN / 1833

William Balston and the Hollingworth Brothers, Turkey Mill, Maidstone, Kent.

I[79] / J WH[ATMAN]
1794 / J WHATMAN
J WHATMAN / 1804

John Budgen?, Dartford Mill, Kent.
J BUDGEN / 1820

This is unlikely to be Budgen as he was a prisoner for debt in the King's Bench Prison for most of 1820. He died in the October of that year. Whoever was working Dartford Mill was still using Budgen's watermarks.

John Dickinson, Nash Mills, Hertfordshire.
JOHN DIC[] / 18[]

Robert Edmeads and John Pine, Ivy Mill, Maidstone, Kent.
E & P
E & P / 1801
E & P / 1802

John Gilling and Robert Allford, Cheddar Mill, Somerset.
GILLING & / ALLFORD / 1829

John Hayes and John Wise, Padsole Mill, Maidstone, Kent.
Posthorn / H&W

T and J Hollingworth, Turkey Mill, Maidstone, Kent.
J WHATMAN / TURKEY MILLS / 1817
TURKEY MILLS / J WHATMAN / 1819
J WHATMAN / TURKEY MILL / 1821
J WHATMAN / TURKEY MILLS / 1824

John Pine and William Thomas, Basted Mill, Wrotham, Kent.
BASTED MILL / 1824

John Portal and William Bridges, Laverstoke Mill, Hampshire.
PORTAL & CO / 1794

William Bridges had originally been in partnership with Joseph Portal who died in 1793. He then went into partnership with Joseph's son John Portal. The most common forms of watermarks from the two partnerships are PORTAL & CO or PORTAL & BRIDGES, with or without a date. There is also a rare 'transitional' watermark, from the period between the two partnerships reading W BRIDGES.[3]

Joseph Ruse, Upper Tovil Mill, Maidstone, Kent.
J RUSE / 1800

Robert Tassell, Lower Mill, East Malling, Kent.
R TASSELL / 1833

James Whatman the younger, Turkey Mill, Maidstone, Kent.
J WHATMAN

Thomas Wickwar, West Mills, Newbury, Berkshire.
T WICKWAR / 1801

Constable also used several examples of Bath wove post writing paper, from unidentified makers, with its typical blind-embossed Crown / BATH stamp.

1 Published by John Martin in 1834.
2 Published sources for some watermarks found in papers used by John Constable: Graham Reynolds, *Catalogue of the Constable Collection in the Victoria and Albert Museum*, London 1973. Jane McAusland, 'Some of the Drawing Materials Available to Artists in the Late Eighteenth and Early Nineteenth Centuries', in *Constable: A Master Draughtsman*, London 1994, pp.13–15.
3 Found in works by William Blake.

SAMUEL PALMER (1805–1881)

80 A Dream in the Appenine
exh.1864

660 × 1016 (26 × 40)
Four-ply laminate of white watercolour papers
No watermark visible
Unknown maker, probably Balston at Springfield Mill, Maidstone, Kent
Watercolour, bodycolour and pencil

N05923
Illustrated on page 70

80A Micrograph of the area around the sun at × 10 magnification showing the white primed ground.
Illustrated on page 72

80B Micrograph of the right-hand edge of the sheet showing the four layers of paper and Palmer's paintwork at × 10 magnification.

80C Detail of the pin holes at the edge of the sheet at × 10 magnification.

80D Ultra-violet photograph of the work, showing the blue-white fluorescence of Palmer's priming.

As with many artists Palmer worked on a variety of papers throughout his life. Many of them were the same papers that other artists used, but for some of his later, larger works, such as this and the

80B

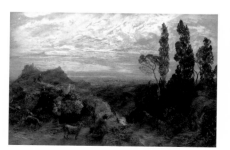
80D

80C

series of complex watercolours based on poems by Milton, he developed an extraordinary system of preparing his working surfaces. A letter from Palmer to Richard Redgrave describes some of his curious methods and is worth quoting from at length:[1]

about the board I work upon. It is a six-sheet 'London Board' of best quality from Newman's, Soho Square[2] (which I think a most reliable place for watercolours), Imperial or Royal: the royal, they say, is made for or used by flower painters.

I take off the gloss by rapidly sponging with water (a *little* alum dissolved in it might perhaps do no harm) rapidly lest the paste should soften underneath; thoroughly, so far as to see that it takes the water everywhere. I was driven to use it simply because, on the best modern paper (the only sort to be had since Creswick's was bought up), I found it impossible to get any one quality I liked.

At first I felt like a baby on a slide, but found that this might be avoided by using the colours less wet than on a simple paper. Ultramarine especially, and the ashes, always difficult to wash, will not bear a full, wet brush; but a very thin wash of zinc white over the sky and distance part, before beginning, might facilitate. Several practised artists have done this.

These difficulties have their equivalent advantage in the ease with which a bit of sponge or even a wet brush will remove dried colour. In this respect the surface is intermediate between paper and ivory.[3] I have done my largest things upon it; getting it made on purpose rather than use paper.[4] I fasten it around the edge with the smallest flat-headed brass pins (not passing them through it, which if you avoid working on parts already wet, prevents warping), upon a thin, light, drawing-board of seasoned pine ... a sheet of white paper is fastened on the front of the drawing-board, so that even if you have not much margin of the 'London Board' you have a sort of white mount[5]

In this very large work, Palmer appears not to have used the 'very thin wash of zinc white over the sky and distance part'

he describes above.[6] Under ultra-violet light the ground fluoresces a distinctive blue-white, quite different to the fluorescence of zinc white, suggesting that a very different priming has been used. Palmer's son described his father using 'pure white grounds ... laid with "Blake's White" a pigment for the making of white of which Blake gave my father the recipe.'[7] Townsend describes 'Blake's White' as chalk, or whiting, in glue (probably carpenter's glue rather that pure gelatine), a very similar recipe to one of Cennino Cennini's.[8] His description of using pins to fasten the sheet to a wooden board can also be seen in this work, where the minute pin holes at the edges of the sheet are still visible.

According to Palmer, a London Board, prepared in this manner

reflects light through the pigments. It shows the full depth of the colours laid on, and as you retouch with more colour the retouchings are still darker, as one would suppose they naturally must be. In the modern papers, you come to a full stop at a point far short of the depth of the pigment – in fact it is an ocular paradox.

Palmer had very distinct views on the right kinds of papers depending upon what sort of work was being contemplated. Two further extracts from other letters show his particular fondness for creamy whites for painting and etchings and brownish-grey tinted papers for sketching:

Dark pictures are best drawn on brown crayon-paper (the tint of Whitey-Brown, but a little darker)[9]

Water colours upon paper hued like the lightest whitey-brown paper (I have a sketchbook of whitey-brown paper which Mr Newman got hot-pressed for me)[10]

Palmer hated some of the developments in artists' papers that the merchants, and the papermakers were insisting on

Supposing there should be a lucid interval in this vile grey and blue paper system [i.e. JDH Pure Drawing Paper, etc] ... it is evident to me that something has been done either to blue or bleach the paper. If we asked the papermaker to make us a creamy tone we should rue the day. All I say is,

after you have washed them, make up the rags, pure and simple or impure and simple, into paper, just as they are, and let them alone: no bleaching acid, please, no blue bag, no toning ...

My demurs as to papermaking are a trifle. I was told at Mr Colnaghi's that a chemical agent was used in making the paper for a large and expensive engraving, which after a good while turned it BLACK.[11]

1 A.H. Palmer, *The Life and Letters of Samuel Palmer*, London 1892 (1972), Letter XLVII to Mr Richard Redgrave, 14 July 1865.
2 James Newman, one of the oldest established artists' colourmen in London, specialised in selling papers made up to his own specifications.
3 There were many attempts at making boards that replicated the ivory tablets used by painters of miniatures and several recipes survive. The Society of Arts received 'Mr Enslie's process for making Ivory Paper' in 1819, where it was noted down by Bryan Donkin.
4 E.g. the group of Palmer's watercolours based on Milton's *L'Allegro* (three subjects) and *Il Pensero* (five subjects), dating from 1868–70.
5 The normal way of exhibiting 'Exhibition' watercolours during this period was to mount them in a gold mount, right up to or overlapping the edge of the painted area. It is interesting that Palmer seems to be recommending a white mount: quite simply it allows the colours to stand on their own.
6 Most Double Elephant Drawing papers were made at 40 or 41 inches by 26 or 27 inches. This work measures 26 × 40 inches, but has been trimmed for some reason, before painting along the bottom edge.
7 Quoted in Griselda Barton and Michael Tong, *Underriver: Samuel Palmer's Golden Valley*, 1995, p.12.
8 Joyce Townsend, 'William Blake: Moses Indignant at the Golden Calf *c.*1799–1800', in Hackney, Jones and Townsend (eds.), *Paint and Purpose: A Study of Technique in British Art*, Tate Gallery 1999, p.66.
9 A.H. Palmer, *The Life and Letters of Samuel Palmer*, London 1892 (1972), Letter XLII to Miss Louisa Twining, 22 Nov. 1864. The 'whitey-brown' that Palmer refers to was originally a strong wrapping paper, made from a blend of white linen rags and old hemp rope, and which ranged in tone, depending on the maker and the batch, from a warm cream to a pale buff-grey.
10 Ibid., Letter LXXXIX to Mr P.G. Hamerton, Nov. 1872.
11 Ibid., Letter LXXXVI to Mr Richard Seeley, 6 Nov. 1872.

Glossary of Papermaking Terms

These definitions apply to paper manufacture and usage during Turner's lifetime. In some cases, these definitions are not applicable to modern handmade, or machine-made, papers.

Words in italics within a particular definition are themselves defined elsewhere in this glossary.

ALUM: Traditionally, potash alum, but superseded later in the nineteenth century by aluminium sulphate. Added to *gelatine* in the *sizing* of paper, to stabilise the gelatine and aid its bite into the surface of the sheet.

ASS: Curved wooden post on the corner of the *vat*, where the *mould* is rested after the sheet has been formed.

BACK: The marks left in the centre of a handmade sheet of paper when dried over ropes.

BEATER: Machine invented in Holland in the seveteenth century for the preparation of *pulp*, consisting of a heavy *beater roll* rotating above a *bedplate*, placed midway down one side of an oval trough.

BEATER ROLL: Barred roll used to crush, cut and *fibrillate* the *fibre* as it passes round the *beater*.

BEDPLATE: A barred plate, situated in the base of the *beater* and over which the roll passes.

BROKE: Flawed paper that is not of sufficient quality to sell, usually repulped.

BROWN-WHITE: Papermakers' description of papers made from blends of white and coloured linen rags, and usually having some addition of hemp or jute fibre derived from rope.

CARTRIDGE: Originally used for making cartridges, and later used as both strong wrapping paper and by many artists for drawing and watercolour.

CHAIN LINES: Lines visible in a *laid paper* when it is held up to the light. Caused by the wires used to hold the *laid wires* together.

COUCH: The action of transferring the newly formed wet sheet from the *mould* to the *felt*, hence *coucher*.

COVER: The old name for the forming surface of the *mould*.

CURING: Allowing the paper to mature for a time before packing and sale.

CYLINDER MOULD MACHINE: Invented by John Dickinson in 1809. Designed to produce single sheets rather than the continuous *web* of paper produced on a *Fourdrinier machine*.

DANDY ROLL: Free running hollow wire mesh roll situated on the forming table of a paper machine. The Dandy compresses the top surface of the newly formed sheet and is also used to impart a laid or wove *look-through* to the sheet. Watermarks in machine-made papers are impressed into the top surface of the sheet by images attached to the surface of the Dandy cover.

DECKLE: A removable frame which fits on and around the working surface of the *mould*, retaining the *pulp* on its surface, during the formation of the sheet.

DECKLE EDGE: The slightly ragged edge to the sheet found in handmade paper, caused by small amounts of pulp seeping under the *deckle* during the formation of the sheet.

DOUBLE-FACED MOULD: Papermaking mould with a secondary supporting wire layer underneath the formation surface. Developed at the very end of the eighteenth century for *wove* moulds. Began to be used for *laid moulds* at the turn of the century.

DRY PRESS: The various pressing sequences given to the sheets after drying.

DUSTER: A wire mesh drum used to shake loose dirt out of rags.

EDGE CHAINS: Extra chain lines running on the outer edge of both short sides of the mould. Added for strength.

ENGINE: See *beater*.

ENGINE SIZING: The addition of *size* to the *beater* rather than adding size to the finished sheet.

FELTS: Woven woollen blankets used in handmade papermaking during *couching* and during the first *wet press*.

FELT SIDE: The side of the paper which first comes into contact with the *felt* after formation. Opposite to *wire side*.

FERMENTATION: The old method of preparing rags for the *beater*, which involved letting piles of wet rags heat up and begin to rot.

FIBRE: Plant based cellulose used in making paper. Towards the end of the eighteenth century the paper industry changed its raw material use from fibre obtained from linen rags and old ropes, sailcloth etc., to cotton rags and eventually to wood based fibres.

FIBRILLATION: The action of breaking up the surface of the individual cellulose *fibres* used to make the paper. It takes place during *beating*.

FINISH: Term used when describing the nature of the surface of the sheet.

FINISHING: The process of imparting the final surface to the sheet of paper.

FORM: The action of making a sheet of paper. Also the old name for the *mould*.

FOURDRINIER MACHINE: Papermaking machine developed by Bryan Donkin, for the Fourdrinier Brothers in 1803–4, based on the original invention of Nicholas-Louis Robert. Produces a continuous web of paper rather than individual sheets.

FURNISH: The raw materials that make up the sheet. Particularly the *fibre* or blend of fibres used.

GELATINE: A type of *size* added as a coating to the dry sheet, to prevent ink and paints bleeding across the surface. Has the added effect of increasing the surface strength of the sheet. Gelatine is made from animal parts such as hides, hooves and bones.

GLAZING: The degree of smoothness or polish of a paper surface.

HALF STUFF: Partially beaten *fibre*.

HOLLANDER: See *beater*.

HOG: A wooden paddle used to keep the *fibre* in suspension in the *vat*. Later replaced by a mechanical paddle fitted in the base of the vat.

HOT PRESSES (or HP): One of the three traditional *finishes* of handmade paper. Originally produced by pressing the paper between hot metal plates, this *finish* is now approximated by passing the metal plates and paper between *glazing* rollers.

HYDRATION: A process taking place during *beating* whereby the fibres, through crushing and *fibrillation*, take up water.

INSIDES: Used to describe the best paper, regardless of the type of paper being made: the sheets used as the 'inside' *quires* of a *ream*, when paper was packed with the best paper protected by lower quality paper, placed top and bottom of the ream. See *outsides*.

KNOTS: Small lumps of badly beaten or twisted fibres in the *pulp*.

LAID LINES: Tightly spaced parallel lines seen in *laid paper* when it is held up to the light. These lines are produced by the wires of the mould surface. See *chain lines*.

LAID PAPER: Paper made on a laid *mould*.

LAYER: The worker who separates the *felts* and wet sheets of paper after pressing.

LITRESS: A kind of smooth *cartridge* paper made in two sizes, Royal and Foolscap, and used for drawing.

LOADING: Non-cellulose material added to the pulp: e.g. 'smalts', the finely powdered cobalt blue glass added to rags to make them appear whiter, or china clay, added to bulk up the fibre and act as an aid to ink retention.

LOOK-THROUGH: The details of the internal structure of the sheet of paper when looked at in transmitted light.

MATURING: See *curing*.

MILLBOARD: Heavyweight boards made from hemp and flax fibres and/or fibre refuse.

MOULD: A rectangular wooden frame covered with a sieve-like *laid* or *wove wire* surface, used for forming sheets of paper by hand. The mould is dipped into the *pulp* in the *vat* and lifted out. The excess water drains away through the *mould cover*, leaving the *pulp* as a thin flat sheet on the surface of the *mould*.

NOT: A traditional paper *finish*, slightly rough and unglazed, produced by pressing wet paper against itself, after the first *wet press*.

OUTSIDES: Second quality papers, used top and bottom of the *ream*, to protect the good sheets. See *insides*.

PACK: Pile of wet sheets, after separation from the *felts*, after the first press. Or, small stack of paper prepared for *glazing*.

PLATE GLAZING: Method of producing sheets of smooth paper by interleaving the sheets with metal plates and passing the whole *pack* through glazing rollers.

PLATE PAPER: Paper designed for copperplate engraving.

POST: The pile of newly formed sheets and *couching felts*, ready for pressing.

PRESSING PAPERS: Rag and rope based papers or boards, sometimes heavily glazed, used for pressing or resurfacing woollen cloth.

PRINTINGS: Papers designed for letterpress printing.

PULP: The cellulose *fibre*, held in suspension, from which paper is made.

QUIRE: Originally twenty-four sheets of paper, now more usually twenty-five sheets.

RAGS: Formerly the principal raw material for handmade paper made in the European tradition, generally linen for the finest papers, but increasingly, after the end of the eighteenth century, from cotton goods. By association also used for old hemp rope, sailcloth, etc.

REAM: Traditionally 480 sheets (twenty *quires*, each of twenty-four sheets), though this varied, depending on the use the paper was to be put to: e.g. a printer's ream was 516 sheets. Now counted as 500 sheets.

RETING: The rotting down of flax to begin the break up of the stems. Sometimes applied to a similar process used with rags. See *fermentation*.

RETREE: Sheets with minor faults. Usually sold 10 per cent cheaper.

RIBS: Thin wooden struts fixed into the frame of the *mould* to support the wire *mould* cover.

ROUGH: Traditional paper surface, formed by the weave of the *felts* during the first *wet press*.

SALLE: The room in the mill where the sorting, *curing* and packing of paper took place.

SHADOWS: Thicker areas in the sheet, formed either side of the *ribs* on a *single-faced mould*, as the water draining through the wire is drawn to the *ribs*. See also *white shadows*.

SHAKE: The *vatman's* action of dipping, shaking and forming the sheet.

SHIVES (sometimes sheaves): Specks visible in the finished paper, caused by impurities in the raw materials used.

SINGLE-FACED MOULD: A mould on which the wire surface sits directly on the supporting *ribs*.

SIZE: Originally a solution of *gelatine*, gum or starch, used to make the paper water resistant. Now any chemical which has the same effect, whether by coating the finished sheet, or by addition to the *pulp* before formation.

SPUR: Group of sheets dried together as a wad.

STAMPER: Early machine for making *pulp*, consisting of several sets of large wooden hammers, driven by a waterwheel, falling into mortars, filled with rag. Superseded by the *beater*.

STATIONER: Takes his name from his 'station' or shop: the name was used to distinguish himself from itinerant street vendors.

STOCK: See *pulp*.

STUFF: *Pulp* ready for making into paper.

STUFF CHEST: Storage vat for *pulp*.

TEXTURE: The actual surface of the sheet. Can be altered at various stages of the process.

TREBLES: (or TRIBBLES): Racks of drying ropes.

TUB SIZING: The addition of *size* after the sheet has been formed, pressed, dried and allowed to *cure*.

VAT: Contains the *pulp* from which the paper is formed.

VATMAN: Person who works at the *vat* forming the sheets.

WATERLEAF: Unsized paper.

WATERMARK: An image in the sheet, formed by varying the density of the *pulp* at certain points in the sheet, by raising or lowering the surface of the *mould* at selected places. Usually done by attaching a design in wire to the working surface of the *mould*.

WEB: Newly formed paper, still in its wet state, formed on a *Fourdrinier machine*. Formed on a continous travelling wire.

WET PRESS: The first pressing received by the newly formed sheets.

WHITE SHADOWS: Lighter areas in the sheet, when seen in transmitted light, usually caused by pulp drying between the forming wire and the support struts of the mould on *double-faced mould*. Caused by the papermaker neglecting to clean the mould after use. Very useful in terms of showing details of the mould construction that would otherwise have remained invisible.

WILD: Used to describe the *look-through* of a poorly formed sheet.

WIRE MARK: More accurate term for a *watermark*.

WIRE PROFILE: The wire design used to form the *watermark*. Or, by extension, the description of the wires used to form the surface of the *mould*.

WIRE SIDE: The side of the paper next to the wire during the formation of the sheet. Opposite to *felt side*.

WRAPPINGS: Low grade coloured papers, destined for wrapping various articles, but often, because of their strengths, textures, colour, tones etc. used by artists for both chalk, pencil and colour.

WRITINGS: Papers designed for the quill or the steel nib.

WOVE MOULD: *Mould* whose cover is made from woven wire, rather than *laid* and *chain* wires.

WOVE PAPER: Paper made on a *wove mould*.

BIBLIOGRAPHY

All books published in London unless otherwise stated.

UNPUBLISHED SOURCES

Various archives and unpublished sources have been consulted in the course of this research:

Archives and paper collections of the
National Paper Museum, Manchester:
Donkin, Bryan *Journal: February 1809 – January 1810*. MS transcription by R.H. Clapperton.
Donkin, Bryan *Journal: April 1813 – February 1814*. MS transcription by R.H. Clapperton.
Donkin, Bryan *Travel Journal: September 1842 – July 1843*. MS transcription by R.H. Clapperton.
The Introduction of Machinery into English Papermaking as Shown in the Fourdrinier Towgood Papers 1803–1838 MS, 1934.

Cowell, Norman, *Transcription of the Papers Relating to John Gamble and St Neots Paper Mill*, from Noris Museum St Ives, Cambridgeshire.

Kent County Archives, Maidstone: *Whatman, Balston and Hollingworth Papers*.

National Portrait Gallery Archives, London.

Patent Office Records, London.

Public Record Office, London.

Royal Society of Arts, London.

Serota, Nicholas, 'J M W Turner's Alpine Tours', unpublished MA report, Courtauld Institute of Art, 1970.

Science Museum Library Archives, London: The Rhys Jenkins Papers and The Simmons Collection

Windsor & Newton Archives, Harrow, Middlesex: *Trade Catalogues* from Newman, Reeves, Winsor & Newton, etc.

Woolrich, A.P., *Transcription of the Journals of Joshua Gilpin*

PAPER

André, Louis, *Machines à papier: les usines Arjo Wiggins au XIXᵉ siècle*, Paris 1996.

André, Louis, *L'Invention de la machine à papier et les débuts du papier continu en France*, Mulhouse, France 1991.

Balston, T., *William Balston, Paper Maker, 1759–1849*, 1954.

Balston, T., *James Whatman, Father & Son*, 1957.

Balston, J., *The Elder James Whatman*, 2 vols., Kent 1992.

Balston, J., *The Whatmans and Wove (Velin) Paper*, Kent 1998.

Barcham Green, J., *Papermaking by Hand*, Maidstone 1967.

Barrett, Timothy, 'Early European Papers, Contemporary Conservation Papers', *The Paper Conservator*, vol.13, Worcester 1989.

Bidwell, John, *Early American Papermaking*, Delaware 1990.

Boithias, J.-L. and C. Mondin, *Les Moulins à Papier at les Anciens Papetiers d'Auvergne*, Nonette, France 1981.

Bolam, F., (ed.), *Stuff Preparation for Paper and Paperboard Making*, 1988.

Bower, Peter, *Basic Principles of Papermaking*, 1980.

Bower, Peter, *Turner's Papers: A Study of the Manufacture, Selection and Use of his Drawing Papers 1787–1820*, 1990.

Bower, Peter, 'Information Loss and Image Distortion Resulting from the Handling, Storage and Treatment of Sketchbooks and Drawings' in *IPC 1992 Manchester Conference Proceedings*, 1992.

Bower, Peter, 'Challenge and Responsibility: Caring for Random Collections of Paper', *The Paper Conservator*, vol.19, 1995.

Bower, Peter (ed.), *The Oxford Papers*, Studies in British Paper History, vol.1, 1996.

Bradshaw, *List of Papermills in England, Scotland and Northern Ireland*, Manchester 1853.

Campbell, H., 'Remarks on the Present State of Papermaking in England and France', in Nicholson's *Journal of Natural Philosophy*, vol.2, 1802.

Castagnari, Giancarlo (ed.), *Produzione e uso delle carte filigranate in Europa (secoli XIII–XX)*, Fabriano 1996.

Chater, M., *Family Business: A History of Grosvenor Chater 1690–1977*, 1977.

Churchill, W.A., *Watermarks in Paper*, Amsterdam 1935.

Clapperton, R.H., *The Paper Machine: Its Invention, Evolution and Development*, Oxford 1967.

Cohen, C., *The James McBey Collection of Watermarked Paper*, Cambridge, Massachusetts 1981.

Cohen, C. and G. Wakeman (eds.), *The Art of Making Paper*, 1978.

Coleman, D.C., *The British Paper Industry, 1495–1860*, 1958.

Crocker, Alan and Martin Kane, *The Diaries of James Simmons, Papermaker of Haslemere, 1831–1868*, Oxshott 1990.

Dagnall, Harry, *The Taxation of Paper in Great Britain 1643–1851*, 1998.

Eineder, Georg, *The Ancient Paper Mills of the Austro-Hungarian Empire and their Watermarks*, MCPHI vol.VIII, Hilversum, Holland, 1960.

Evans, Joan, *The Endless Web*, 1955.

Gaudriault, Raymond, *Filigranes et autres caractéristiques des papiers fabriqués en France aux XVIIᵉ et XVIIIᵉ siècles*, Paris 1995.

Gravell, Thomas and George Miller, *A Catalogue of Foreign Watermarks Found on Papers in Use in America, 1700–1835*, New York 1983.

Grimaccini, Alberto, *L'Arte della Carta a Fabriano*, Fabriano 1985.

HM Customs and Excise, *Instructions for Officers who Survey Papermakers*, 1845.

Heawood, E., *Watermarks mainly of the 17th and 18th Centuries*, rev. ed., MCPHI vol.I, Hilversum, Holland, 1986.

Hills, R.L., *Papermaking in Britain, 1488–1988*, 1988.

Hunter, D., *Papermaking*, 1974.

Juries of the Royal Commission for the Exhibition of the Works of Industry of All Nations, *Report on Paper*, 1851.

Kälin-Sautter, Hans B., 'Wappen in Schweizer Wasserzeichen', *IPH Yearbook 1986*.

Koops, Matthias, *An Historical Account of the Substances Used to Make Paper*, 1800.

Krill, J., *English Artists Paper*, 1987.

Labarre, E.J., *Dictionary and Encyclopaedia of Paper and Paper-making*, 2nd ed., Amsterdam 1952.

Le Français de la Lande, J.J., *L'Art de faire le papier*, 1761.

Leif, Irving P., *An International Sourcebook of Paper History*, Connecticut 1978.

Loeber, E.G., *Supplement to E.J. Labarre Dictionary and Encyclopaedia of Paper and Paper-making*, Amsterdam 1967.

Loeber, E.G., *Paper Mould and Mouldmaker*, Amsterdam 1982.

Lyddon, Denis and Peter Marshall, *Papermaking in Bolton*, Altrincham 1975.

Muir, Augustus, *The Kenyon Tradition: The History of James J. Kenyon and Son Ltd 1664–1964*, Cambridge 1964.

Murray, John, *Observations and Experiments on the Bad Composition of Modern Paper*, Edinburgh 1824.

'Paper' from Abraham Rees, *The Cyclopaedia or Universal Dictionary*, 1819.

'Paper' from *The Encyclopaedia Brittanica*, 1797.

'Paper Manufacture' from *The Engineers and Mechanics Encyclopaedia*, 1836.

Piette, Ludwig, *Die Fabrikation des Papiers aus Strob und vielen andern Substanzen in Grosen*, Cologne 1838.

Portal, Sir Francis, Bt., *Portals*, Oxford 1962.

Reynaud, Marie-Hélène, *Les Moulins à papier d'Annonay à l'ére pré-industrielle*, Annonay 1985.

Schmidt, Frieder, *Von der Mühle zur Fabrik*, Mannheim 1994.

Schmidt, Frieder, *Papiergeschichte(n)*, Wiesbaden 1996.

Schmidt, Frieder, *Besitzerfolgen von Papiermühlen in Thüringen*, Leipzig 1998.

Schmoller, Tanya, *Sheffield Papermakers: Three Centuries of Papermaking in the Sheffield Area*, Wylam 1992.

Shorter, A.H., *Paper Mills and Papermakers in England, 1495–1800*, MCPHI vol.VI, Hilversum 1957.

Shorter, A.H., *Paper Making in the British Isles*, Newton Abbott 1971.

Shorter, A.H., *Studies on the History of Papermaking in Britain*, Aldershot 1993.

Spicer, Sir Albert Dykes, *The Paper Trade* [n.d.].

Staples, P.J., *The Artists' Colourmen's Story*, 1984.

Thomson, A.G., *The Paper Industry in Scotland, 1590–1861*, Edinburgh 1974.

Tschudin, Peter, *Schweizer Papiergeschichte*, Basle 1991.

Tschudin, W. Fr., *The Ancient Paper Mills of Basle and their Marks*, MCPHI vol.VII, Hilversum, Holland 1958.

TURNER

Bailey, Anthony, *Standing in the Sun: A Life of J.M.W. Turner*, 1997.

Brown, David Blayney, *Turner and Byron*, exh. cat., Tate Gallery 1992.

Butlin, M. & E. Joll, *The Paintings of J.M.W. Turner*, 2 vols., rev. ed., 1984

Butlin, Martin, Mollie Luther and Ian Warrell, *Turner at Petworth*, 1989.

Campbell, Mungo, *Turner in the National Gallery of Scotland*, Edinburgh 1993.

Cormack, M., *J.M.W. Turner, R.A. 1775–1851: A Catalogue of Drawings and Watercolours in the Fitzwilliam Museum*, Cambridge. 1975

Dawson, Barbara, *Turner in the National Gallery of Ireland*, Dublin 1988.

Finberg, A.J., *A Complete Inventory of the Drawings of the Turner Bequest …*, 2 vols., 1909.

Finberg, A.J., *The History of Turner's 'Liber Studiorum'*, 1924.

Finberg, A.J., *The Life of J.M.W. Turner*, 1961.

Gage, J., *Colour in Turner: Poetry and Truth*, 1969.

Gage, J., *J.M.W. Turner: 'A Wonderful Range of Mind'*, 1987.

Gage, J., *George Field and his Circle*, exh. cat., Fitzwilliam Museum, Cambridge 1989.

Gage, John (ed.), *Collected Correspondence of J.M.W. Turner*, Oxford 1980.

Hamilton, James, *Turner: A Life*, 1997.

Hamilton, James, *Turner and the Scientists*, exh. cat., Tate Gallery 1998.

Hartley, C., *Turner Watercolours in the Whitworth Art Gallery*, Manchester 1984.

Herrmann, L., *Ruskin and Turner*, 1968.

Herrmann, L., *Turner: Paintings, Watercolours, Prints and Drawings*, 1986.

Lyles, Anne, *Turner: The Fifth Decade*, exh. cat., Tate Gallery 1992.

Manchester City Art Gallery, *Turner at Manchester*, 1982.

Milner, Frank, *Turner Paintings in Merseyside Collections*, 1990.

Nugent, Charles and Melva Croal, *Turner Watercolours from Manchester*, Washington 1996.

Piggott, Jan, *Turner's Vignettes*, exh. cat., Tate Gallery 1993.

Powell, Cecilia, *Turner in the South*, 1987.

Powell, Cecilia, *Turner's Rivers of Europe*, exh. cat., Tate Gallery 1991.

Powell, Cecilia, *Turner in Germany*, exh. cat., Tate Gallery 1995.

Powell, Cecilia, *Italy in the Age of Turner*, exh. cat., Dulwich Picture Gallery 1998.

Reynolds, Graham, *English Watercolours*, rev. ed., 1988.

Rodmer, William S., *J.M.W. Turner: Romantic Painter of the Industrial Revolution*, University of California Press, Berkeley 1997.

Roget, J.L., *History of the Old Watercolour Society*, 1891.

Russell, John and Andrew Wilton, *Turner in Switzerland*, Zurich 1976.

Shanes, Eric, *Turner's England 1810–1838*, 1990.

Shanes, Eric, *Turner's Watercolour Explorations*, exh. cat., Tate Gallery 1997.

Sloan, Kim, *J.M.W. Turner: Watercolours from the Lloyd Bequest*, exh. cat., British Museum 1998.

Thornbury, W., *The Life of J.M.W. Turner R.A.*, 2 vols., 1862.

Townsend, Joyce, *Turner's Painting Techniques*, exh. cat., Tate Gallery 1993.

Townsend, Joyce (ed.), *Turner's Painting Techniques in Context*, UKIC 1997.

Turner Society News, various issues.

Turner Studies, various issues.

Upstone, R., *Sketchbooks of the Romantics*, 1991.

Warrell, Ian, *Turner: The Fourth Decade*, exh. cat., Tate Gallery 1991.

Warrell, Ian, *Through Switzerland with Turner*, exh. cat., Tate Gallery 1995.

Warrell, Ian, *Turner on the Loire*, exh. cat., Tate Gallery 1997.

Wilton, A., *Turner and the Sublime*, exh. cat., British Museum 1980.

Wilton, A., *Turner in his Time*, 1987.

Wilton, A., *J.M.W. Turner: The 'Wilson' Sketchbook*, 1988.

Wilton, A., *The Life and Work of J.M.W. Turner*, 1979.

Wilton, A. and Anne Lyles, *The Great Age of British Watercolour 1750–1880*, exh. cat., Royal Academy 1993.

Index